Learn to Paint
in Watercolor
with 50 Paintings

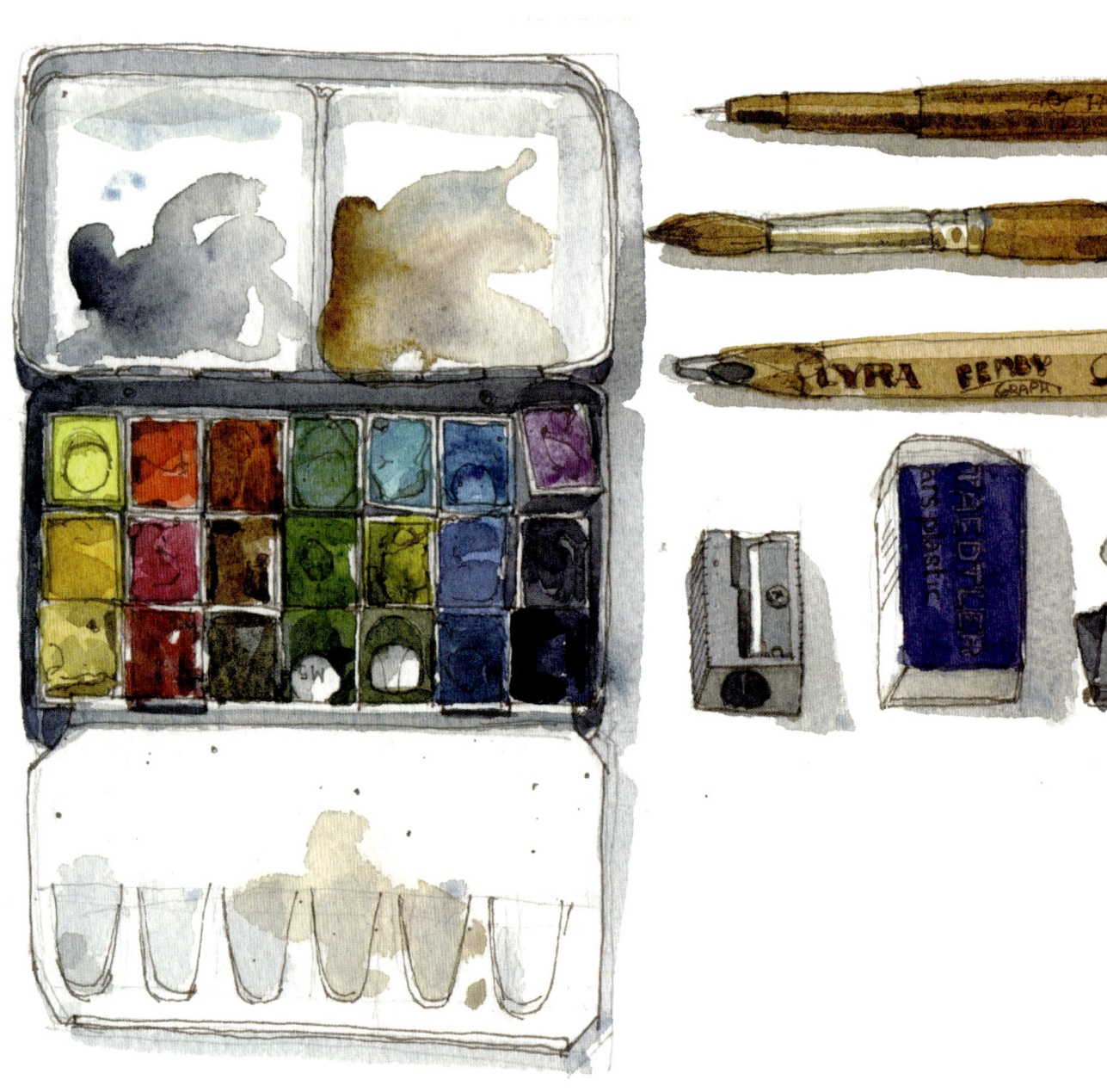

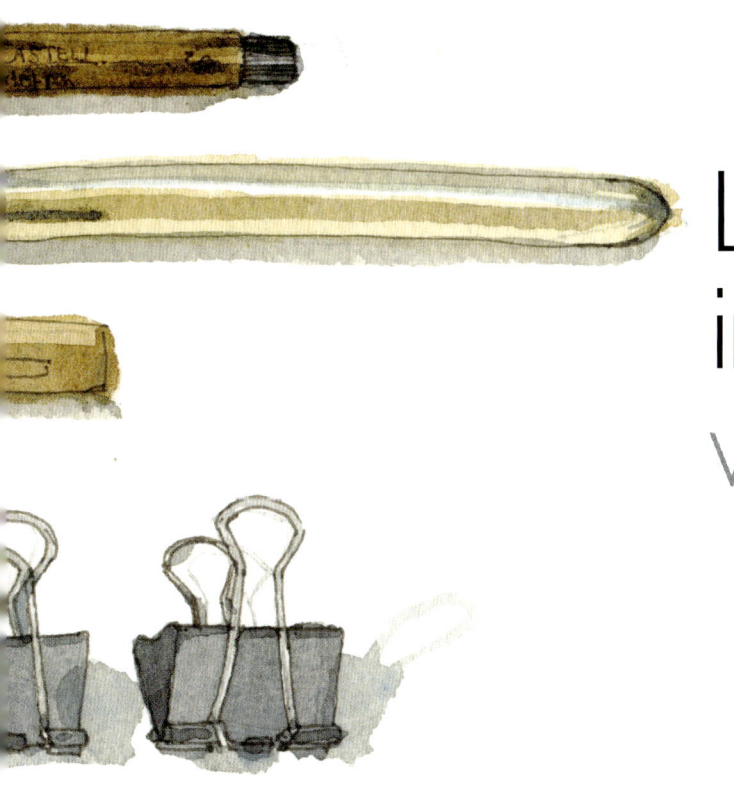

Learn to Paint
in Watercolor
with 50 Paintings

Wil Freeborn

Quarto is the authority on a wide range of topics.
Quarto educates, entertains, and enriches the lives of our readers—enthusiasts and lovers of hands-on living.
www.quartoknows.com

A QUARTO BOOK

Copyright © 2017 Quarto Inc.

First published in the USA in 2017 by
Fair Winds Press, a member of
Quarto Publishing Group USA Inc.
100 Cummings Center
Suite 406-L
Beverly, MA 01915-6101
www.quartoknows.com

All rights reserved. No part of this book may be reproduced or utilized, in any form or by any means, electronic or mechanical, without prior permission in writing from the publisher.

ISBN: 978-1-63159-277-5

Library of Congress Cataloging-in-Publication Data available

Conceived, designed, and produced by
Quarto Publishing plc
The Old Brewery, 6 Blundell Street
London N7 9BH

QUAR.WSFP

Senior editor: Victoria Lyle
Copy editor: Diana Craig
Editorial assistant: Danielle Watt
Proofreader: Sarah Hoggett
Indexer: Helen Snaith
Designer: John Grain
Step-by-step photography: Wil Freeborn
Still life photography: Beth Chalmers
Art director: Caroline Guest
Creative director: Moira Clinch
Publisher: Paul Carslake

Printed in China by Hung Hing Ltd

10 9 8 7 6 5 4 3 2 1

Contents

8 Welcome to my world

Chapter 1: Getting started
12 Basic Kit
14 Choosing your colors
16 Color mixing
18 Paper
20 Washes
22 Color, light, and atmosphere
24 How to keep a sketch book
28 Hints and tips

Chapter 2: Simple still lifes

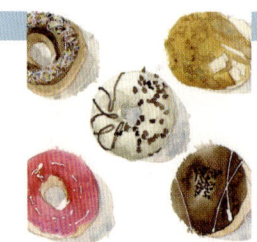
32–33 Lively washes

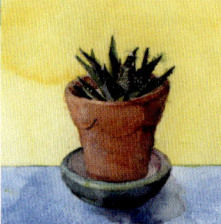
34–35 Backgrounds for still lifes

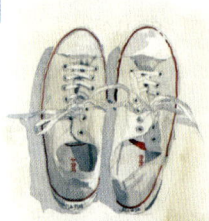
36–37 Working with a minimal palette

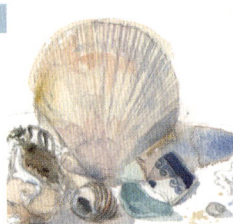
38–39 Arranging a simple still life

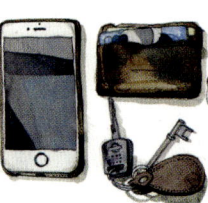
40–41 Basic drawing for watercolor

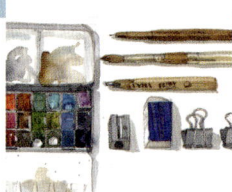
42–43 Get confident with color

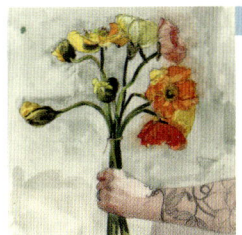

44–45
Classic subjects, new approaches

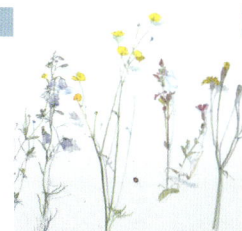

46–47
Compose as you go

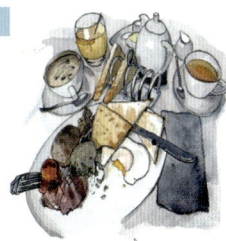

48–49
Watercolor with pen and ink

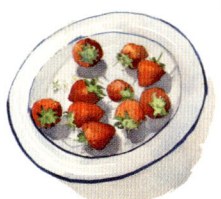

50–51
Sight sizing

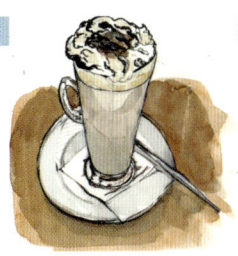

52–53
Quick watercolor sketch

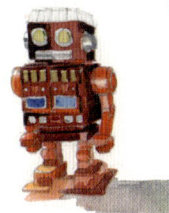

54–55
Hard edges

Chapter 3: Landscapes

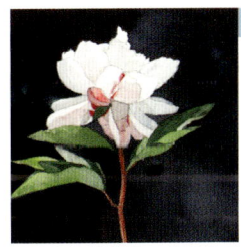

56–57
Creating dynamic contrast

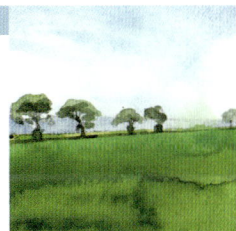

60–61
Washes for atmosphere

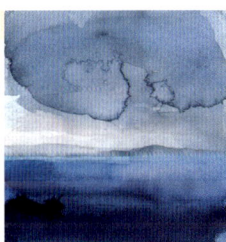

62–63
Simple wash with gradation

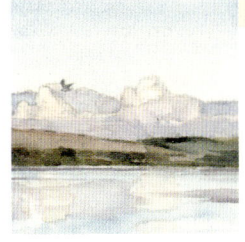

64–65
Creating a sense of distance

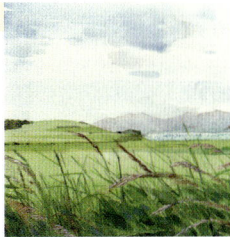

66–67
Masking areas of white paper

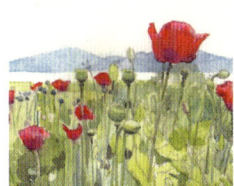

68–69
Bright colors in landscapes

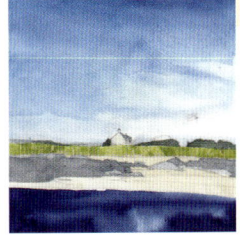

70–71
Ideas for composition

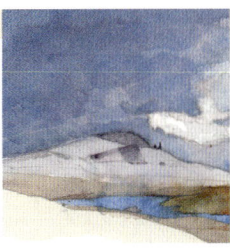

72–73
Bold shapes

74–75
Finding interesting shapes

Chapter 3: **Landscapes** continued

76–77
Pure texture and subtle washes

78–79
Working with one color

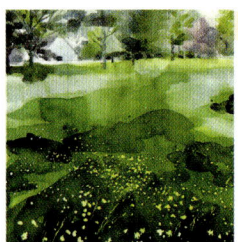
80–81
Reserving colors

82–83
Telling stories

84–85
Abstract patterns

Chapter 4: **Cityscapes**

88–89
Simplifying what you see

90–91
Exploiting granulation

92–93
Sparkling sunlight

94–95
Symmetry and proportion

96–97
Painting multiple buildings

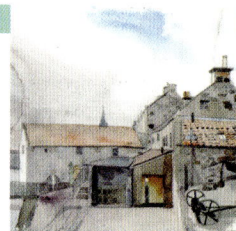
98–99
Perspective for beginners

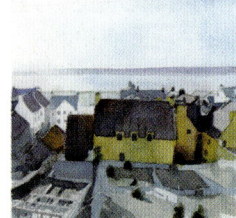
100–101
Building up a complex scene

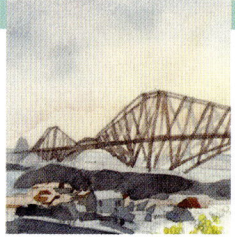
102–103
Finding your interpretation

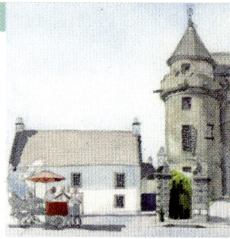
104–105
Introducing a sense of scale

Chapter 5: Animals

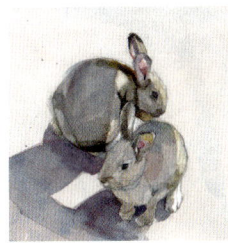
108–109 Grouping subjects

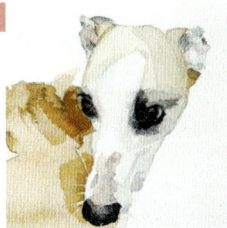
110–111 Editing out

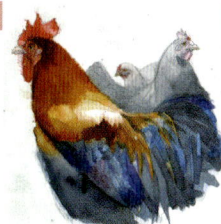
112–113 Expressive brushwork

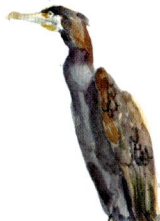
114–115 Painting a museum specimen *by Lara Scouller*

116–117 Painting live animals *by Lara Scouller*

118–119 Working from photos

120–121 Three-color washes

122–123 Painting a marine subject

124–125 Landscapes with wildlife

Chapter 6: Figures, portraits, people

128–129 Adding figures to landscapes

130–131 Simplifying people

132–133 Painting quickly *in situ*

134–135 Grisaille

136–137 Capturing movement

138–139 Mixing media

140 Stretching paper **141** Glossary **142–143** Index **144** Credits

Hello, welcome to my world...

My name is Wil Freeborn and I live and work on the west coast of Scotland, where I'm inspired to travel and record the places I love. I went to art school in the 90s, where I studied environmental art, which was a modern, conceptual course. From there I worked in a few design agencies, specializing in web design.

It was during my daily commute that I picked up a sketchbook and started making a point of drawing every day, slowly building up my confidence. I then started exploring what else I could draw and paint. I would cycle and drive around Scotland, finding new places that would mean something to me, and hopefully to you.

I've planned this book around a similar idea. Initially, we'll start by painting objects you can find in your own home. As you grow in confidence, you can venture outside of the house and explore your town or city, and the countryside nearby.

Although the lessons use subjects from where I live, I hope they will inspire you to find places near you. Viewing the areas around you with an eye for watercolor could be the start of a great journey—I hope you take your first steps here.

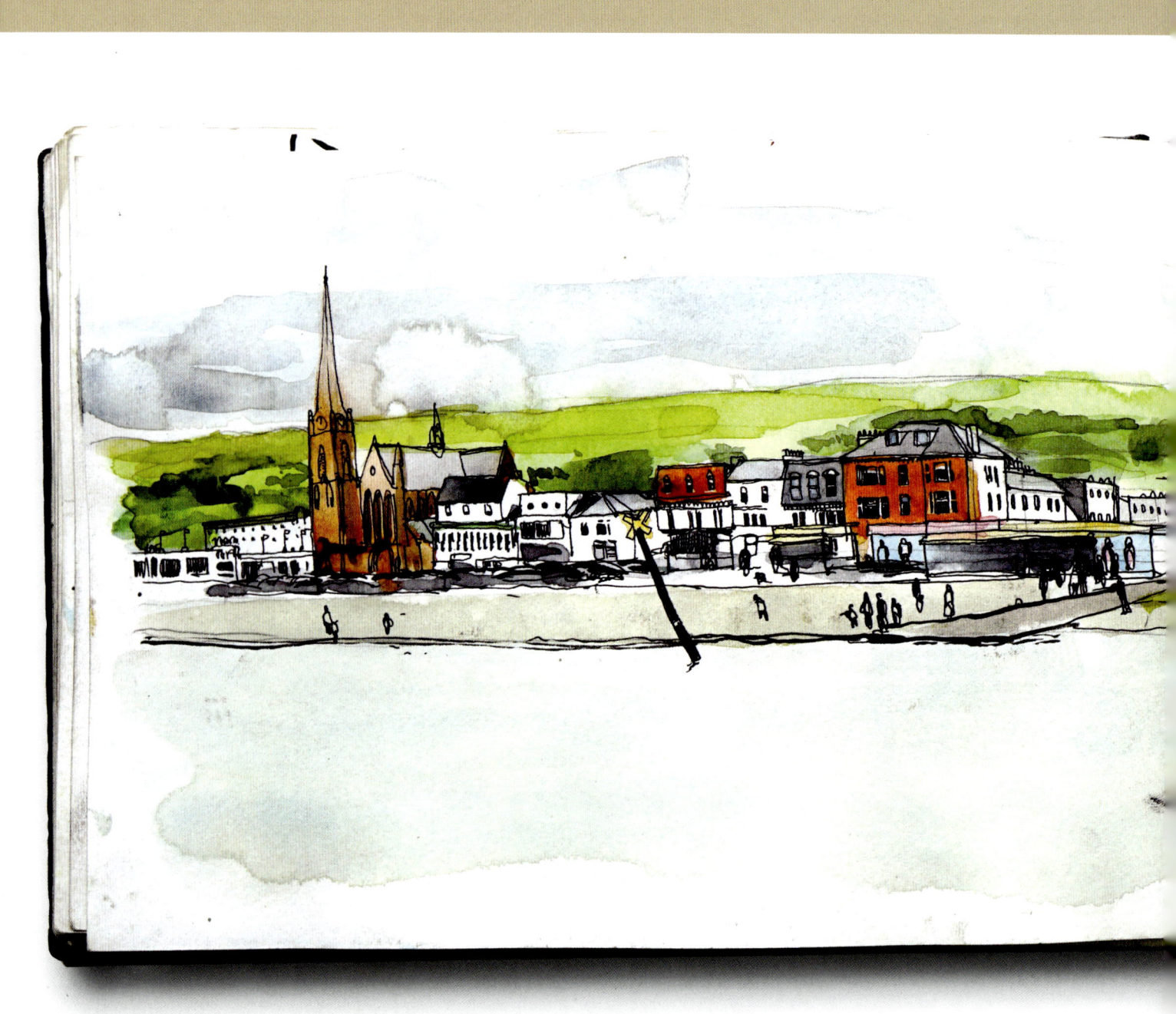

Chapter 1
Getting started

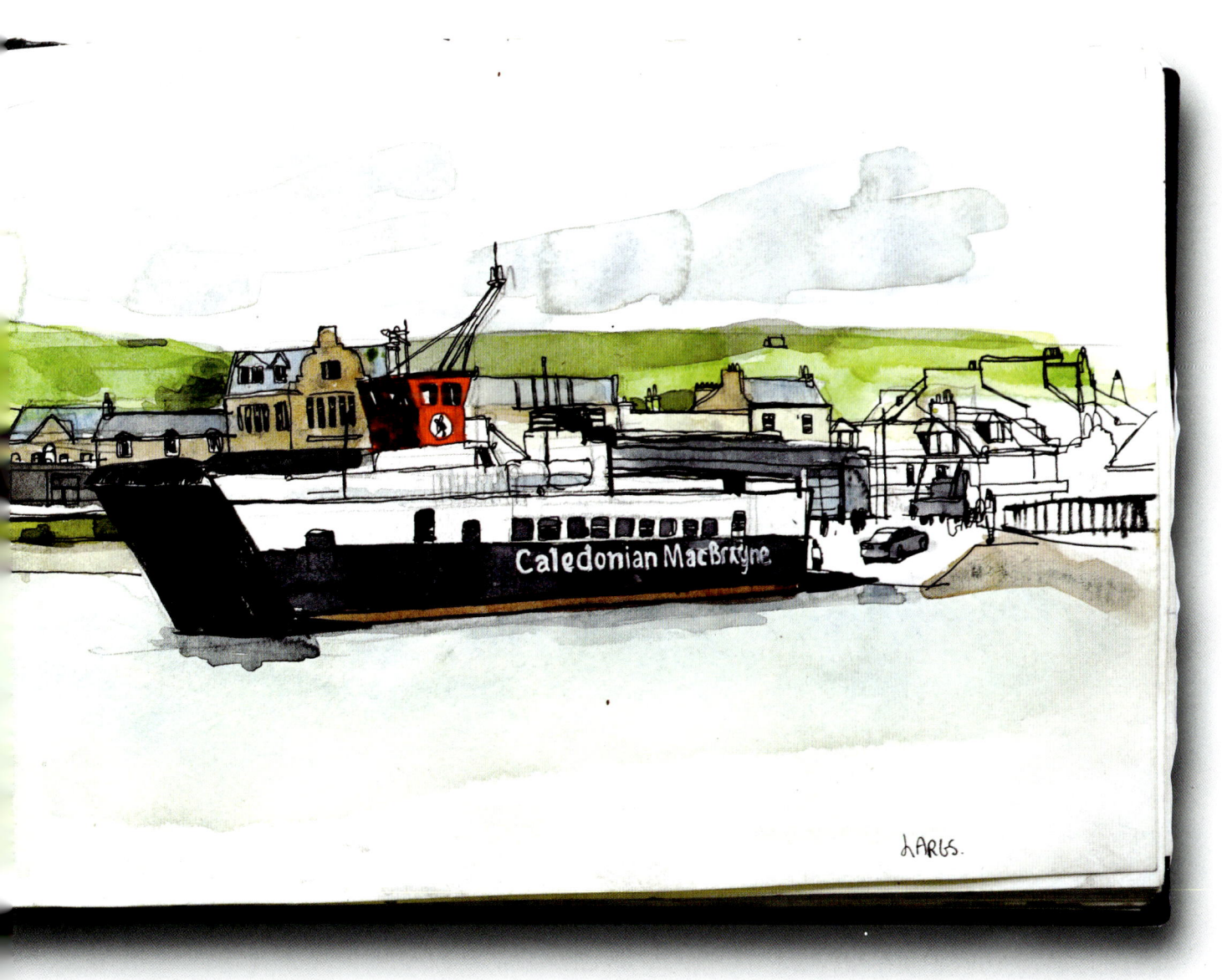

12 **GETTING STARTED**
Basic kit

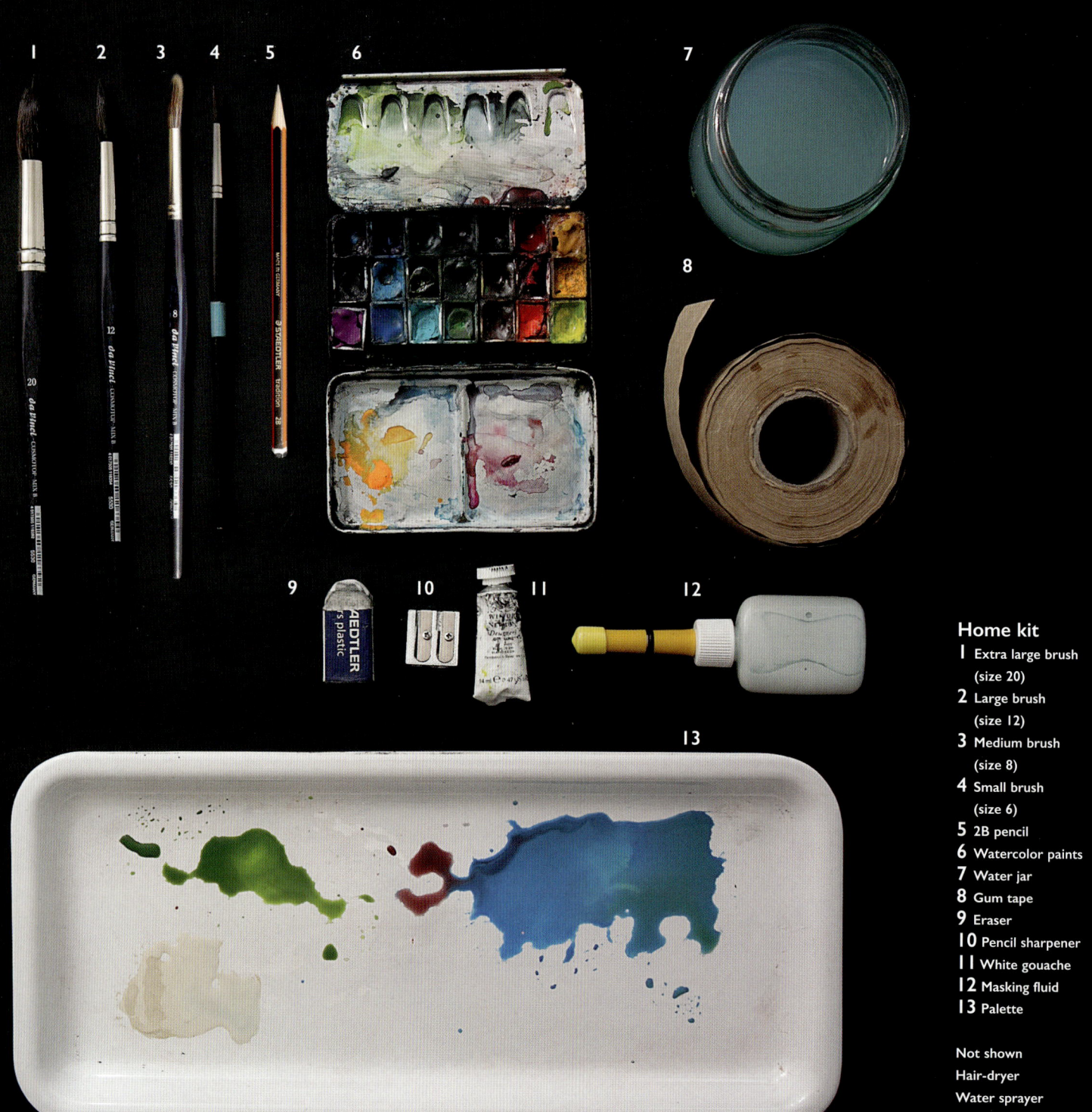

Home kit
1 Extra large brush (size 20)
2 Large brush (size 12)
3 Medium brush (size 8)
4 Small brush (size 6)
5 2B pencil
6 Watercolor paints
7 Water jar
8 Gum tape
9 Eraser
10 Pencil sharpener
11 White gouache
12 Masking fluid
13 Palette

Not shown
Hair-dryer
Water sprayer
Paper towels and sponges

BASIC KIT

One of the great things about painting with watercolors is that you do not need lots of equipment to start.

I've listed here a selection of materials to get you started. Try to find what works for you and build up your own kit to suit your way of painting.

Home kit

This is a simple kit that is a good guide to what you'll need to start painting with watercolor.

Watercolor paints: see over the page for color selection.
Paper: see page 18
Brushes: I use round brushes almost all of the time. A good selection to have would be a size 12 (large), size 8 (medium), and size 6 (small). A size 20 brush can also be useful for those large washes. You can, of course, experiment with flat-head brushes, squirrel mops, or dagger brushes. I recommend buying brushes that are a blend of synthetic and sable hair. Sable brushes have a unique way of holding lots of water, but they tend to be quite expensive, whereas sable and synthetic mix brushes are a good quality to paint with but more affordable for beginners.
Palette: I like to use white plastic food trays—they're cheap, you get a large mixing area, and, if they're wide and narrow, they're easy to place in front of your painting.
Water jar: Use a fairly big glass jar. I like to use old salsa jars since they have a wide base, which makes them hard to knock over. Change your water often, so that your paint doesn't get muddy.
Gum paper: For stretching paper (see page 140).
White gouache: For occasional use for highlights.
Pencils: A soft 2B pencil is recommended for making light sketches before painting. You will also need an eraser and pencil sharpener.
Masking fluid: Use to mask areas of a painting to save the white of the paper.
Hair-dryer: Can speed up drying time.
Water sprayer: Handy for some wet-in-wet techniques.
Paper towels and sponges: For taking excess water off your brushes and mopping up spillages; can also be good for texture effects on your painting.

Travel kit

I recommend keeping your travel kit as basic and simple as possible.

My own kit consists of one, fairly large, sable/synthetic mix travel brush—you can use the tip for small, detailed work and the body for large washes. I also carry a brush that has water in it (number 12 right)—the quality isn't as good, but it is very handy when you don't have easy access to jars of water.

I also carry an empty plastic water jar, which I fill from water bottles.

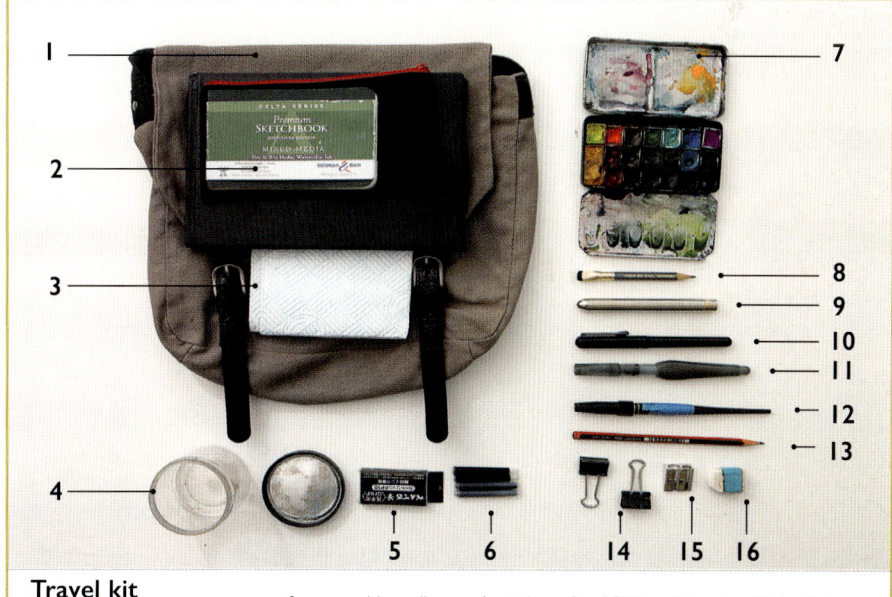

Travel kit

1 Bag
2 Sketchbook
3 Paper towel
4 Water jar (plastic)
5 & 6 Spare ink cartridges for use with a nib pen (not shown)
7 Watercolor set
8 Pencil/brush (optional)
9 Mechanical pencil (optional)
10 Black pen
11 Pentel brush pen
12 Travel brush with built-in water reservoir (optional)
13 Pencil
14 Clips (optional)
15 Pencil sharpener
16 Eraser

Choosing your colors

This is a core palette of colors that will give you the flexibility to cover most of your needs.

There are two grades of paint—student and artist. To save money you can buy student-grade paints for some of your colors, especially the earthy ones, such as Yellow Ocher, Burnt Sienna, and Burnt Umber, and the dark colors, such as Payne's Gray and Indigo. I recommend buying artist-grade colors for Cerulean Blue, Sap Green, Alizarin Crimson, Cadmium Yellow, and Cadmium Red.

Colors are seen as either warm or cold—yellow, orange, and red are warm, and blue and green are cold. To complicate things a little bit, there are warm and cold versions within these categories. For example, you can have a warm blue or a cold red. However, referring to colors in this way is really just a label to help you perceive their different qualities. I like to organize my colors in pairs, which makes it easy to visualize what colors I need for each situation.

YELLOWS

Cadmium Yellow
This is a warm yellow. It's a very dense, colorful paint and a lot of fun to use—like splashing sunlight onto your paper!

Cadmium Lemon
This is a cold yellow that is more subtle than Cadmium Yellow. I like to mix it with Cerulean Blue or add it to Sap Green to get a really bright, acidic green for fields of spring grass.

REDS

Cadmium Red
This is a bright, colorful, warm red. This red is perfect for painting fresh strawberries, poppies, or red clothes.

Alizarin Crimson
This is a slightly dark, purple, cold red. It's great mixed with Yellow Ocher to create a good Caucasian skin tone, or with Cerulean Blue to get a flexible neutral tone that granulates well.

GREENS

Yellow Ocher
This is one of my most flexible colors, which I use a lot. Its subtle appearance can make it appear boring, but that's what makes it so good to work with. You can mix it with almost every color on the palette to add an earthy quality.

Sap Green
This is a great subtle green that works well on its own or mixed with other colors. Add Cadmium Yellow to get a vibrant, bright green, or Cerulean Blue for a watery green.

BLUES

Cerulean Blue
I find diluted Cerulean Blue ideal for painting skies. You could also try Cobalt Blue.

French Ultramarine Blue
I don't use this blue in its pure form that much, but it is valuable for making reds and browns darker.

CHOOSING YOUR COLORS 15

Watercolors come in tubes or pans. I choose pans because they are easier to carry around, as you simply slot them into your paintbox. Pans are available in whole or half sizes. Try a half size if you are unsure about a color. There is a wide range of paintboxes designed to hold pans and half-pans, which can be removed and replaced when used up.

ADDITIONAL COLORS

When choosing colors, experiment, talk to fellow artists, and have fun creating a palette that is unique to you. Here are some of the extra colors used in this book.

Cadmium Orange
This is a mix of Cadmium Yellow and Cadmium Red. Outside I mix this from the core palette, but at home it's easier to have it premixed.

Quinacridone Magenta
This vibrant pink-purple color is surprisingly useful. I use it as a light wash or glaze over parts of the sky (near the horizon) or over skin tones to add a bright warmth.

Undersea Green
This murky, brown green is not a necessity, but I love the weird, slightly unusual granulation you can get.

BROWNS

Burnt Sienna
This rich, red brown is a fantastic color to have in your palette. It's great for adding depth to all types of skin tones, or for wood and furniture.

DARK COLORS

Payne's Gray
This is a convenient premixed version of Burnt Umber and Ultramarine Blue. Get dark tones of your colors by mixing with this.

Cobalt Turquoise Light
Although, theoretically, you can mix blue and green to get a turquoise, I find it difficult. If you feel that life is too short to try and mix a good turquoise, just buy this.

Perylene Green
This is a dark, rich, green that is fantastic for deep shadows in trees. You can darken any green, but I enjoy using this green equivalent to Indigo.

Burnt Umber
A great, solid, dependable color for dark tones.

Indigo
This dark blue color is very vibrant. Be careful when using it, because its vivid, slightly oily, petrol appearance can dominate your painting.

Cobalt Violet
A more subtle, bluish-tinged purple tone than magenta, that is great for adding a warmth to brickwork and shadows.

Lunar Black
This black contains iron, which means that it granulates in an interesting manner. The way it separates looks almost like charcoal.

Color mixing

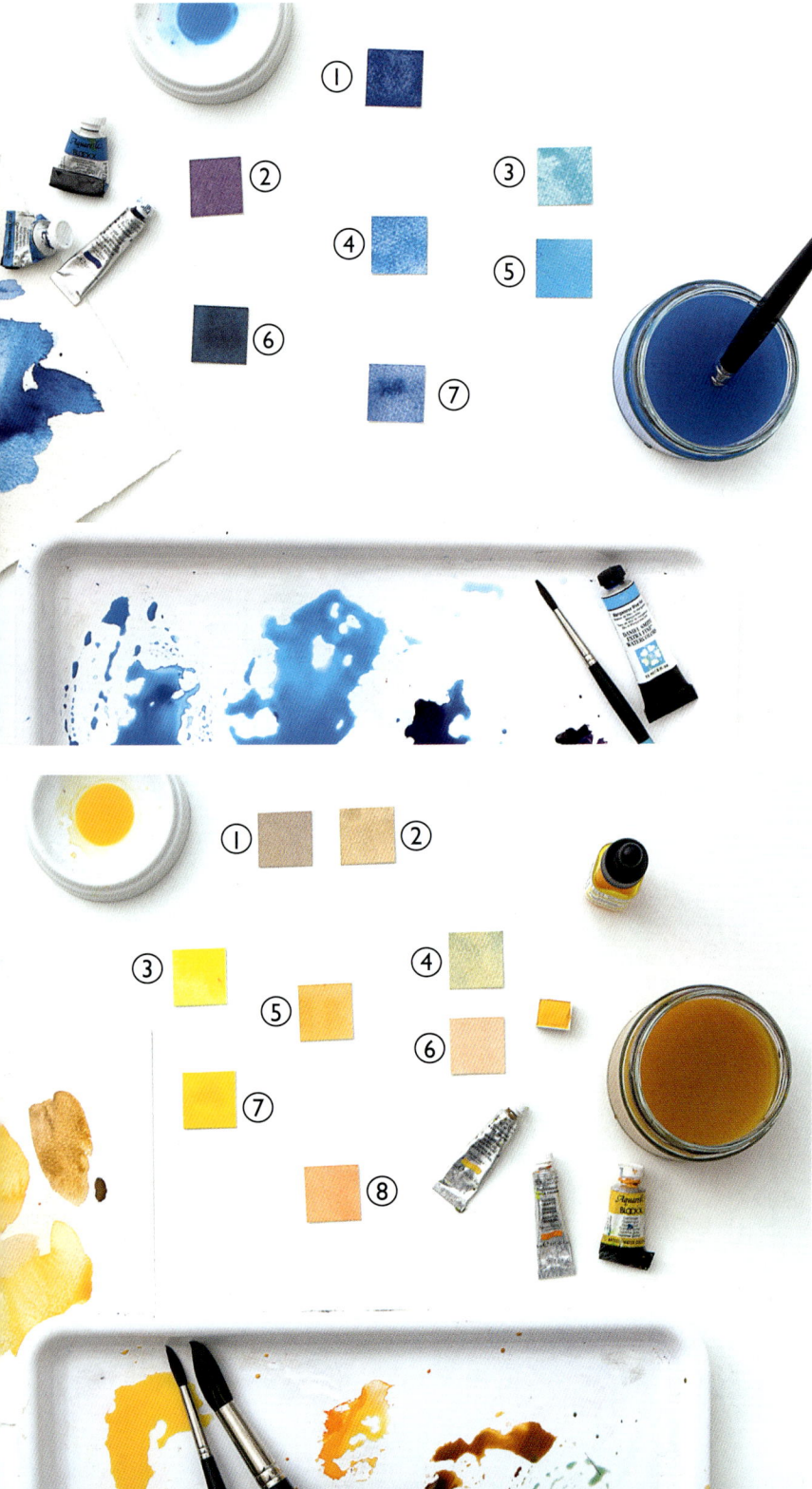

Color mixing can be very confusing when you first start painting in watercolor. I always recommend starting with a simple color palette, learning its different qualities, and expanding your knowledge as you build your confidence.

Mixing blues

1 For a strong, vivid, bold blue: use French Ultramarine Blue.
2 For a purple blue: mix Cerulean Blue with Alizarin Crimson.
3 Cobalt Turquoise - another good turquoise variant.
4 Unmixed Cerulean Blue.
5 For a green blue: use Turquoise.
6 For a dark blue: use Indigo or mix Cerulean Blue with Payne's Gray.
7 For a bright vivid blue: use Manganese Blue or Cobalt.

Mixing yellows

1 For a dark yellow: mix Yellow Ocher with Cobalt Violet.
2 For a dark yellow: mix Yellow Ocher with Burnt Umber.
3 For a bright yellow: use Cadmium Lemon.
4 For a cold yellow: mix Yellow Ocher with Cerulean Blue.
5 Unmixed Cadmium Yellow.
6 For a warm yellow: mix Yellow Ocher with Alizarin Crimson.
7 For a bright yellow: use Cadmium Yellow.
8 For a red yellow: mix Yellow Ocher with Alizarin Crimson.

COLOR MIXING | 17

The way I mix color is to pick the paint closest to what I'm seeing and adapt it to how I want it to be. I ask myself whether it needs to be more blue/red/yellow, and add colors accordingly. The more you understand your color palette and the way the colors work together, the easier this will be. Soon you will be mixing paints with confidence, and can start experimenting with your own combinations. Use a test piece of watercolor paper to see how the colors work with each other.

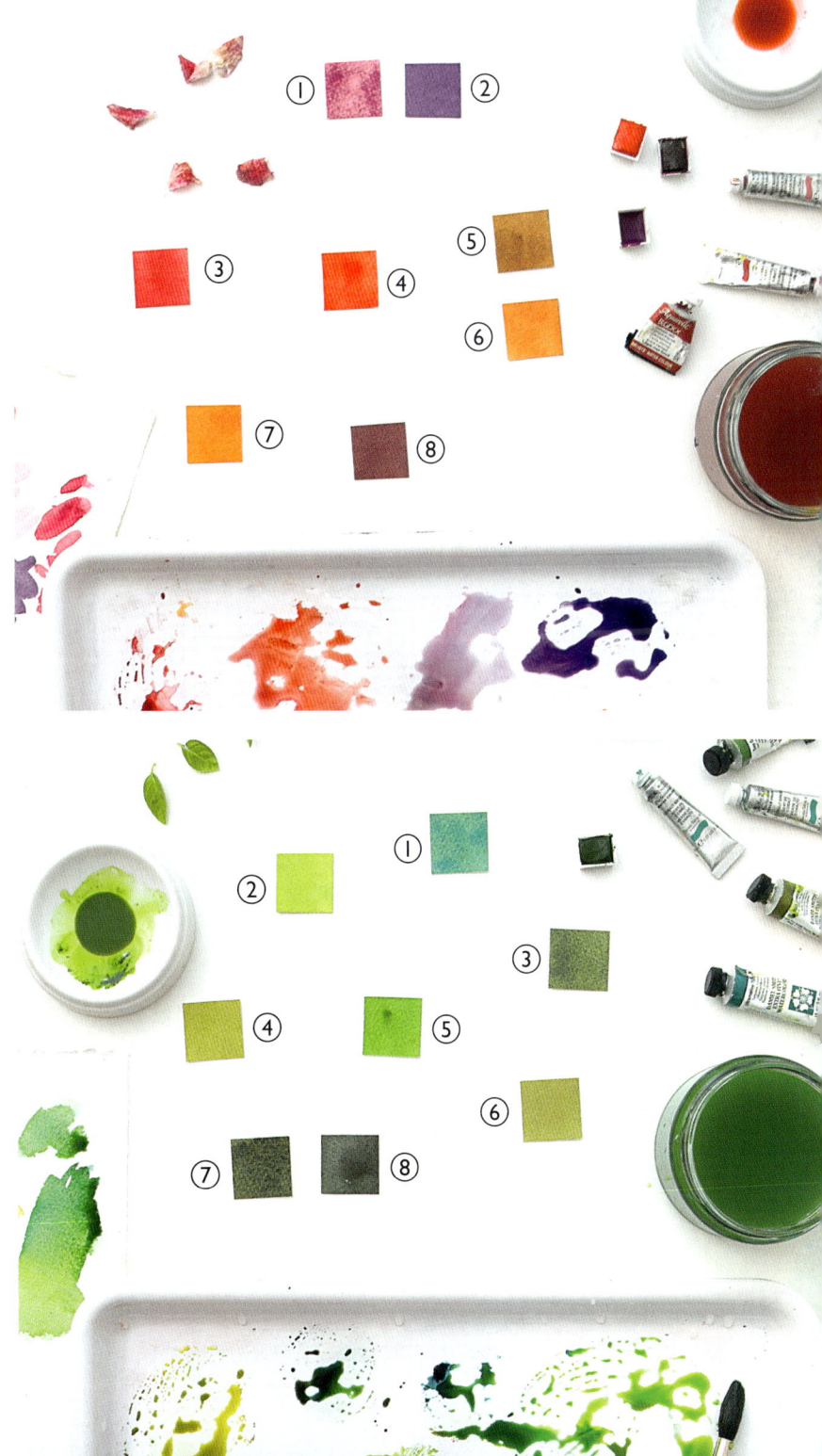

Mixing reds

1 For a pink red: use Quinacridone Magenta.
2 For a purple red: mix Alizarin Crimson with French Ultramarine Blue.
3 For a rich, dark red: use Alizarin Crimson.
4 For a bright red: use Cadmium Red.
5 For a brown red: mix Alizarin Crimson with Burnt Sienna.
6 For a brown red: mix Alizarin Crimson with Burnt Umber.
7 For an orange red: mix Alizarin Crimson with Cadmium Yellow.
8 For a dark red: mix Alizarin Crimson with French Ultramarine Blue.

Mixing greens

1 For a turquoise green: use Cobalt Turquoise Blue.
2 For a bright, vivid green: mix Sap Green with Cadmium Lemon.
3 For a blue-green: mix Sap Green with Cerulean Blue.
4 For a brighter but subtle green: mix Sap Green with Yellow Ocher.
5 Unmixed Sap Green.
6 For a muted green: mix Sap Green with Alizarin Crimson.
7 For a dark green: mix Sap Green with Payne's Gray.
8 For a dark green: use Perylene Green.

Paper

Watercolor paper comes in a variety of surfaces and weights that can initially appear confusing. To put it simply, watercolor paper is either smooth (hot press) or rough (cold press).

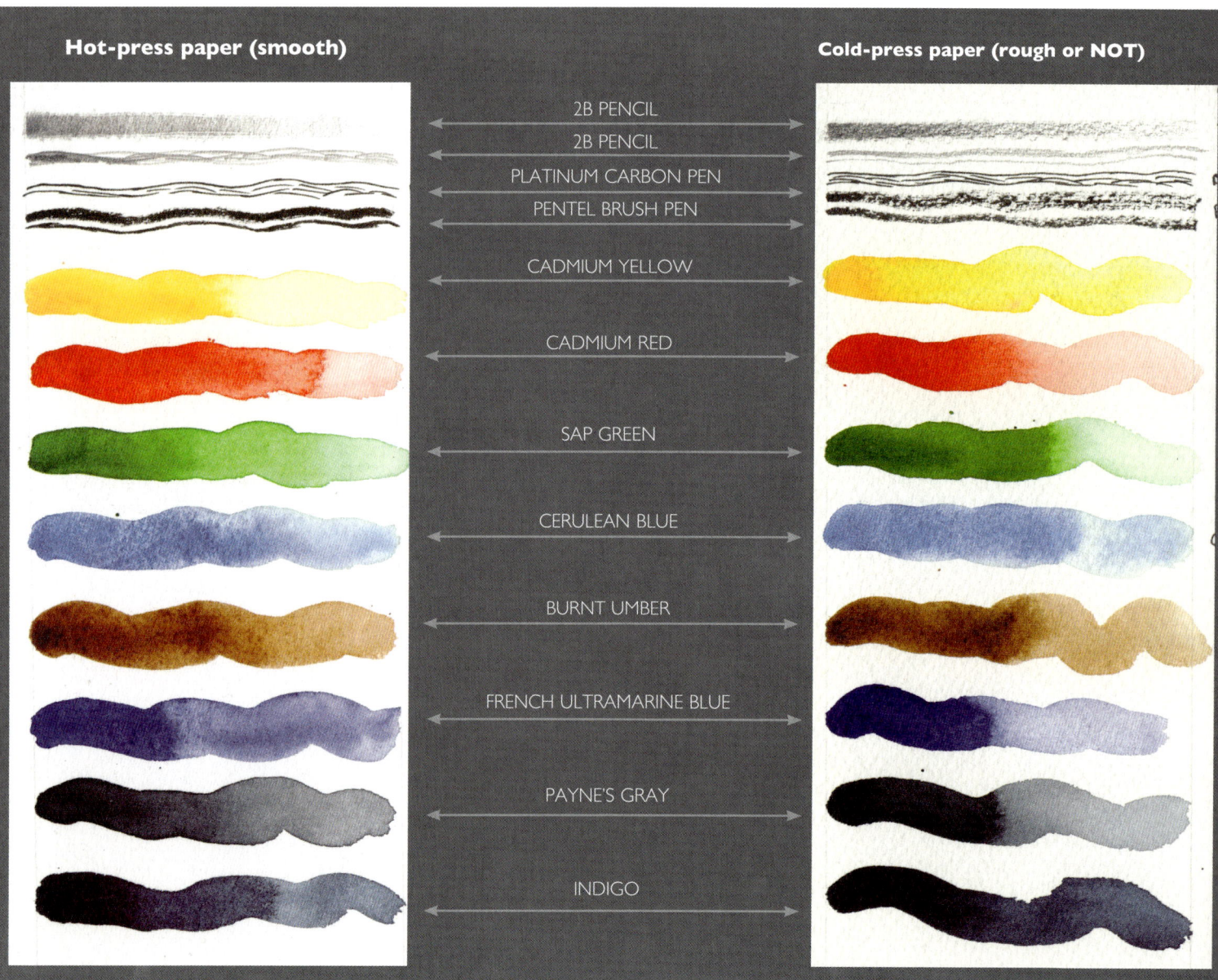

Hot-press paper (smooth)

This has been made on a flat surface and, as a result, the paper is very smooth to paint on. Beginners sometimes start with this, because it's a very predictable surface to paint on. It's ideal for detailed work such as botanical illustrations or architectural paintings.

Paint dries evenly (see left), which is ideal if you want a high level of control and predictability. Hot-press paper is also great for penwork, since the marks aren't affected by the texture of the paper.

Cold-press paper (rough or NOT)

This paper has a rough, dimpled texture. The dimples create areas where the paint sits, creating variety in your brushmarks. Although its unusual properties can seem intimidating, I recommend trying it out. One of the wonderful qualities of watercolor painting is its random expressiveness and the texture of the cold-press paper adds to the possibility of this happening.

Using a pencil can be challenging. The texture of the paper means that the marks don't cover the paper evenly. In some ways it's like making a pencil rubbing over a tree trunk. It's the same using a pen—there's much more variety and interest in the line quality.

In contrast with hot-press paper, paint dries a bit more randomly (see left). As your brush goes over the textured paper, the paint fills some areas and not others. This means your individual brushmarks become much more expressive, adding interest to your painting.

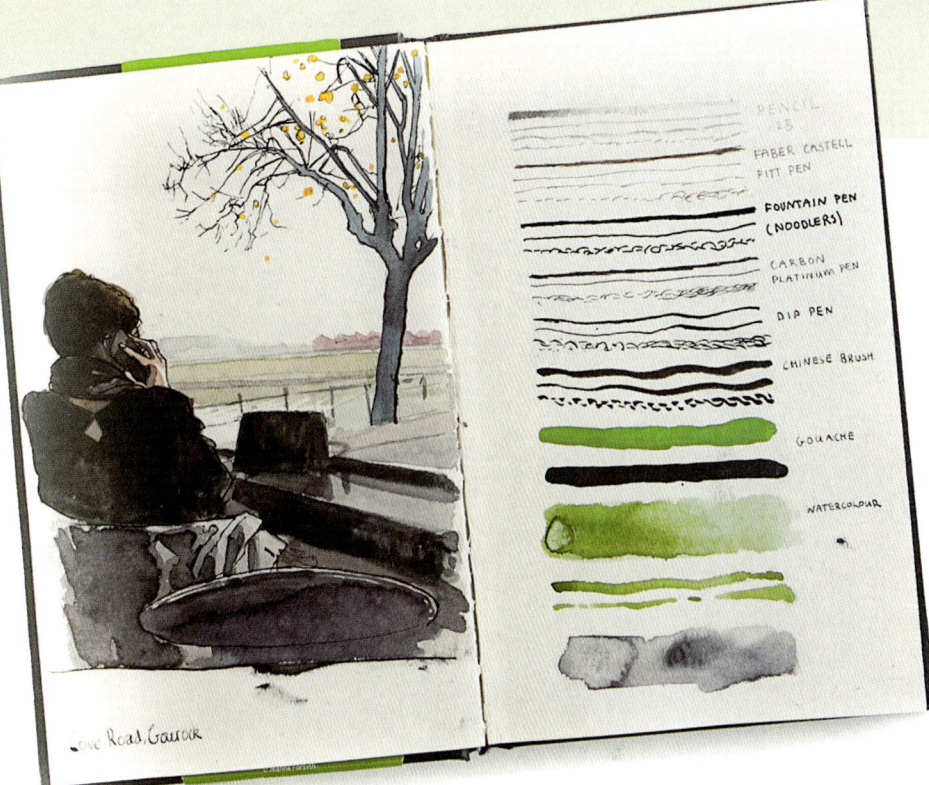

Experiment with different pens and watercolor samples in your sketchbook to see how different materials work with your paper.

Weight

Paper comes in various weights. Lighter paper broadly means less paper pulp is used per sheet, and heavy paper uses lots of paper pulp. This means that lighter paper is more susceptible to buckling (warping). Heavy paper is great to use, but the disadvantage is that extra paper adds to the cost, so it can get very expensive! It's possible to find a compromise between light and heavy paper. I like to use 140 lb (300 gsm) paper that is slightly heavy but is affordable to buy.

Color

Paper comes in slightly different shades, from subtle cream to bright white. I find the glare of very bright white paper hard to work with, so prefer to use an off-white shade.

Watercolor blocks

Almost all of the demonstrations in this book have been painted on watercolor blocks. These are sheets of paper that have been glued on four sides, saving you the need to stretch paper. They come in pads of 14 × 10 in. (355 × 254mm).

Stretching paper

See page 140 for instructions on how to stretch paper.

Washes

Washes are the basis of all watercolor painting. At its most basic, all you're doing is diluting your paint with water and adding it to paper with your brush.

The following exercises demonstrate the core techniques required for the upcoming lessons. Bear in mind that, although they may appear very ordered and precise, my method is much more intuitive and haphazard. Remember, the fun begins when we start making paintings.

Before applying a wash in watercolor, the paper is usually dampened to allow the paint to spread more easily. Tilt the board slightly at an angle of 30°, to allow the brushstrokes to flow into each other—but not so steeply that the paint dribbles down the paper. This means that, unless you are working on very heavy paper or a watercolor pad, it is crucial that you stretch the paper (see page 140).

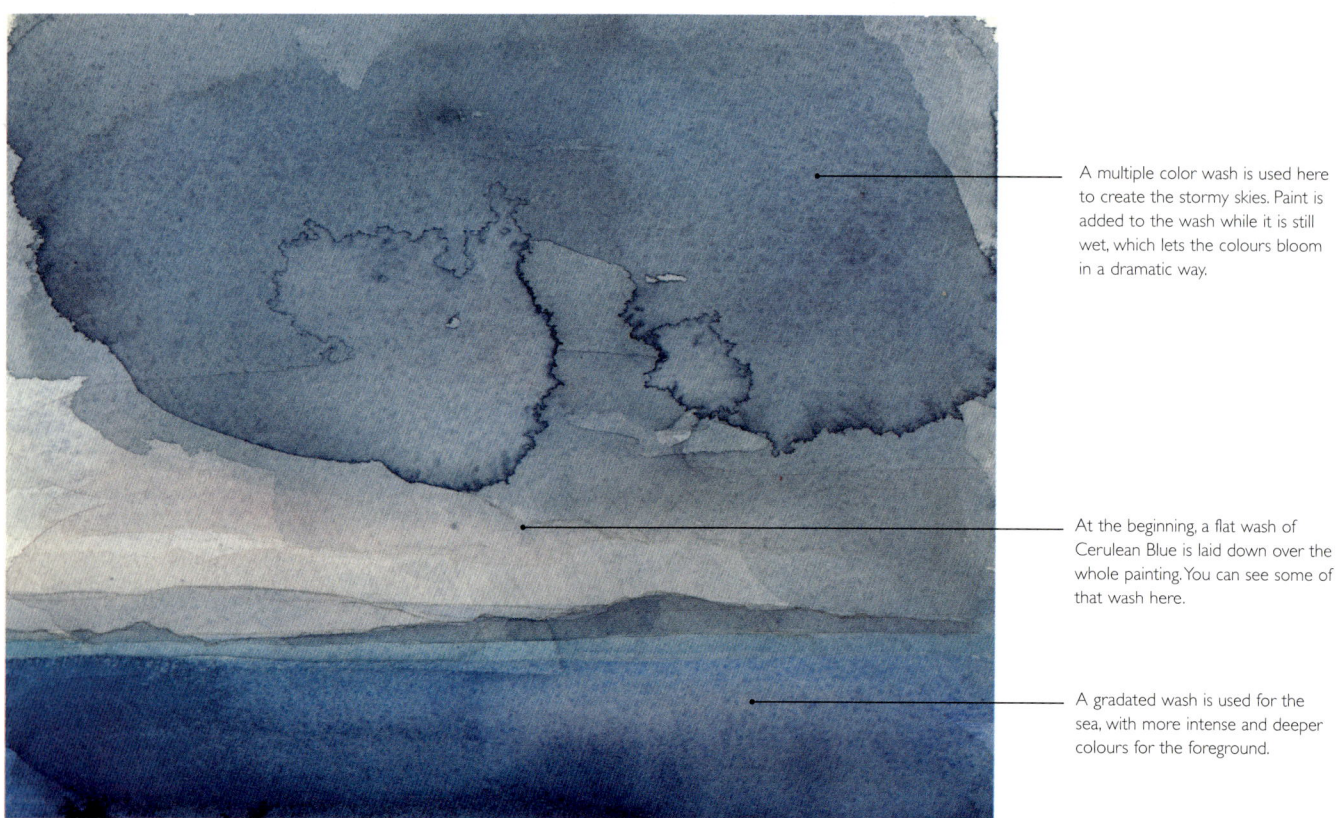

A multiple color wash is used here to create the stormy skies. Paint is added to the wash while it is still wet, which lets the colours bloom in a dramatic way.

At the beginning, a flat wash of Cerulean Blue is laid down over the whole painting. You can see some of that wash here.

A gradated wash is used for the sea, with more intense and deeper colours for the foreground.

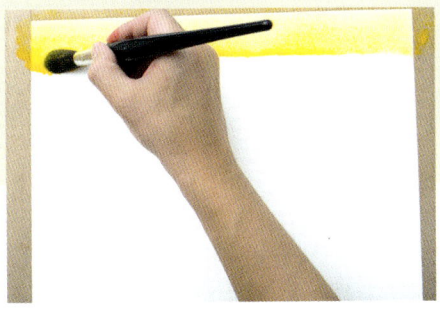 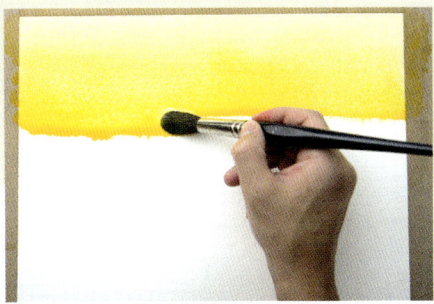 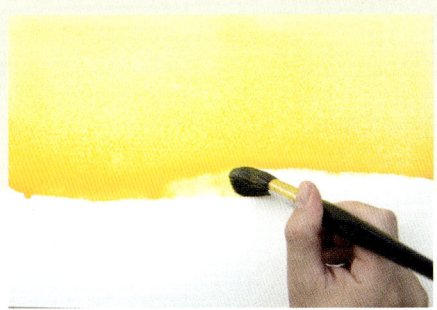

Flat wash

1 In practice you'll be painting areas of flat color in much smaller areas, unless you're painting deserts or flat blue skies. Mix your chosen color with lots of water. Add a line of color at the top of your paper.

2 While the paint is still wet, add another line in the opposite direction, slightly overlapping the first, and continue down the paper, alternating directions.

3 Continue working from left to right, then right to left until you reach the bottom of the paper. Don't allow the paint to dry between strokes.

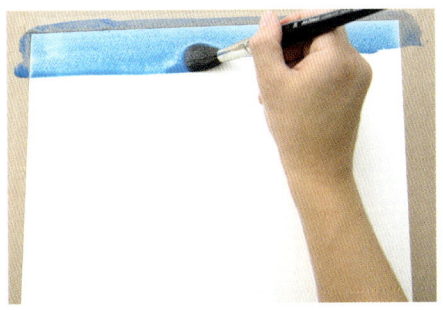 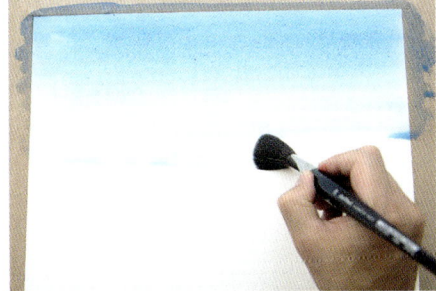 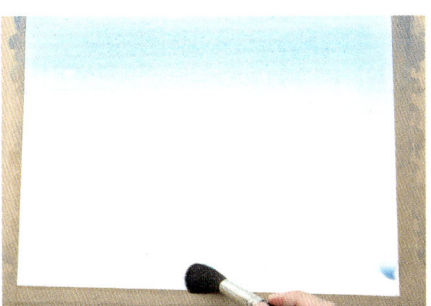

Gradated wash

1 This is a handy wash to learn for skies. Mix your chosen color with lots of water. Add a line of color at the top of your paper, then add another line in the opposite direction, slightly overlapping the first so that they blend evenly.

2 Dip your brush into water once, then back into your premixed color, then paint two more lines in opposite directions.

3 Repeat step 2 until you reach the bottom of the paper. Each time you dip your brush in the water, you use a little less color, which creates the gradated effect.

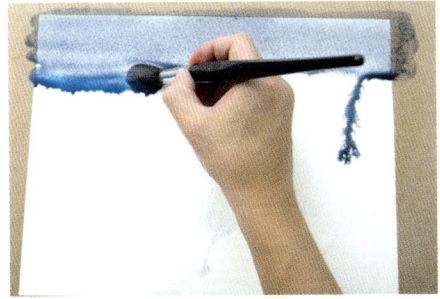 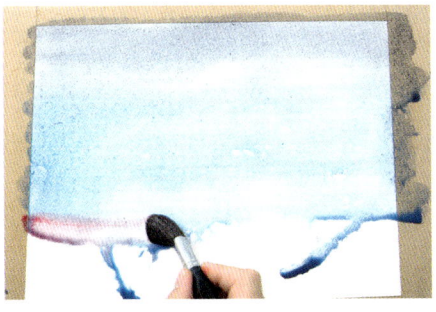

Multiple colors wash

1 This time we'll be combining three colors and allowing the colors to run into each other. Mix your chosen colors with lots of water (I have used Indigo, Cerulean Blue, and Magenta). Add the first color to the top third of the page. Don't worry about drips.

2 While the first color is still wet, add the second color to the middle third of the page. Overlap each brushstroke and work from left to right, then right to left.

3 Add your third color to the bottom of the page in the same way.

Color, light, and atmosphere

In this exercise you'll see how you can change a scene's atmosphere by using different color palettes.

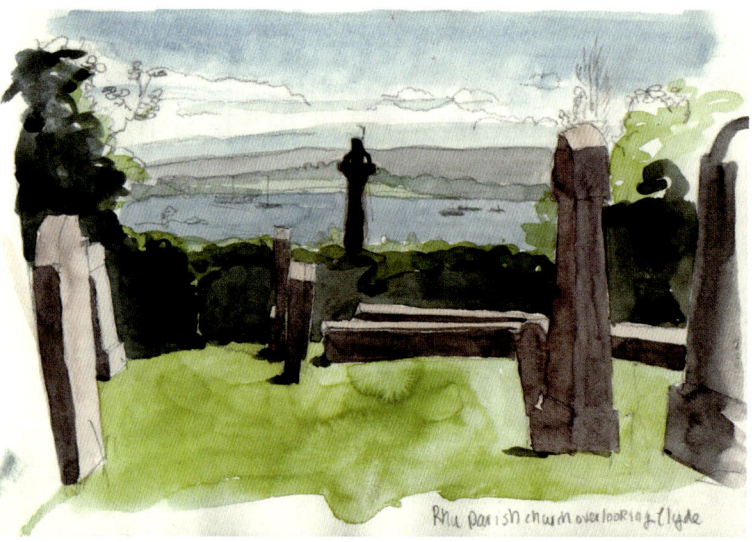

Here is the simple landscape that is used as the basis of this exercise. It's very common to paint outside when the sun is shining—who doesn't love painting in the warm sunlight? Unfortunately, this can make paintings look a little predictable—with bright blue skies and green grass, a truthful rendition might look too "primary." But with a selection of different color palettes, you can create a very different atmosphere.

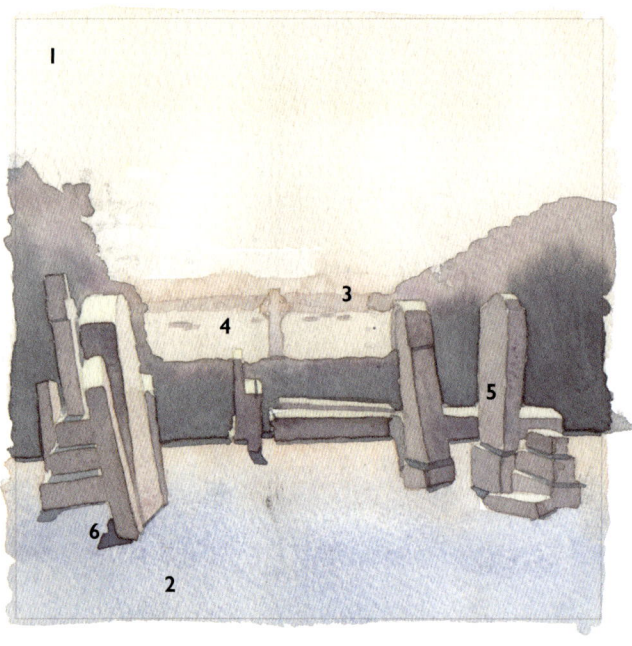

SUNRISE

1 Sky Simple dilute watercolor wash of Yellow Ocher with a touch of Burnt Sienna, applied lightly as a gradation from the top of the page to where the sky meets the sea.
2 Foreground Gradated wash of diluted Burnt Sienna to Cerulean Blue.
3 Hills Farthest hills use a very light Burnt Sienna; for the close ones, add a touch of Cobalt Violet to make them a little darker (not too much).
4 Boats Use the hills mixture to paint the boats. Make simple horizontal brushmarks to suggest the boats—you don't need to go into details.
5 Tombstones Cobalt Violet, with a touch of Indigo for the shaded sides.
6 Cast shadows Wait until tombstones have dried, then mix a dark tone with Cobalt Violet and a small touch of Indigo. Paint the cast shadows from the tombstones with pure Indigo.

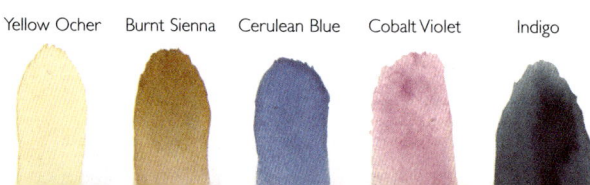

Yellow Ocher • Burnt Sienna • Cerulean Blue • Cobalt Violet • Indigo

COLOR, LIGHT, AND ATMOSPHERE 23

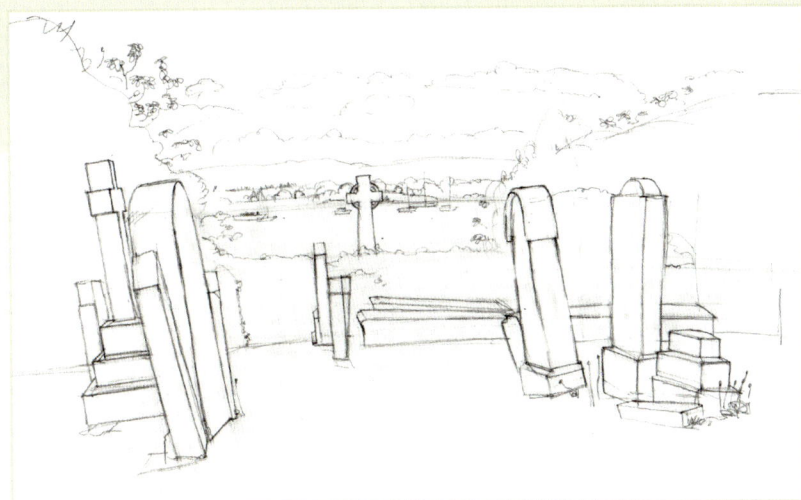

Draw out the scene you'd like to use. Keep the lines fairly simple and light. I used a printer to print out the lines onto four separate sheets of watercolor paper. This is a great way to experiment with your painting, because you don't need to go through the process of drawing the same scene over and over again.

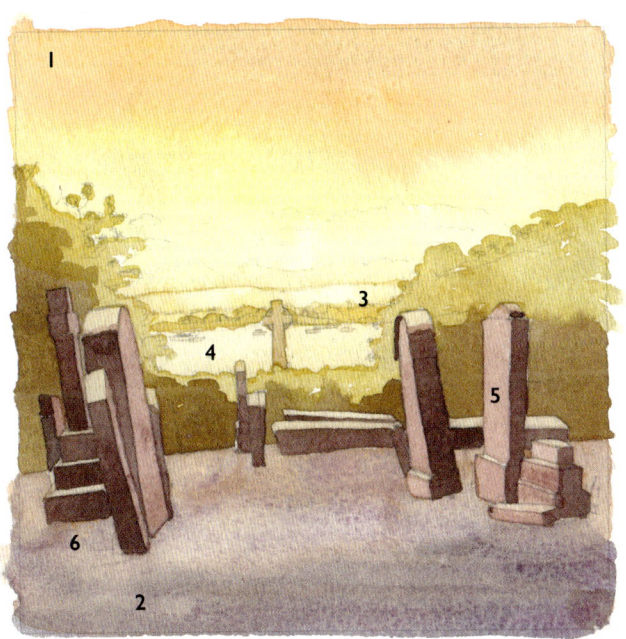

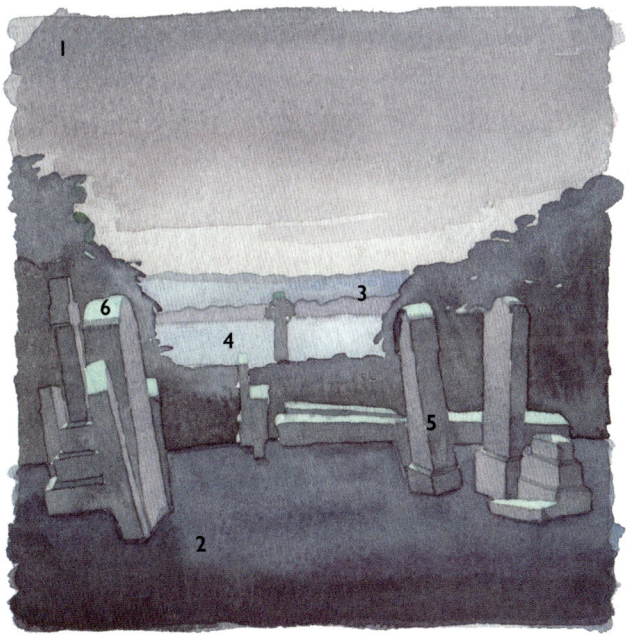

SUNSET

1 Sky Wash of Yellow Ocher with a touch of Cadmium Orange.
2 Foreground Cobalt Violet with a touch of the yellow and orange.
3 Hills Yellow Ocher, use more pigment, less diluted.
4 Sea Diluted Yellow Ocher.
5 Tombstones Cobalt Violet with some Burnt Sienna added for the shadows.
6 Cast shadows Purple with Payne's Gray.

MOONLIGHT

1 Sky Wash of Indigo with a touch of Purple.
2 Foreground Gradated wash of Indigo.
3 Hills Cerulean Blue, closer ones with a touch of Purple.
4 Sea Cerulean Blue.
5 Tombstones Purple with Indigo added for the shadows.
6 Highlights Paint the top of the tombstones with Cobalt Turquoise Light (moonlight color has a slight green tint).

Yellow Ocher Burnt Sienna Cobalt Violet Purple Payne's Gray

Cerulean Blue Indigo Purple Cobalt Turquoise Light

How to keep a sketchbook

There are many different reasons for developing a habit of frequent sketching—to keep journalistic reference notes on places, people, and things you have seen; to gather visual impressions that may contribute to more finished work; to record little details of natural or architectural forms.

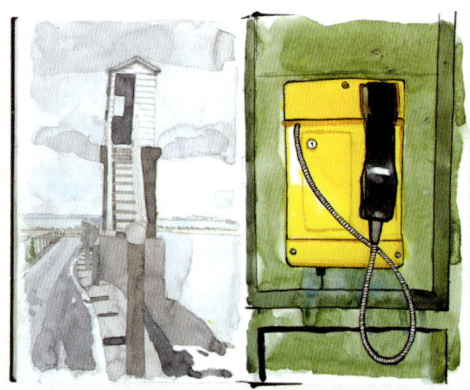

When you start keeping sketchbooks, there are practicalities to consider. What size of sketchbook, what paper, what binding? You can develop your preference for materials and methods as you become used to the habit of sketching, but there are other kinds of practical problems. Especially if you are just starting out, it can be embarrassing to sketch in public. People do come to look at what you are doing; if you are sketching strangers, they sometimes get uneasy when they realize that they are being studied. However, trying to sketch surreptitiously is not going to help your confidence or your technique. The only answer is to go for it. Problems are best solved by working through them. If you are sketching strangers in a strange place, just make sure that no offence can be taken.

Think about the composition and what you want to sketch. In vertical formats, separate sketches can be made on opposite pages and you can work one sketch across two pages to capture wide scenes. Landscape sketchbooks are more appropriate for extra wide scenes or vistas. It is a good idea to have one of each format.

Traditional sewn binding has the advantage of being robust when carried around and you are able to sketch across the two pages. It is available in landscape and portrait formats. The disadvantage is that it doesn't initially lie flat, which can be awkward when applying watercolor washes.

Spiralbound sketchbooks are available in landscape and portrait formats and do open completely flat. The disadvantage of this binding is that with lots of wear, the pages can start to fall out, the spirals can get damaged, and the central gutter makes drawing across two pages more of a challenge. They are very useful when you just want to sketch on a single page.

Paper manufacturers sometimes produce mini sketch pads to promote their different papers. These can be useful as handy color swatch test pads.

Outdoor practicalities

- Decide whether you are going to study a particular view or move further afield looking for varied views and details. If you are on the move, don't burden yourself with unnecessary equipment.

- If you are spending time in one location, check out comfortable places to sit and look for a flat stone or wall, for example, where you can set out your materials.

- Make sure you have an adequate water supply or there is somewhere near your work spot where you can rinse out and freshen water jars. Although you don't want to carry huge quantities of water, it's frustrating when colors become muddied and you cannot clean brushes properly.

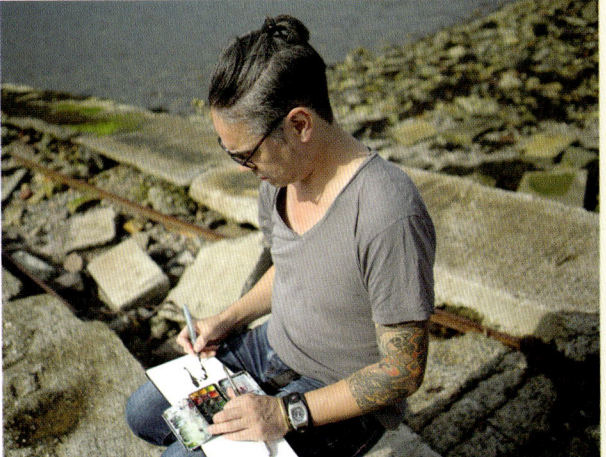

Take a liter bottle of clean water to refill water jars or rinse brushes when they get dirty.

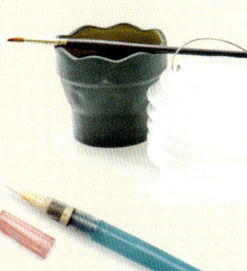

SKETCHBOOK GALLERY
See over the page for a series of pages taken from my own watercolor sketchbooks.

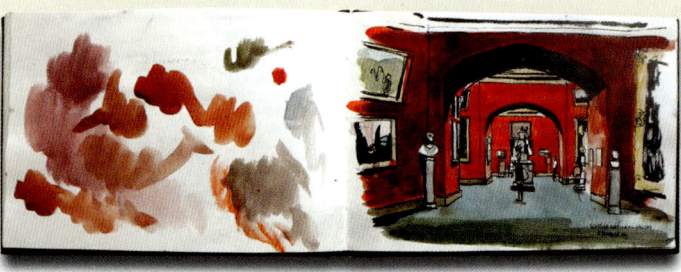

A sketch of the Scottish National Gallery in Edinburgh. They have drawings of the gallery done by artists through the ages, and it was good fun trying to continue the tradition.

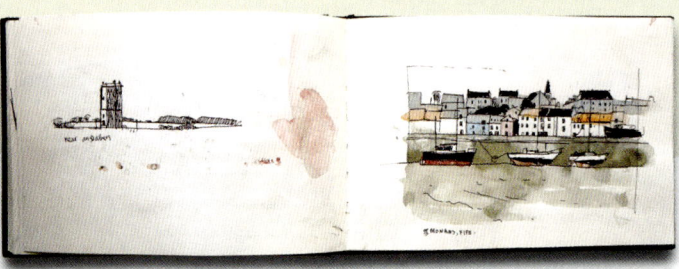

A small painting of St Monans Harbour, Fife, made during a road and boat trip there.

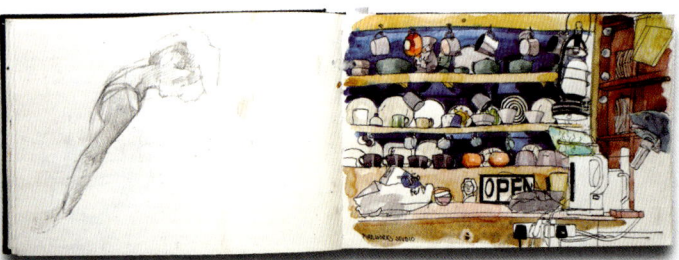

A display of plates, cups, and bowls in a ceramic shop in Garnethill, Glasgow—I enjoyed the challenge of drawing the variety of shapes.

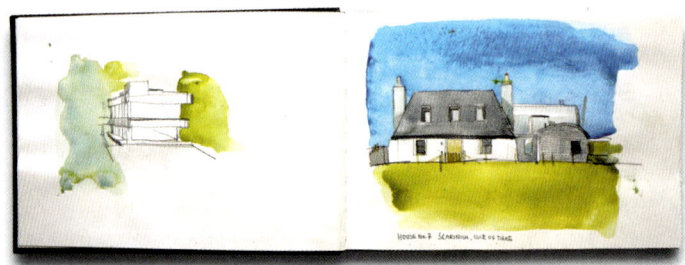

House number 7 on Scarinish, Isle of Tiree.

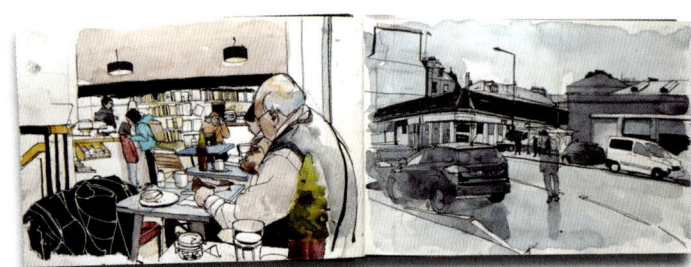

In the bookshop café on Byres Road, Glasgow—cold and wet outside, warm and dry inside.

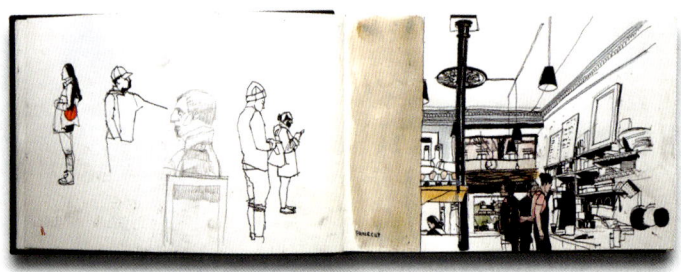

Papercup Café in Glasgow's west end, as well as some small figure drawings to the left.

Visiting the Paul Smith exhibition at the Lighthouse in Glasgow.

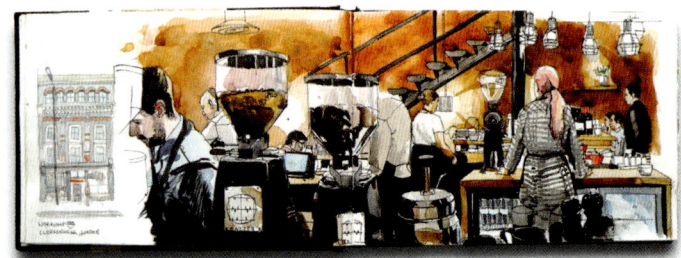

The interior and a small outside study of Workshop Coffee in Clerkenwell, London.

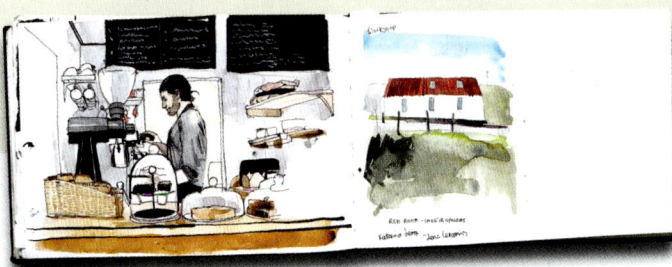

The lovely Red Roof Café in Glendale on the Isle of Skye, run by Gareth and Iona.

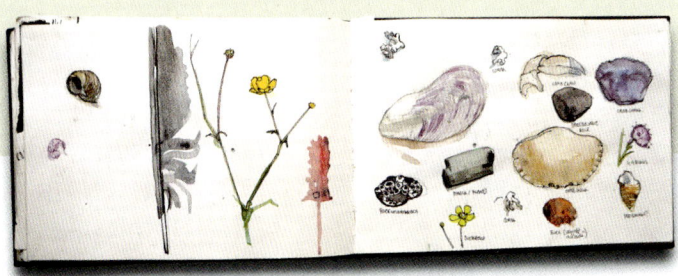

Beach finds on the Isle of Skye—it's refreshing to change from big views of landscapes or cityscapes to the small details beneath your feet.

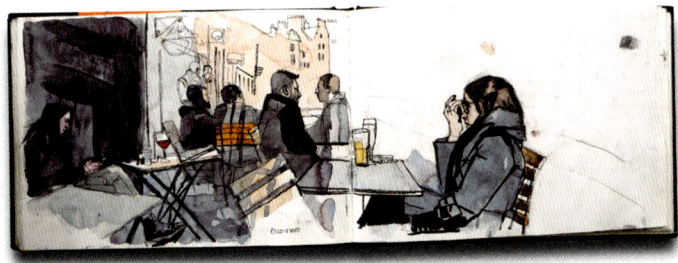

Wine and antipasto as the sun goes down in Edinburgh's Ecco Vino on Cockburn Street.

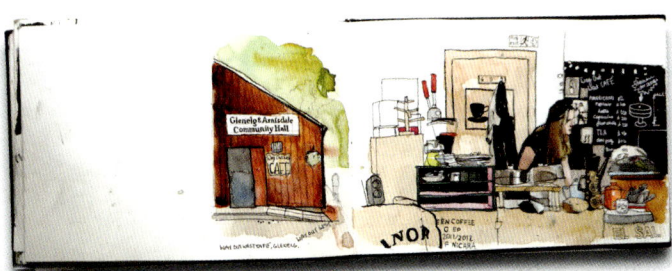

On the way back from Skye, I came across this cool gallery café in the Glenelg community centre called Way Out West.

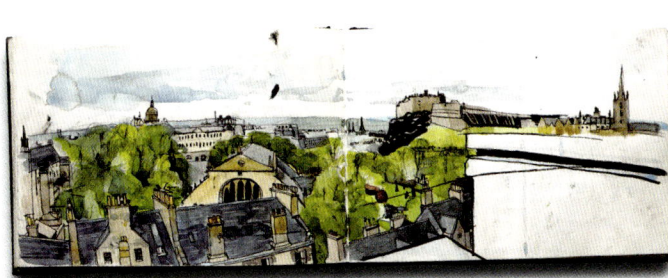

Painting from the rooftop of the National Museum of Scotland to get a great panoramic view of Edinburgh.

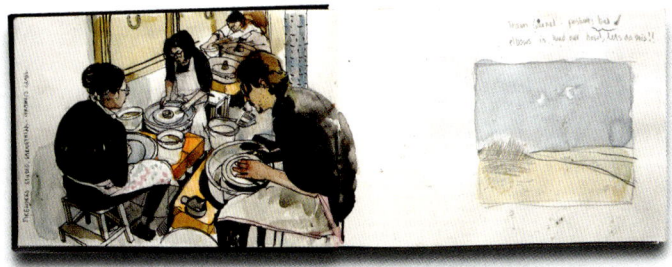

A ceramic class I took in Garnethill, Glasgow: backs bent, elbows in, head over bowl—let's do this!

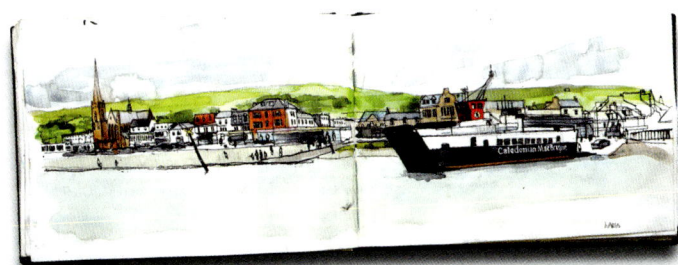

A view of Largs from the docks, overlooking the ferry and seaside promenade.

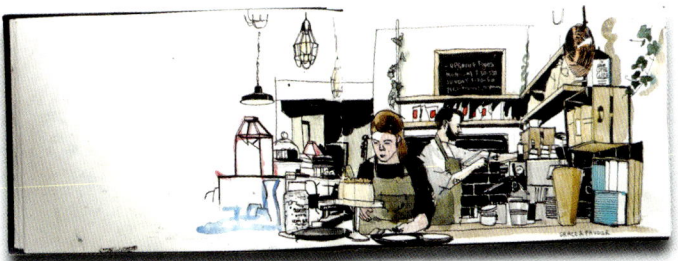

Lunch and coffee in Grace and Favour, Bearsden, Glasgow.

Hints and tips

Hard pencil *Great for subtle, detailed work. It is easy to rub out. However, use the pencil gently or it can score the paper.*

Soft pencil *Use a soft pencil (such as a 2B) and make your pencil marks part of the painting.*

Testing *Use a scrap piece of watercolor paper—the same type and weight as you're using for your final painting—to test your colors.*

Go sketch free *If you're feeling confident, try not using a pencil or pen at all—you can achieve a free, spontaneous look.*

Add water *Try using more water when you're mixing and painting—the paint becomes less uniform and more interesting.*

Big brush/little brush *Use your big brushes to start with, and for as long as possible, before you use the smaller ones.*

Granulate *Some paints granulate naturally, which means that they separate as they dry, producing a grainy effect. Experiment with different mixtures—this is Cerulean Blue and Alizarin Crimson.*

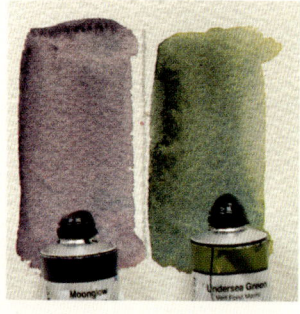

Premixing *Premixed, granulating colors, such as Moon Glow or Undersea Green, can be fun to experiment with.*

HINTS AND TIPS 29

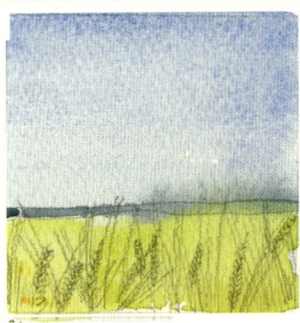

Cerulean Blue Watercolor kits always include French Ultramarine Blue. It took me ages to discover Cerulean Blue, which I find a more versatile and subtle blue that is great for skies.

Lunar Black This paint contains iron particles that produce a charcoal look, which is really effective for atmospheric paintings.

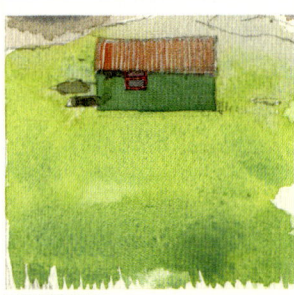

Good greens To get a great vivid green, try mixing Cadmium Yellow with Cerulean Blue—the Cerulean Blue will granulate slightly to make a lovely effect.

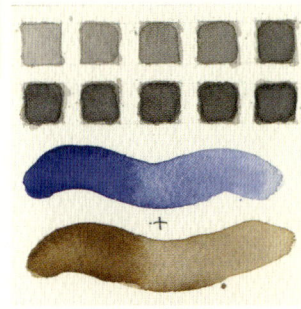

Getting good grays Mix French Ultramarine Blue and Burnt Umber to achieve a full gray scale.

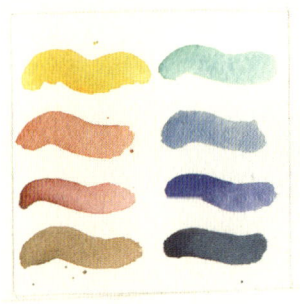

Warm/cold colors Yellow and red are seen as "warm" colors, while blue and green are considered "cold."

Dropping color Experiment with adding different colors into your watercolor washes while they are still wet.

Spatter Use a toothbrush to create a spattering effect—great for adding texture to your paintings.

Water jars Use a deep, squat jar that holds lots of water and is difficult to knock over! Change the water often.

Hair-dryer effects A hair-dryer can help to dry your watercolor paintings, but be careful not to create blown trails if the paint is too wet.

Refilling pans You can save money by refilling your watercolor pans from tubes of watercolor paint.

Hot-press paper Smooth paper is great for linework, dry brush, and detailed paintings.

Cold-press paper The texture, or "tooth," of rough paper shows up brushmarks for textural effects: paint will lie unevenly on the surface.

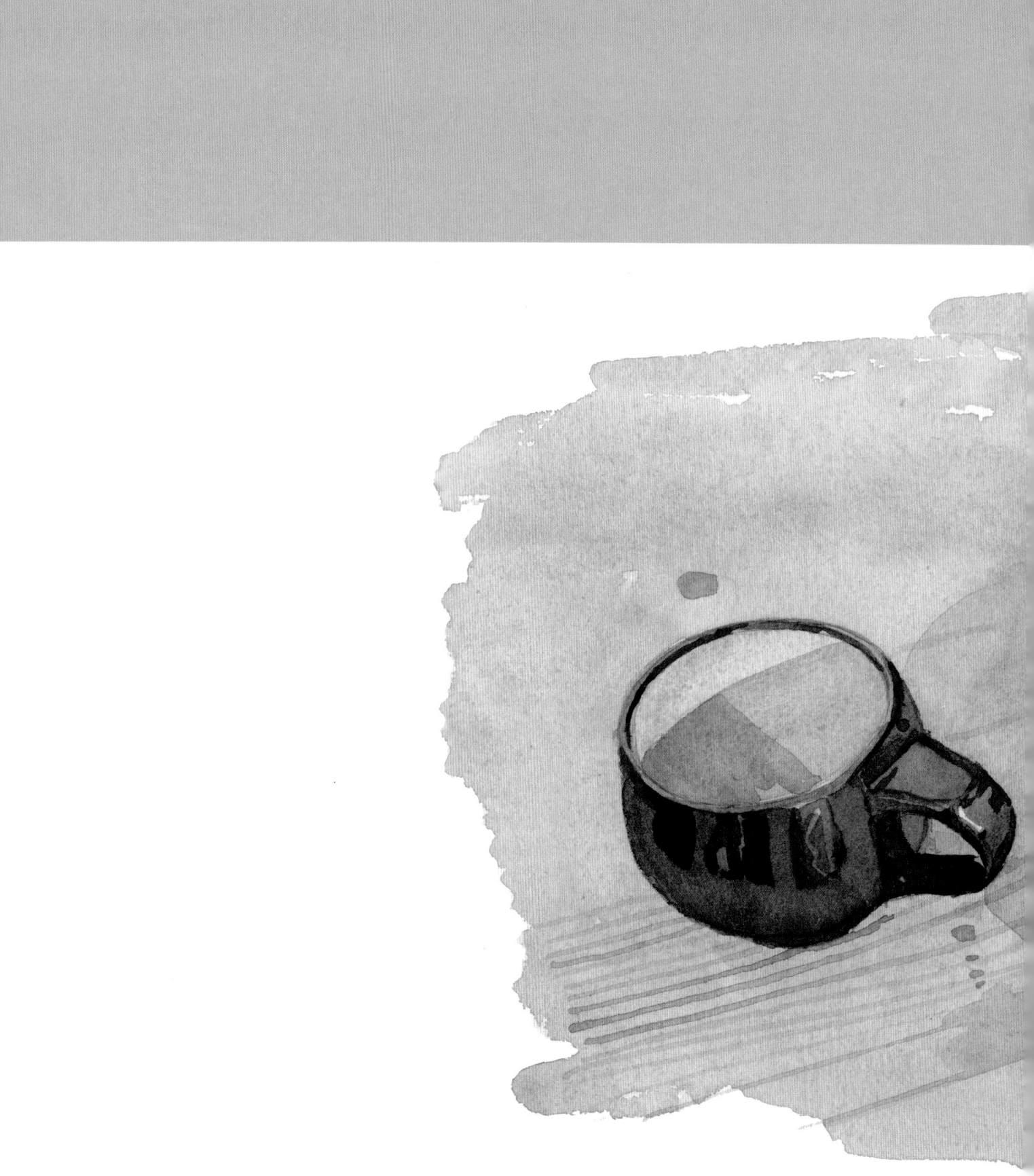

Chapter 2
Simple Still Lifes

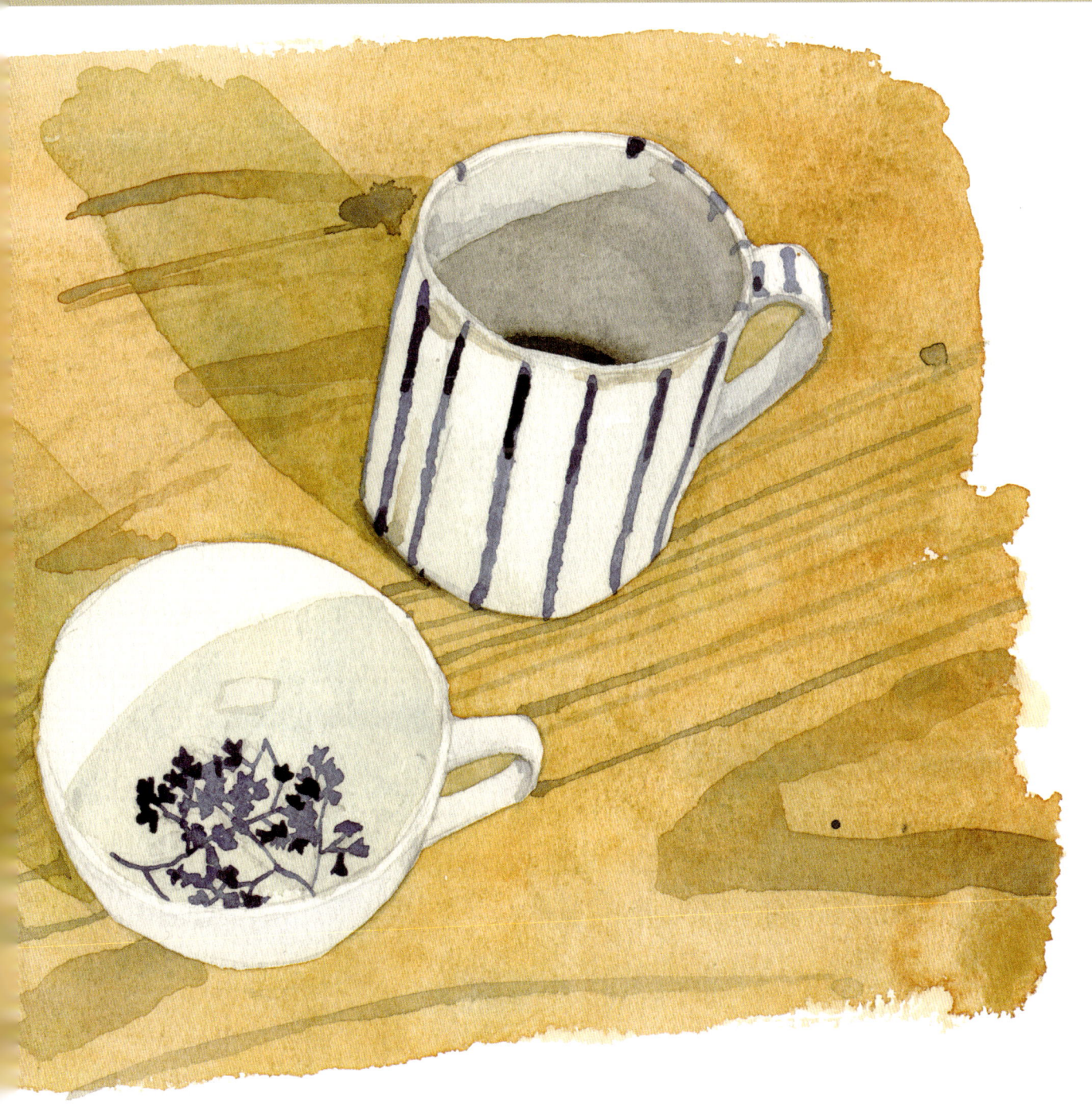

SIMPLE STILL LIFES

01 | Donut delights
Lively washes

If you ignore three-dimensional form and see what is in front of you just in terms of shape, color, and pattern, you can enjoy drawing the individual shapes and filling them in with bright colors. I chose donuts for this project because each one has such different patterns and colors. Their "pop art" qualities make them an ideal subject here. Varying the amount of paint and water, and allowing a second wash of color to blend wet into wet into the first, prevents the washes from looking too flat and uniform. It also helps to make the donuts look more three-dimensional.

Materials

- Watercolor block, 14 x 10 in. (355 x 254 mm)
- 2B pencil
- Size 8 and 6 round brushes
- Masking fluid

Color palette

- Buff Titanium (or mix Yellow Ocher with a touch of White)
- Burnt Umber
- Burnt Sienna
- Cadmium Lemon Yellow
- Cadmium Orange
- Cerulean Blue
- Quinacridone Magenta

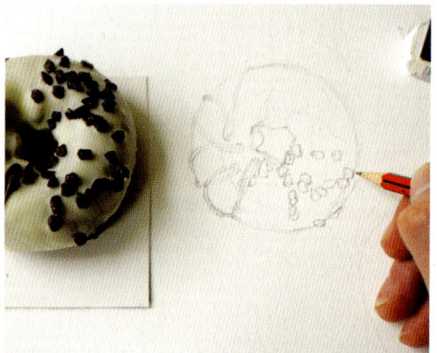

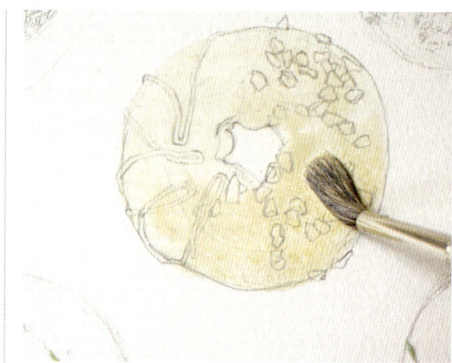

1 Start by drawing each donut. I find it easiest to draw one at a time, with the actual donut right next to the drawing so that you can compare the two without having to look away. It's quite similar to tracing, as you slowly draw the outside shape, then add the decorative elements, such as the frosting and toppings. Before drawing the other donuts, cut out a simple template based on the first donut and use it to experiment with the placement of the others. This will also help you make sure that they are all of a similar size and shape.

2 Use the larger brush to paint the first donut with Buff Titanium and lots of water, so that the paint dries in an interesting way. (If you don't have Buff Titanium, you can use Yellow Ocher with a touch of White.) Add a second wash of Buff Titanium to create depth. When the paint is dry, add the chocolate chips and frosting swirls by filling them in in Burnt Umber, varying the amount of paint and water you use to get more interesting, slightly irregular color.

DONUT DELIGHTS 33

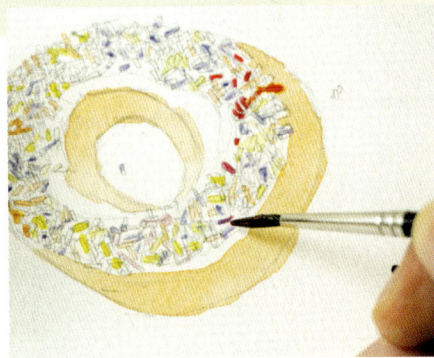 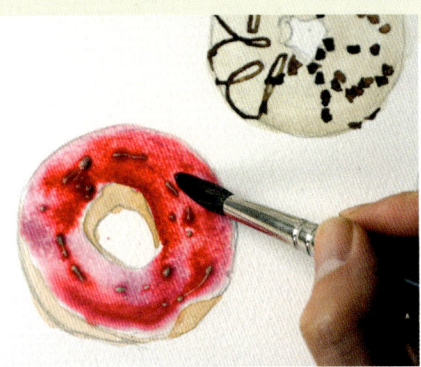 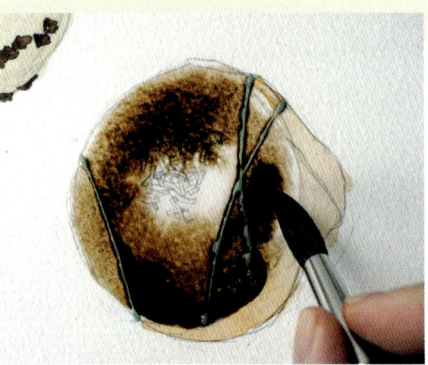

3 Sprinkles on a donut can be difficult to draw. Have the donut next to your drawing, as in step 1, for comparison. Rather than trying to copy the sprinkles exactly, give a general impression by observing how they overlap and drawing them as a pattern. Paint the donut base with a simple wash of Burnt Sienna and leave to dry. To paint the sprinkles, take one color at a time on the smaller brush from the yellow, orange, blue, and magenta, and apply little dashes of color. Leave to dry. Add the Burnt Sienna frosting wash last, carefully painting around the sprinkles.

4 The pink donut is all about the sheer vividness of the magenta. Before you apply color, paint in the glossy highlights with masking fluid and allow to dry. Paint a simple Burnt Sienna wash for the donut base. Next, add plain water to the area you'd like to make pink so that it forms a small puddle. Using lots of your bright magenta, brush the color into the wet area and watch it spread. Leave to dry—it can take a bit of time—then carefully rub off the masking fluid.

5 For the donut on the bottom right, use masking fluid to mask out the white stripes and leave to dry. Apply a simple Burnt Sienna wash for the donut base. Following the same technique you used for the pink donut in step 4, add water, then lots of Burnt Umber directly onto the wet area. Once this is dry you can paint the chocolate sprinkles in Burnt Umber. Paint the final donut in a similar way, using Yellow Ocher and Burnt Sienna for the topping.

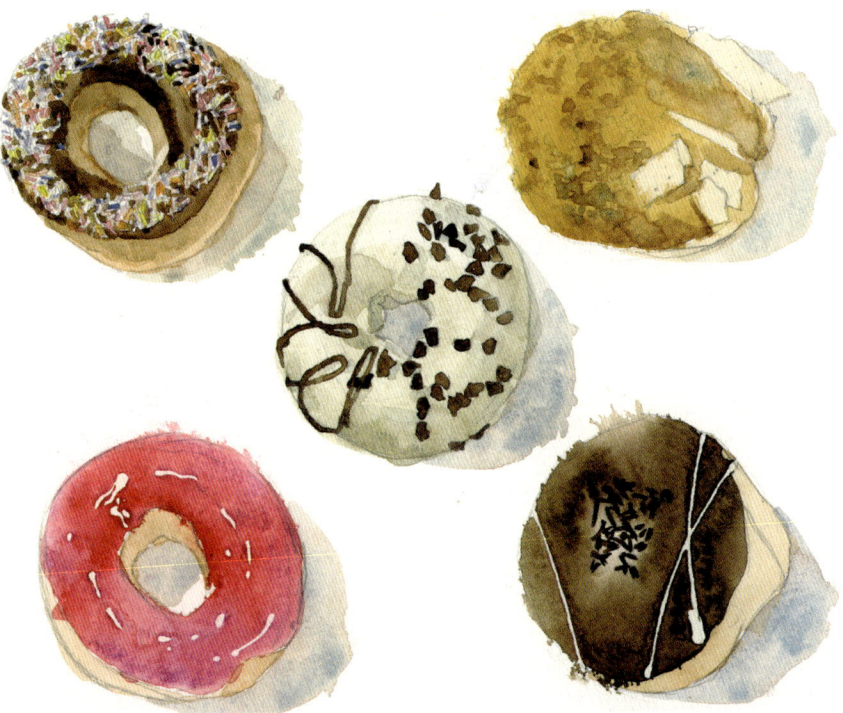

02 | Succulent
Backgrounds for still lifes

Materials

- Watercolor block, 14 x 10 in. (355 x 254 mm)
- 2B pencil
- Size 8 round brush
- White pastel pencil

Color palette

- Gamboge
- Cobalt Blue
- Sap Green
- Cerulean Blue
- Burnt Sienna
- Cobalt Turquoise
- Perylene Green
- Burnt Umber

Succulents have a beautiful simplicity and, because of their relatively symmetrical shape, they are great subjects to start with when you are learning to paint plants. With such a simple subject, however, the right background is critical. Here, two solid colors—one for the wall and one for the tabletop—allow the plant to stand out. I thought it would be fun to experiment with different colored combinations for the background to see which one worked best with the subject.

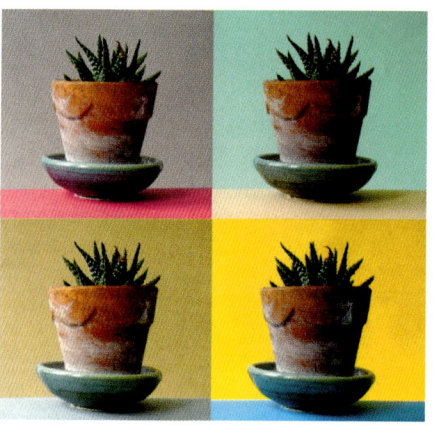

The different backgrounds are shown here in a pleasing symmetrical arrangement. I tried out various colors, before choosing the two complementary colors of blue and yellow as my background.

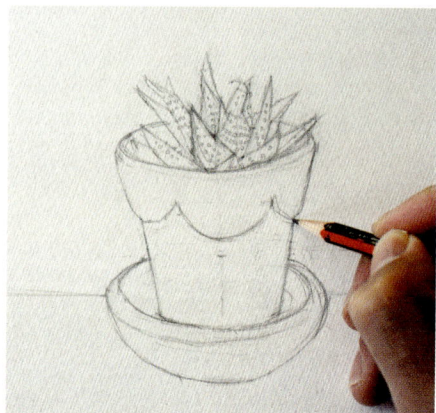

1 Draw the main outlines. Go for a very minimal composition, focusing on the small succulent. The little pencil marks on the succulent indicate the small white dots that you will later create—these are a fun addition, as they add an element of pattern to your painting.

SUCCULENT 35

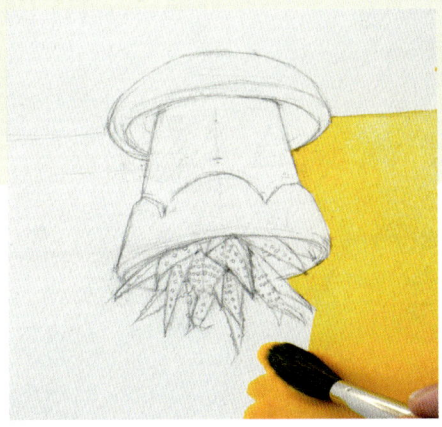
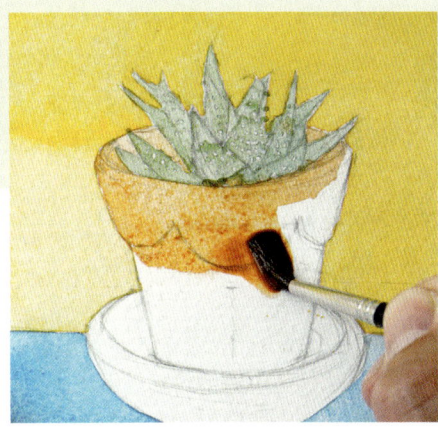
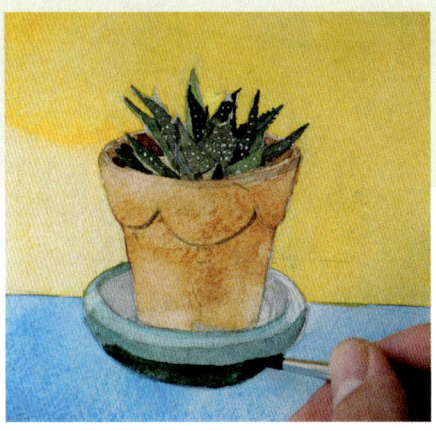

2 Paint the background first, before working on any other part of the painting. Start with a wash of Gamboge, an intense, bright, warm yellow. Normally I let backgrounds run into each other, but this time you need the colors to be quite crisp and separate. Turning the paper upside down while you apply the color will help you to achieve those crisp edges.

3 When the Gamboge is dry, turn the paper the right way up and apply a wash of Cobalt Blue over the tabletop.

Apply a mix of Sap Green and Cerulean Blue to the stems of the succulent, avoiding the white spots. When this is dry, take diluted Burnt Sienna over the plant pot.

4 Use a mix of Cobalt Turquoise and Cerulean Blue for the saucer. Build up the darker tones and shadows, using Perylene Green for the succulent, a darker version of the Cobalt Turquoise and Cerulean Blue for the saucer, and a mix of Burnt Sienna and Burnt Umber for the plant pot. Fill in the foliage dots wit the white pastel pencil. Add a mix of Cerulean Blue and Perylene Green for the saucer's shadow.

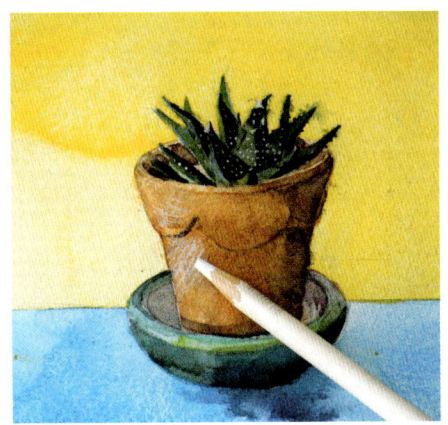

5 Use the white pastel pencil to replicate the mildew that you sometimes get on old terracotta plant pots.

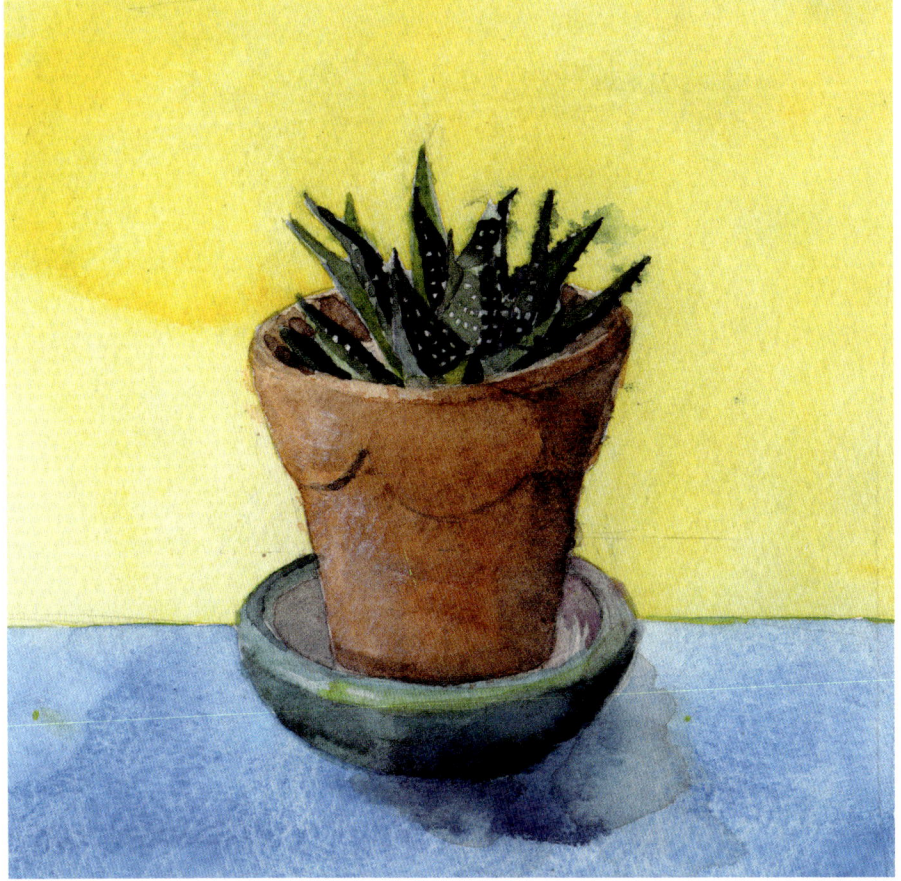

03 | Sneakers
Working with a minimal palette

Materials

- Watercolor block, 14 x 10 in. (355 x 254 mm)
- 2B pencil
- Size 12 and 6 round brushes
- Paper towel

Color palette

- Yellow Ocher
- Cerulean Blue
- Payne's Gray
- Cadmium Red
- Alizarin Crimson

A favorite pair of shoes often shows a certain amount of wear and tear, which gives them a character of their own and makes them an ideal subject for painting. I love my old sneakers, which lend themselves to a minimal palette of cool blue-grays and a simple background. However, if your shoes are more colorful you could balance this with a different background, such as a wooden floor or a patterned carpet.

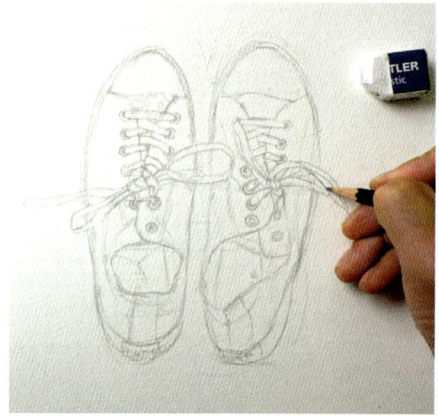

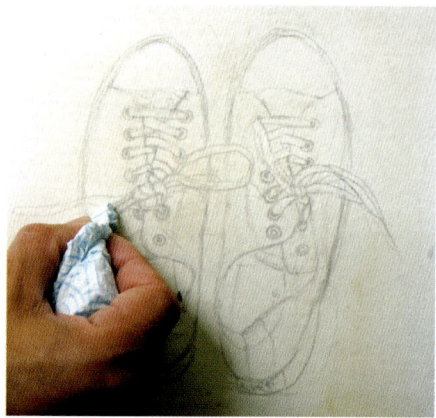

1 Shoes don't often have straight lines, but are usually a collection of wavy, soft lines and circles. Using your 2B pencil draw the main outlines and the details, such as the laces, eyelets, and lines of stitching. Try varying the line width by applying more or less pressure when you're drawing.

2 Apply a pale, very diluted wash of Yellow Ocher over the whole paper. Your drawing will still show through the wash. Use paper towel to dab away the color from the lightest areas.

SNEAKERS 37

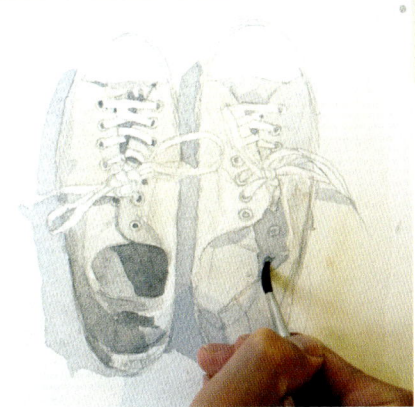

3 Add a little more Yellow Ocher to the previous wash to darken it, then mix in a touch of Cerulean Blue for a cooler color. Use this mixture to paint the uppers of the sneakers. Now add some Payne's Gray to the mix and apply to the darker parts of the sneakers and the cast shadows. For the darkest shadows, add even more Payne's Gray.

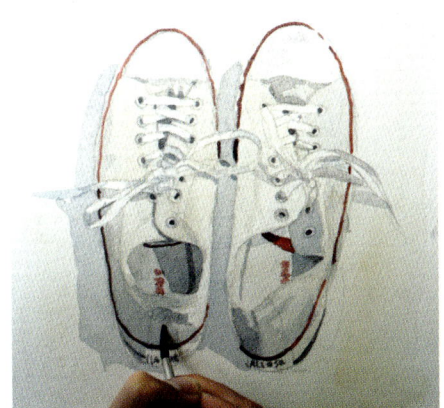

4 To define the details such as the eyelets, add even more Payne's Gray. Mix Cadmium Red with Alizarin Crimson and use the small brush to carefully paint the trim on the sneakers and the labeling on the insoles. Vary your application of the paint to reflect the varying color of these details. Build up the darker parts of the trainers using a mix of Yellow Ocher and Cerulean Blue to give additional depth.

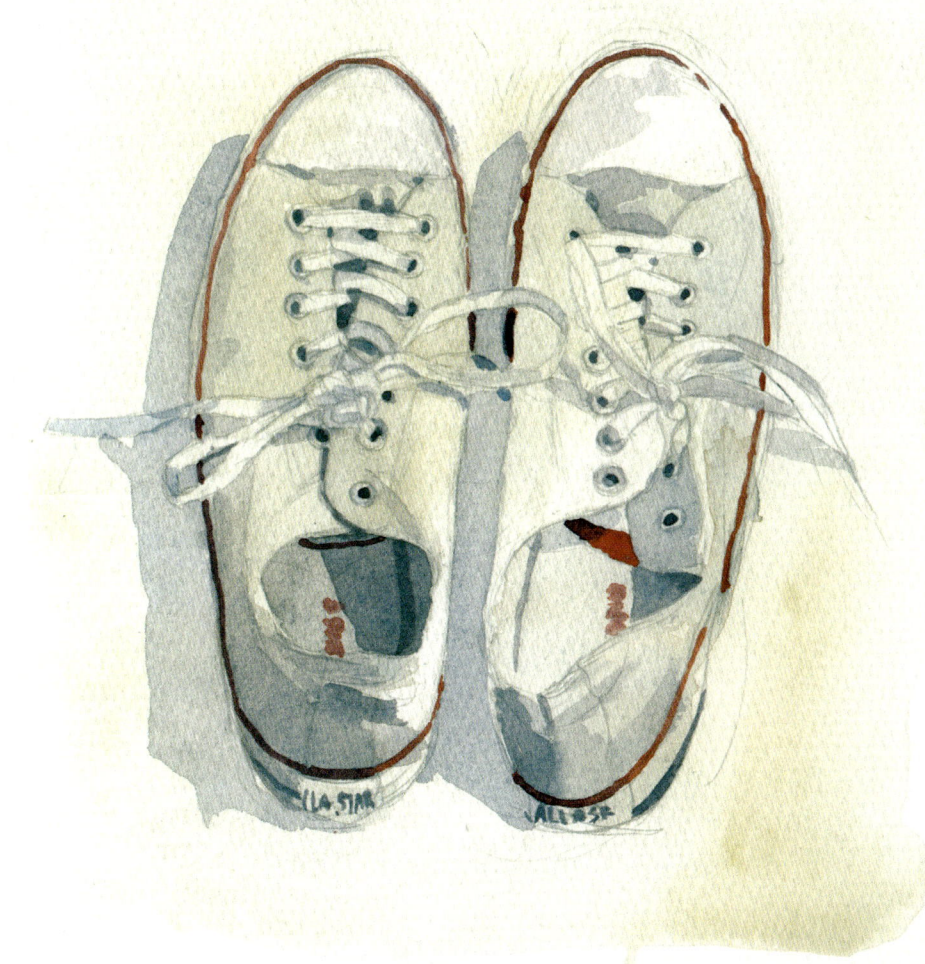

04 | Seashells
Arranging a simple still life

Materials

- Watercolor block, 14 x 10 in. (355 x 254 mm)
- 2B pencil
- Size 6 and 12 round brushes

Color palette

- Yellow Ocher
- Cobalt Turquoise Light
- Burnt Umber
- French Ultramarine Blue
- Burnt Sienna
- Cerulean Blue

Still-life painting is popular because it gives you complete control and the chance to explore sometimes complex forms of beauty. Choose pleasing but simple objects with a mix of colors or shapes. Avoid overcrowding the scene. Odd numbers of things balance better than even ones. A walk along a beach and good memories of vacations were the inspiration here.

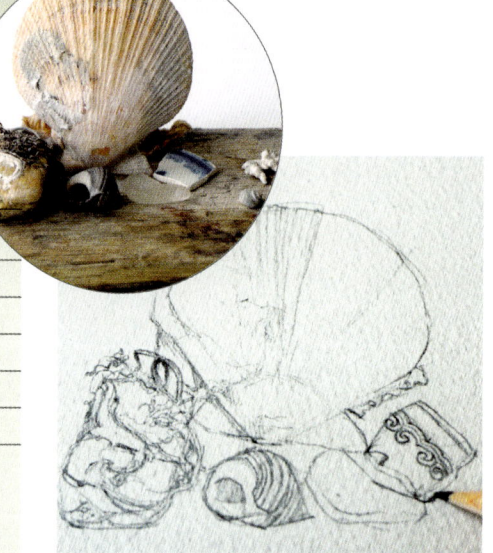

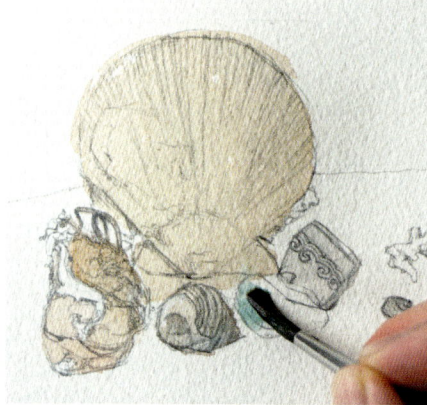

1 Organize the composition, placing your chosen objects where you would like them. There is no right arrangement—just go with your instincts. Draw the still life with a 2B pencil. The drawing shows quite a lot of detail, such as the ridges on the shell in front, that will guide you when you apply the color.

2 Apply initial washes over the main items, using Yellow Ocher for the shells and stones and Cobalt Turquoise Light for the piece of glass. For the pottery fragment, apply a very light gray wash of Cerulean Blue and Burnt Umber. Apply the paint fairly loosely—it's absolutely fine if the colors run into each other slightly and go over the pencil lines.

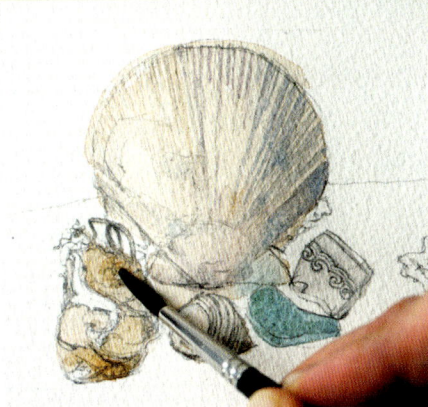

3 Add depth to each object, using a deeper version of the washes you used in step 2.

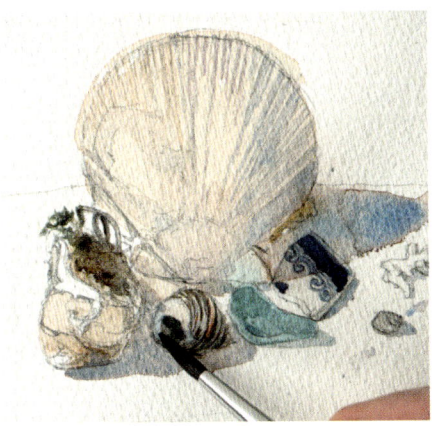

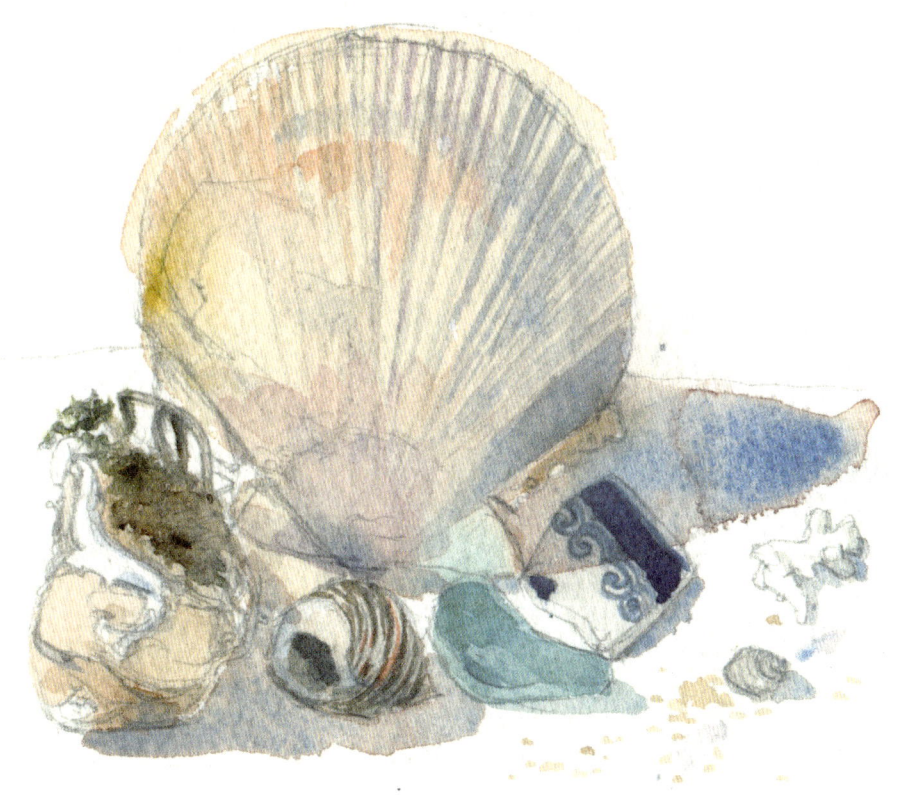

4 Apply a few light strokes of a pale French Ultramarine Blue wash for the shadows on the right-hand side of the main shell. Make a Yellow Ocher and Burnt Sienna mix and add a touch of Cerulean Blue. Use this for the other shadows—I enjoy the granulation effect. Use Ultramarine Blue for the pattern on the piece of broken crockery.

Paint the patches of darker color—such as the shadows on the shells and the little strip of seaweed—with Burnt Umber.

05 | Empty your pockets
Basic drawing for watercolor

Materials

- Watercolor block, 14 x 10 in. (355 x 254 mm)
- 2B pencil
- Black fine liner pen or fountain pen containing waterproof ink
- Size 8 and 6 round brushes

Color palette

- Raw Umber
- Payne's Gray
- Cerulean Blue
- Yellow Ocher
- Cadmium Orange
- Burnt Umber

Rather than spending ages looking around for a subject, try working with everyday items that you have to hand—they can have a familiarity that makes a good painting. The objects used here have basic shapes and are relatively flat, so they won't need much modeling.

This project uses a pen containing waterproof ink; all you have to do is draw the lines and fill them in with watercolor. It can be useful to make a separate pen drawing to establish the areas of shadow.

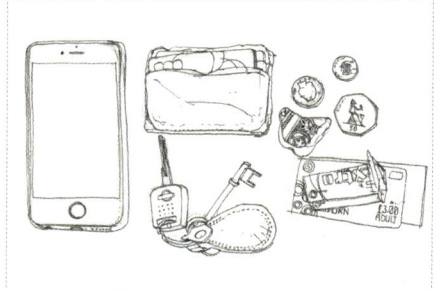

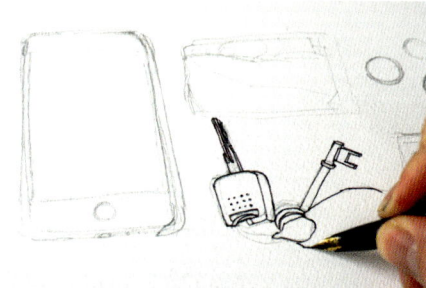

1 Sketch a very rough outline in pencil of the objects you are going to paint. Your drawing doesn't have to be too accurate—all you're doing is getting down the shapes and placing them on the paper, making sure that they all fit.

2 Now start drawing with your pen. Your lines don't have to be too precise—just carefully define the outside shapes of each object one at a time. Don't worry if your lines are slightly wobbly, as this will add character to the picture. This is the drawing you will paint onto.

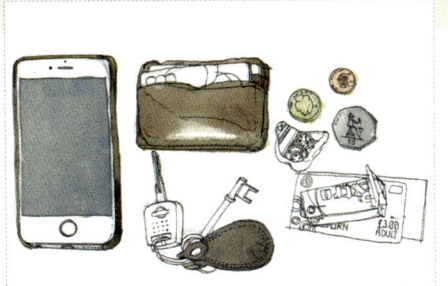

3 Start painting the objects using appropriately sized brushes. Use Raw Umber for the phone case, wallet, and key fob. Use Payne's Gray for the window on the phone, the keys, and the large coin. Use Cerulean Blue for the bank card and chewing-gum packet. Use Yellow Ocher for the left-hand coin and Cadmium Orange for the smallest coin and the tickets. If there is an obvious highlight—for example, on the right-hand key—leave that area unpainted.

SHADOW AREAS

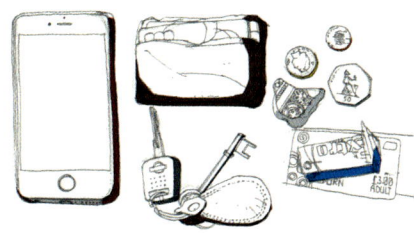 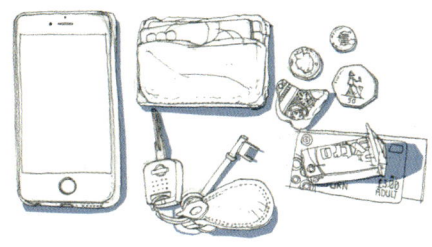

SEE THE FORM LAYER
Most of the objects here have very little depth, but there is a slight depth on the phone, wallet, keys, and pottery fragment, because one side of these items is obviously darker. For the phone and wallet, add some Payne's Gray to Burnt Umber and use this mix to paint the left-hand edges of both these objects. The diagram shows the areas to paint.

SEE THE SHADOW LAYER
For the subtle shadows cast by the other objects, mix Payne's Gray with a touch of Burnt Umber and Cerulean Blue. Apply this mix as a very diluted wash to the areas of shadow to increase the sense of three-dimensional depth and "anchor" the objects to the surface on which they are lying. The diagram above shows the areas to paint.

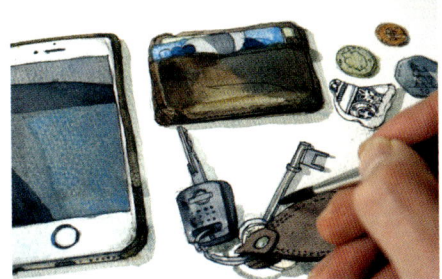

4 Paint the form and shadows as shown in the shadow areas panel.

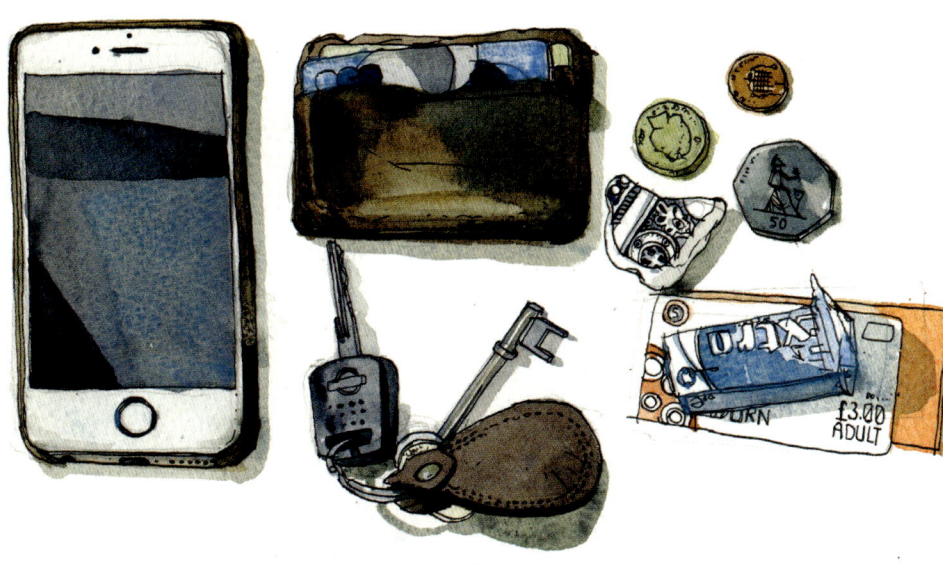

06 | Your painting kit
Get confident with color

Materials

- Watercolor block, 14 x 10 in. (355 x 254 mm)
- 2B pencil
- Brown fine liner pen
- Size 8 and 6 round brushes

Color palette

- Burnt Umber
- Payne's Gray
- Yellow Ocher
- French Ultramarine Blue
- Cerulean Blue
- Plus any additional colors to match to your own watercolor set

This project makes a very literal connection between the colors you see and what you put down on paper. When you look at your own watercolor set, the colors you'll be painting with are the same as the ones you're seeing, and this reinforces how they relate to each other. This really simple still-life exercise will help you to become more confident with color by getting you to use the full range of your palette. Remember that dry pans sometimes look different in color to when the color is applied to the paper, so test on a scrap of paper first of all.

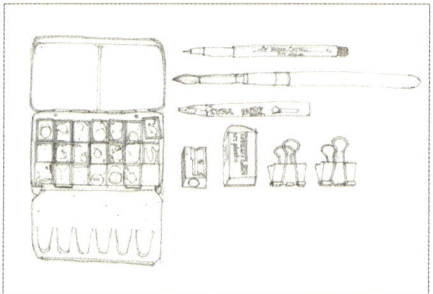

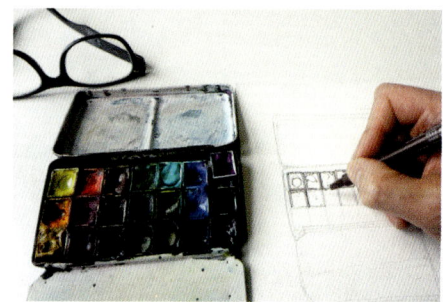

1 When planning the composition, feel free to reorganize the other objects the way you would like them. I prefer to order and align objects neatly, and it makes them easier to draw, but if you'd like them arranged more randomly, go for it—it's your painting. Start with a very rough pencil outline. Luckily all the objects here are made up of simple rectangles or cylinders, which makes makes them easy to draw. At this point your aim is not to be accurate—just block in where each object is, its size, and its relationship to the other objects around it.

2 Use a brown fine liner pen for the next stage. If you use a black line, the line delineates the objects and separates them from each other very strongly (think of comic books and their reliance on black outlines). If you use a brown line, you'll create a more subtle effect and you'll be on your way to not using a pen at all. When drawing your pen lines, try not to trace over your pencil marks but just use them as a guide. This will keep the quality of your line more alive and interesting to look at.

YOUR PAINTING KIT 43

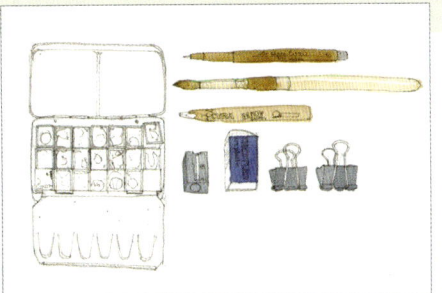 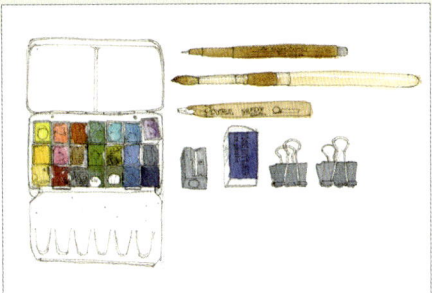 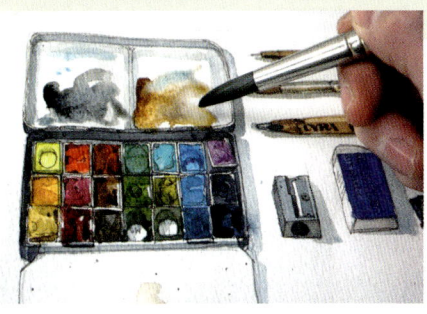

3 Start applying a basic watercolor wash to each object. You don't need to paint precisely within the lines—it's OK to go over them. If you see an obvious highlight, leave the area white. Paint the pen with Burnt Umber and a little Payne's Gray at the end. Use Burnt Umber for the brush head and upper handle, and a light wash of Yellow Ocher for the ferrule and lower handle. Use a light wash of Burnt Umber for the pencil. Apply Payne's Gray to the pencil sharpener, clips, and edges of the watercolor set, and French Ultramarine Blue to the eraser.

4 Start painting the watercolor pans. Take your time and let them dry for a short time if necessary before painting the next one, or paint pans that aren't touching each other. Don't worry, however, if the colors do run into each other a little bit. Keep comparing your painting with the real watercolor set and see how they relate—and enjoy the progress you're making.

5 Add cast shadows using a diluted wash of Payne's Gray with a touch of Burnt Umber and Cerulean Blue. Try this fun technique for the mixing tray: add a little pool of water to the mixing tray area of your painting, then place your brush loaded with color directly into the pool of water and watch the color spread. If you like, you can add another color while the paint is still wet.

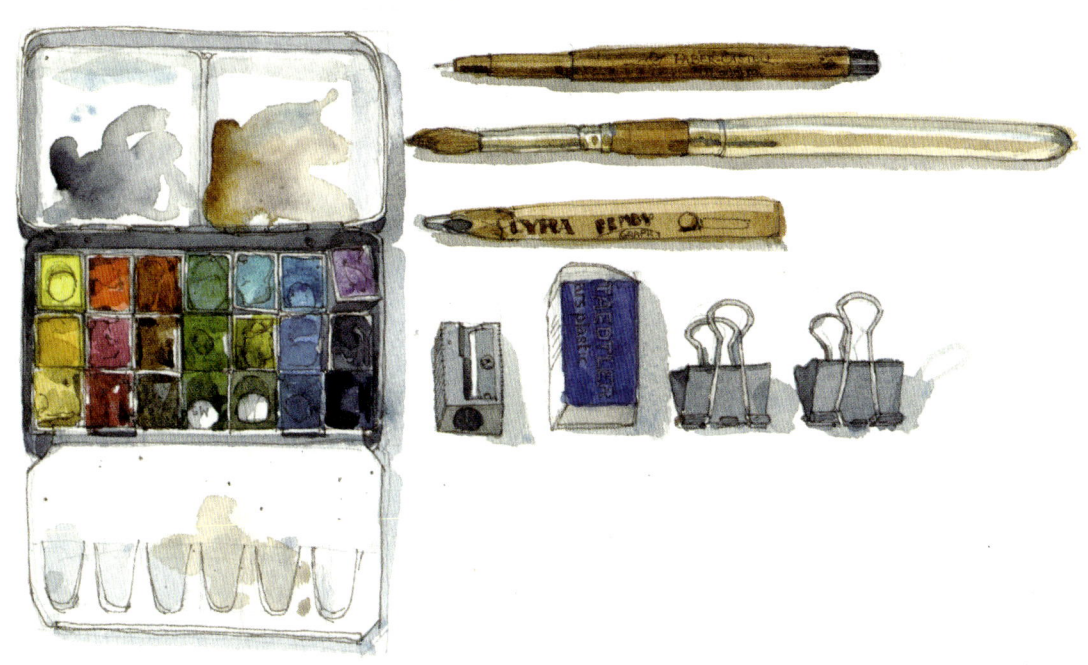

SIMPLE STILL LIFES

07 | Flowers with a difference
Classic subjects, new approaches

Materials

- Watercolor block, 14 x 10 in. (355 x 254 mm)
- 2B pencil
- Size 20, 12, and 8 round brushes
- Water sprayer

Color palette

- Cadmium Yellow
- Sap Green
- Cadmium Red
- Cadmium Orange
- Potter's Pink
- Yellow Ocher
- Alizarin Crimson
- Payne's Gray
- Terre Verte

Painting traditional subjects doesn't mean that you have to paint them in a traditional way—explore different ways of showing classic themes. This painting of a florist and her tattoos is not a typical flowers-in-a-vase approach. The arm adds something new, with its own narrative, so the painting becomes a partial portrait as well as a picture of a bunch of flowers.

When drawing cut flowers, you need to combine careful observation of the forms with an understanding that the subject changes hourly.

1 Use a 2B pencil to sketch out the flowers. Observe the way the stems make interesting, twisting shapes. Try to give your lines a sense of freedom, even the more complicated flower forms. Once you are happy with the rough shapes, go over your lines.

2 Draw the arm holding the flowers. I drew the arm from a separate photo. Draw the fingers curved around the stems as a single unit, then lightly mark in the knuckles and the divisions between the fingers.

FLOWERS WITH A DIFFERENCE 45

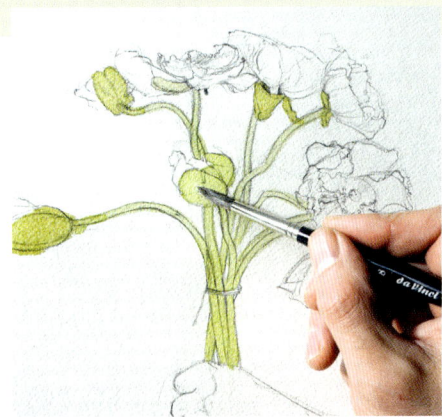 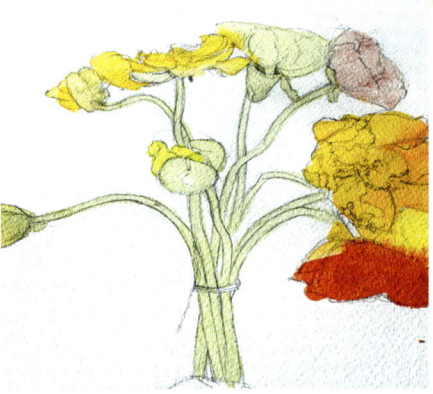 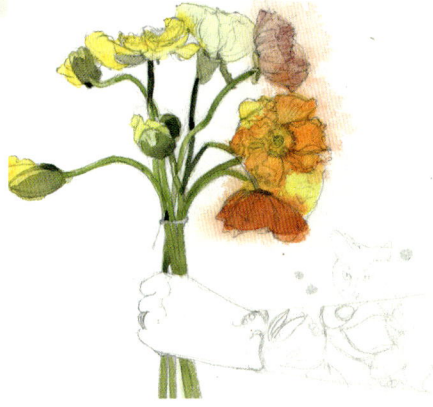

3 Paint the stalks and sepals with the smallest brush in a light green made from Cadmium Yellow and Sap Green.

4 Use the medium brush with Cadmium Yellow, Cadmium Red, Cadmium Orange, and Potter's Pink for the petals, applying thin layers of wet paint and letting the colors run into each other.

5 Let the paint dry, then continue to add more glazes to strenghten the colors as necessary. I occasionally sprayed the flowers with water so that the paint bled into the background.

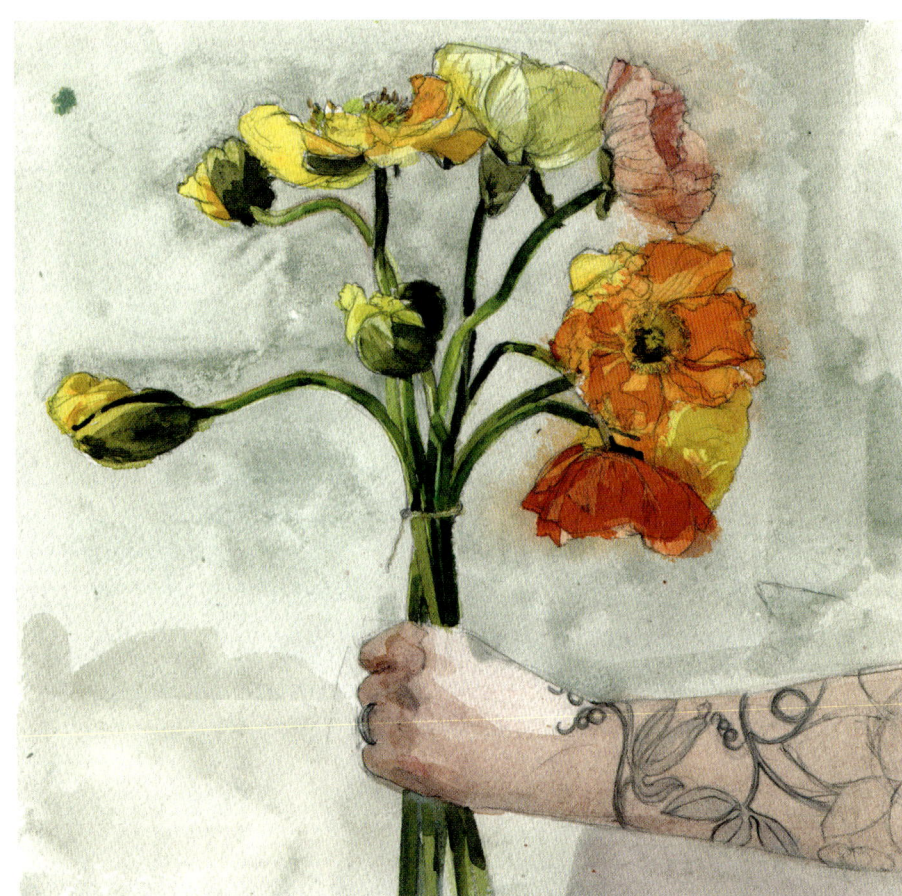

6 Paint the arm with washes of Yellow Ocher mixed with Alizarin Crimson. When dry, paint the tattoos with a light wash of Payne's Gray, using the smallest brush. Use the largest brush to add a wash of Terre Verte to the background.

SIMPLE STILL LIFES

08 | Wild flowers
Compose as you go

Materials

- 16 x 22 in, (400 x 550 mm) NOT 200lb (425gsm) watercolor paper
- 2B pencil
- Size 6 round brush
- Paper towel

Color palette

- Cobalt Violet
- Winsor Violet
- Cadmium Yellow
- Cerulean Blue
- Alizarin Crimson
- Quinacidrone Magenta
- Cadmium Red

Generally speaking, you plan your composition before you start painting. This exercise, however, is about making compositional decisions as you go, painting each flower in turn and then positioning the next one in relation to it so that you're reacting to each element as the painting progresses. This gives your painting a natural spontaneity—so just go with the flow!

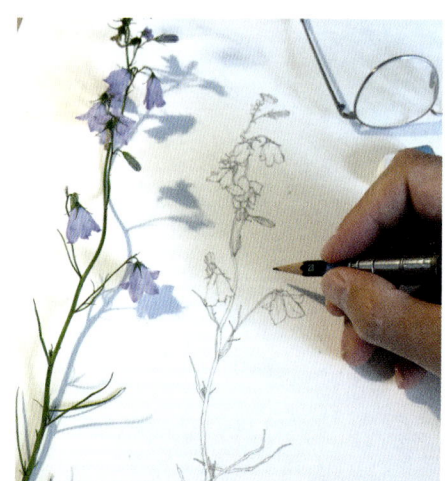

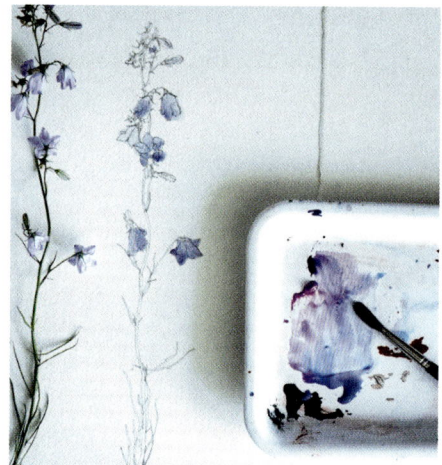

1 Leave most of the flowers in water for the time being and choose the first one to paint; I started with a harebell. Lay it down on the paper next to where you'll be drawing, so that you can compare your drawing directly with the subject without moving your head. Using a 2B pencil, draw the flower.

2 Mix up a light wash of Cobalt Violet and Winsor Violet and paint the petals. You don't have to be too precise—it's okay if you go over the lines. Leave to dry, then paint the darker parts with the same wash. Mix a light green wash of Cadmium Yellow and Cerulean Blue and paint the stalks. Again leave to dry, then paint the darker parts of the stalks with the same wash. For the shadow, use a light mix of Cerulean Blue and Alizarin Crimson.

WILD FLOWERS 47

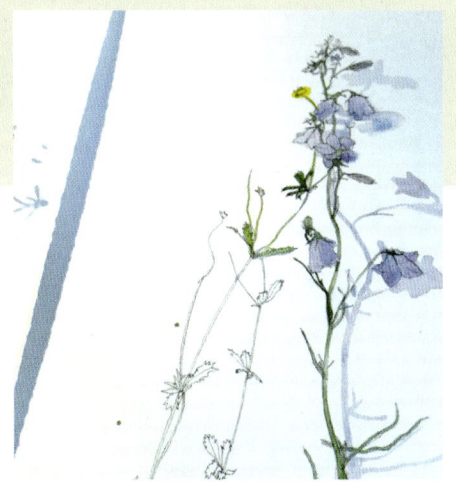 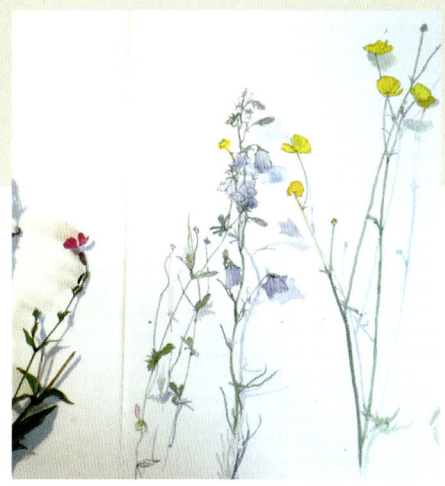

3 For the next flower, I chose some buttercups. I decided to place them to the left of the harebells; one of the flowers overlapped with the harebells but I just drew over it! Paint the buttercup flower with a bright blob of Cadmium Lemon. Paint most of the stalks in a mix of Cadmium Yellow and Cerulean Blue. Some parts of the stalk are a slight pinkish hue—use a light wash of Quinacidrone Magenta for this. The shadow is the same Cerulean Blue and Alizarin Crimson mix as in step 1.

4 Next is the larger group of buttercups, placed to the right of the harebells. Paint them with the same mixes as in step 2. Try to vary your washes to take advantage of the qualities of watercolor. Let some colors bleed into each other—happy accidents are as much a part of painting as careful plans!

5 A small ladybug had got mixed up with the flowers and walked over the page, I took this as serendipity and added it to the painting, making a quick drawing in pencil with a light Cadmium Red wash. While the paint was wet, I dabbed off some paint with paper towel to show the reflective side of the ladybug.

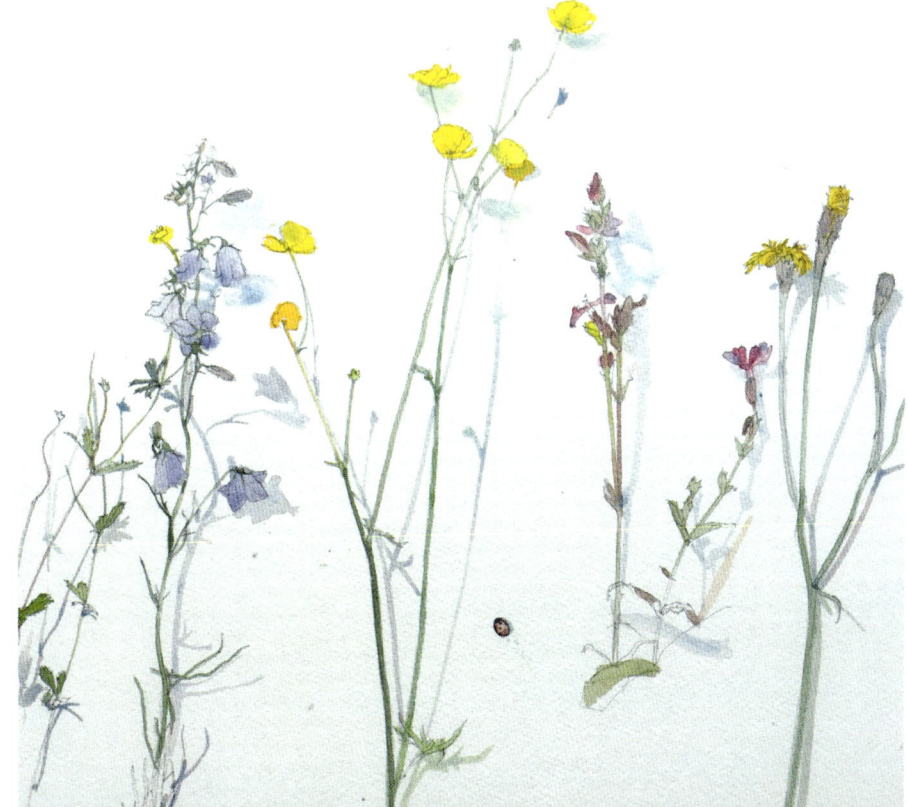

6 I continued the painting, adding a red campion and then a smooth hawksbeard. You can keep adding plants, increasing the size of your composition and stopping when you think it looks right.

SIMPLE STILL LIFES

09 | Breakfast
Watercolor with pen and ink

Materials

- Watercolor block, 14 x 10 in. (355 x 254 mm)
- 2B pencil
- Dip pen
- India ink, waterproof
- Size 6 and 12 round brushes

Color palette

- Payne's Gray
- Burnt Sienna
- Yellow Ocher
- Cadmium Red
- Cadmium Yellow
- Alizarin Crimson
- Burnt Umber
- French Ultramarine Blue

Watercolor with pen and ink is popular for its expressive and suggestive qualities. It's a good technique to use for food, which offers such an interesting mixture of colors, textures, and shapes. Here, I've painted a traditional English breakfast—it may not be the healthiest meal, but it's great for an occasional treat!

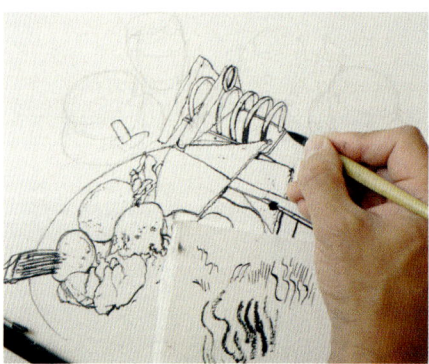

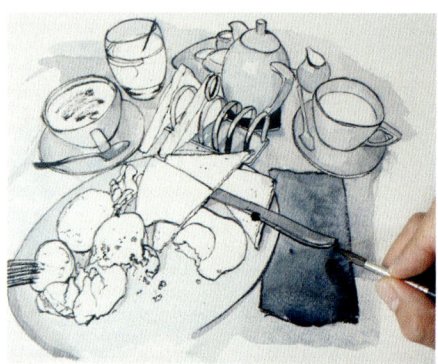

1 Sketch out the rough shapes in pencil first, before drawing with the dip pen. The beauty of using this kind of pen is the variety of line you can achieve, so make the most of this in expressing the character of each object. Practice making marks on spare paper first, and keep it nearby to refer back to. Use short, brittle lines to convey the crispness of the toast, but smoother, more flowing lines for the mushrooms and egg. Use your intuition as to what you think will look right and give you a sense of enjoyment. I like to combine a dip pen with a brush loaded with ink to get a thicker line for, say, the napkin and plate.

2 If you look ahead to the finished picture, you will see that most of the objects that aren't edible are black and white. I've gone with this idea so that the food will look more colorful. I used Payne's Gray to paint the black/white objects, as this is a good place to start.

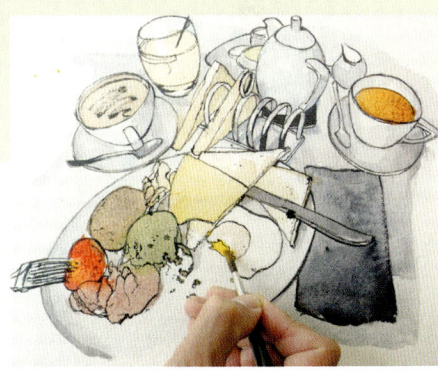 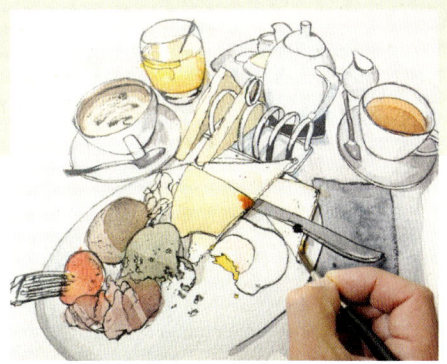 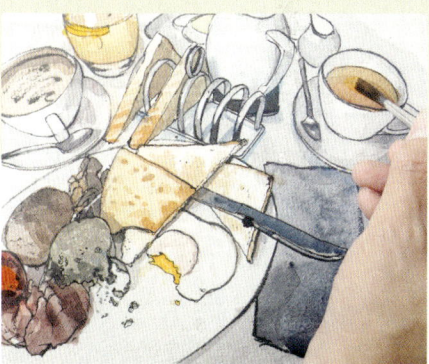

3 Now start adding the color. You've spent quite a bit of time on the pen-and-ink drawing, and now it's time to work more loosely. Don't try to control the color too tightly or to confine it to the pen outlines—let the colors run into each other. Colors used here: tea: Burnt Sienna and Yellow Ocher; tomato: Cadmium Red and Cadmium Yellow; bacon: Alizarin Crimson; toast: Yellow Ocher; sausage: Burnt Umber; egg yolk: Cadmium Yellow; orange juice: Cadmium Yellow; coffee: Burnt Umber.

4 Now you've established the initial colors, it's time to create depth and definition by applying darker washes of the same colors but with more pigment added to them—for example, a touch of French Ultramarine Blue or Payne's Gray. Let the washes dry between applications.

5 To complete your painting, add textures and details, such as the burnt marks on the toast and the shadows in the cup of tea.

10 | Strawberries
Sight sizing

Materials

- Watercolor block, 14 x 10 in. (355 x 254 mm)
- 2B pencil
- Size 8 and 6 round brushes

Color palette

- Cerulean Blue
- Alizarin Crimson
- Sap Green
- Cadmium Red
- French Ultramarine Blue

Sight sizing is a term used to describe the action of drawing and painting objects at the same size as you see them. Here I have arranged my subject right next to my paper, so that it is easy to compare the dimensions while drawing.

There is a real pleasure in picking fresh fruit—which can be eaten once drawn—and looking forward to new things to paint as spring comes around each year.

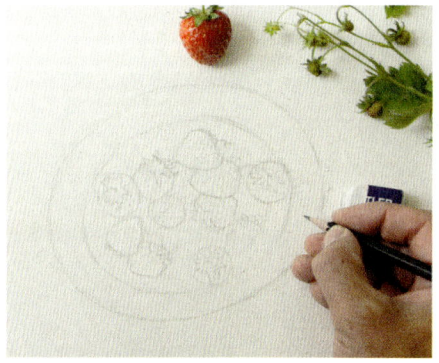

1 Sketch the dish of strawberries with your 2B pencil. I placed the dish to the left of my drawing board because I am right handed; if you're left handed, place it to the right. This makes it easy to compare the shapes and sizes of the strawberries you have drawn to those of the real fruit, simply by turning your head a little to the side.

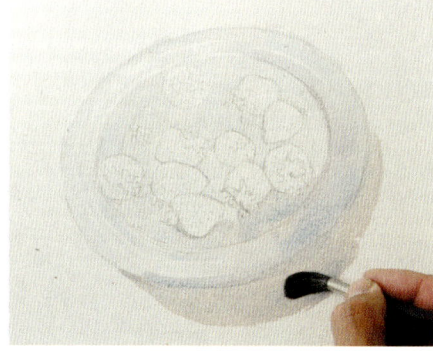

2 For the dish, use the larger brush to apply initial washes of Cerulean Blue mixed with a little Alizarin Crimson. Leave sections of the paper unpainted to create white highlights. Use the same wash for the shadows, but include more Alizarin Crimson in the mixture.

STRAWBERRIES 51

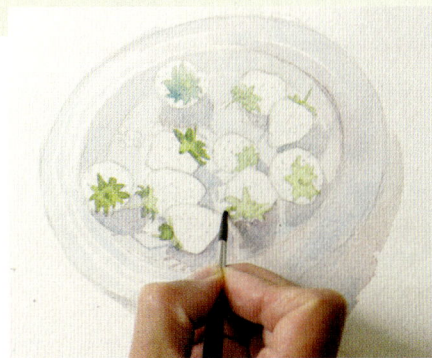 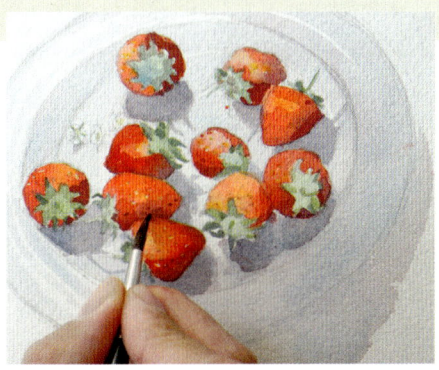 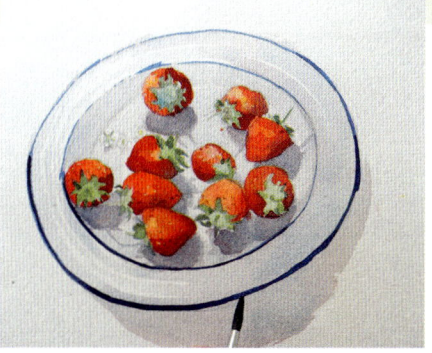

3 Using the same mixture with the smaller brush, add the shadows cast by the strawberries. Remember to include shadows for the leaves and stalks. Let dry. Paint the stalks and leaves themselves with a wash of pure Sap Green. For variety, drop some Cerulean Blue into the green while still wet. For the darker parts of the leaves, use a denser mix of Sap Green. Leave to dry.

4 Paint the strawberries with a Cadmium Red wash. Use less pigmented (more diluted) color on the brightest part of each berry. For the parts that are in shadow, use a deeper red wash of Cadmium Red mixed with Alizarin Crimson. If you feel that the shadows are not dark enough, go over them again with the same wash, when the previous wash is dry.

5 Finally add the blue lines around the edges of the dish with a wash of French Ultramarine Blue. Try to use a big, bold stroke when you're painting these circles—don't hold back, because the sense of energy created by using bold strokes will come through in your painting.

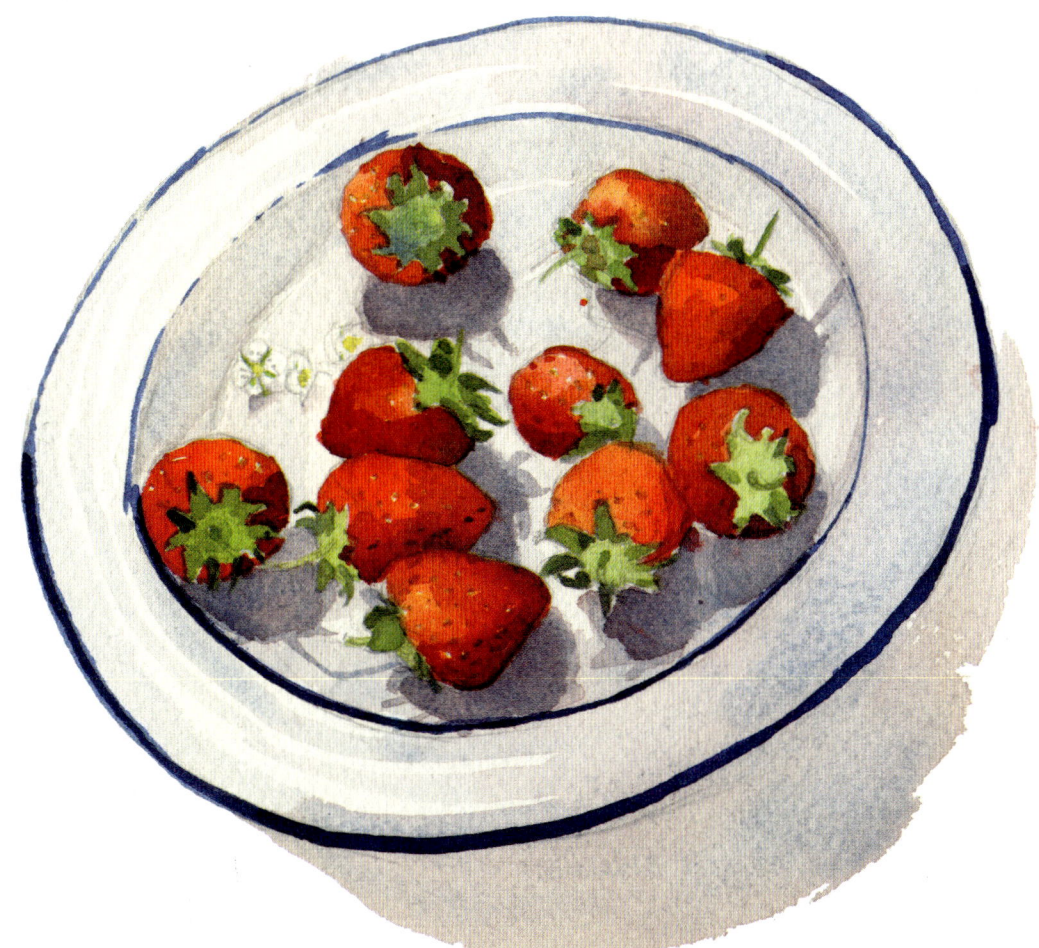

11 | Pumpkin latte
Quick watercolor sketch

Materials

- Sketchbook
- 2B pencil
- Fountain pen containing waterproof ink
- Brush pen
- Size 8 round brushes

Color palette

- Burnt Umber
- Yellow Ocher
- Burnt Sienna
- Cerulean Blue
- Payne's Gray

This lesson is all about working quickly. Start with pen-and-ink lines to help define the shapes so that they're easier to paint, then add basic watercolor washes, laying them down quickly and varying the tone to create visual interest and prevent them from looking too flat and illustrative. It's important to use waterproof ink for the initial pen work—unless, of course, allowing the pen lines to bleed and blur into the watercolor is the look you're after!

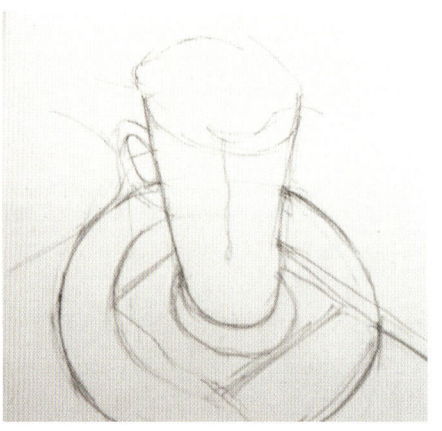

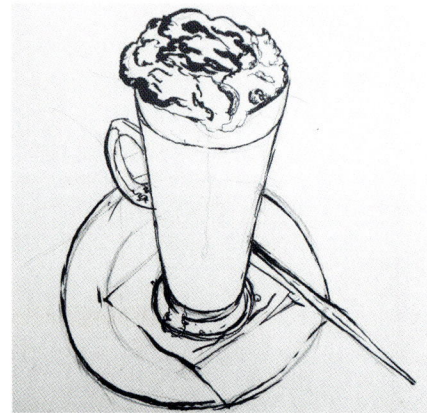

1 Very roughly draw the shape of the glass and saucer with a 2B pencil (this saucer is asymmetrical, which makes the drawing look slightly off).

2 For the ink work, I use a combination of the fountain pen and the brush pen to get a good variation of lines. These pens use waterproof ink. If you don't have these, you can use India ink with dip pens and a brush to achieve the same results.

PUMPKIN LATTE 53

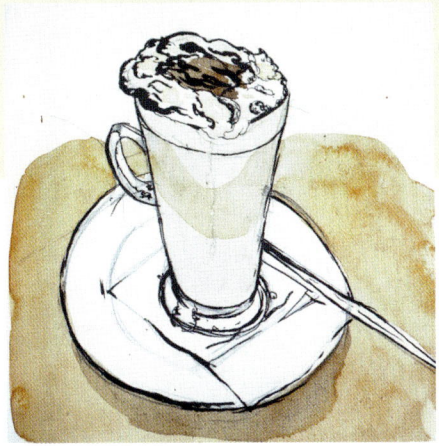

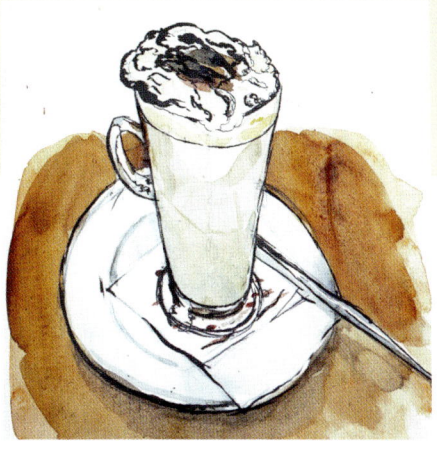

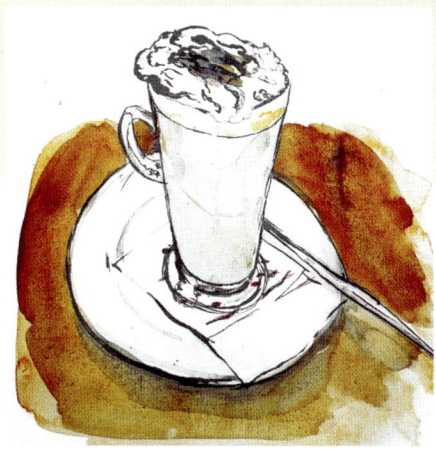

3 Paint an initial wash of Burnt Umber and Yellow Ocher for the coffee and Burnt Sienna for the table. For the shadow of the saucer, I added some Cerulean Blue to give a nice coldness to the shadow and some granulation.

4 With Burnt Sienna, add another wash to the table top. I like to leave some of the first wash visible, as it can give a more organic, rough edge to your painting.

5 Now add details: Payne's Gray to the teaspoon and some diluted Yellow Ocher to show the creamy surface. You can add a few more chocolate sprinkles using Burnt Umber. Then enjoy your coffee—if it hasn't gone cold!

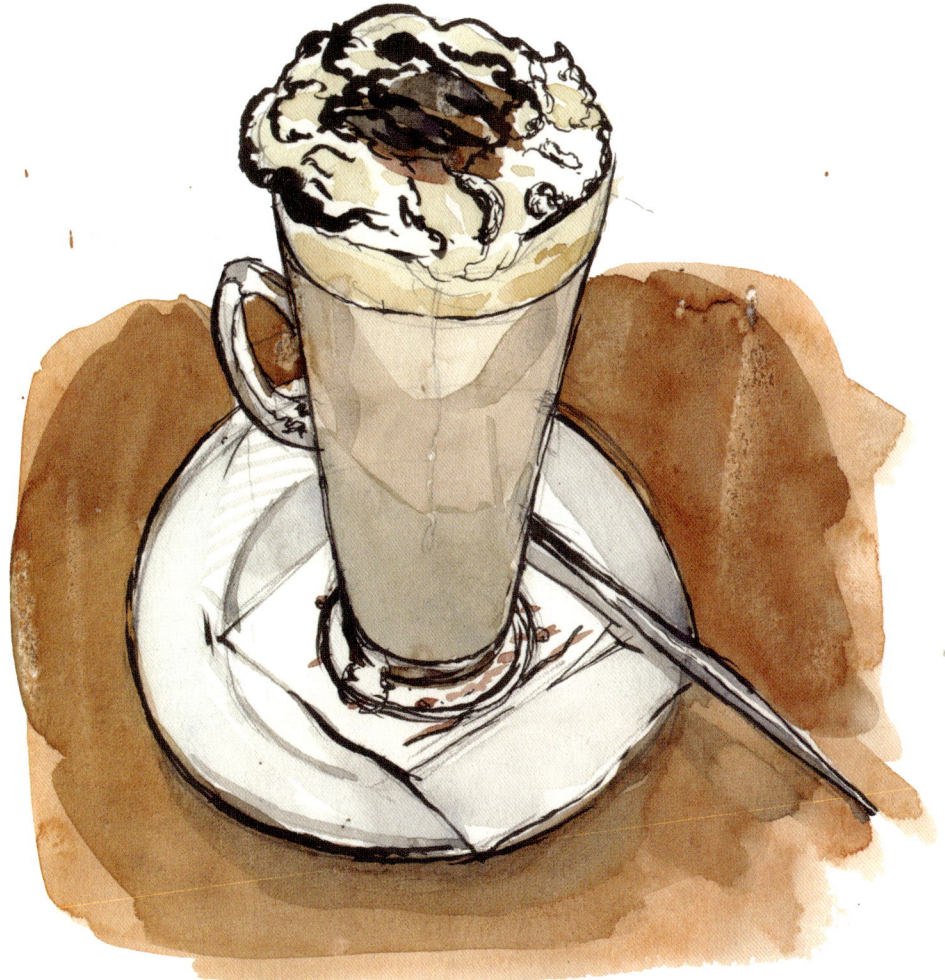

12 | Robot
Hard edges

Materials

- Watercolor block, 14 x 10 in. (355 x 254 mm)
- 2B pencil
- Size 8 and 6 round brushes

Color palette

- Cadmium Red
- Cadmium Orange
- Cadmium Yellow
- Manganese Blue Hue
- Payne's Gray
- Alizarin Crimson
- Cerulean Blue

Children's toys make colorful and interesting subjects for still-life painting. The square qualities of this little robot make it ideal for a study of achieving hard edges with watercolor. You can do this by letting the paint dry between washes.

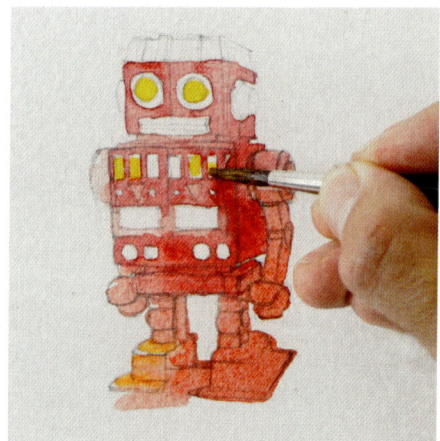

1 Start by making a careful pencil drawing of the robot. There is quite a lot of detail on the front of the robot and this initial pencil drawing will be a helpful guide when it comes to adding the different colors.

2 Apply an initial wash of Cadmium Red. The color should be quite diluted, since this is a really dense, rich red. Leave certain parts unpainted, as shown above. Vary the application of the color, making it lighter in parts to suggest highlights—for example, at the top of the robot's arm on the right. Use a Cadmium Orange wash for the feet, allowing the red and orange to run into each other. When the red and orange areas are dry, paint the robot's eyes and the little rectangles at the top of his body with Cadmium Yellow, using the smaller brush if necessary.

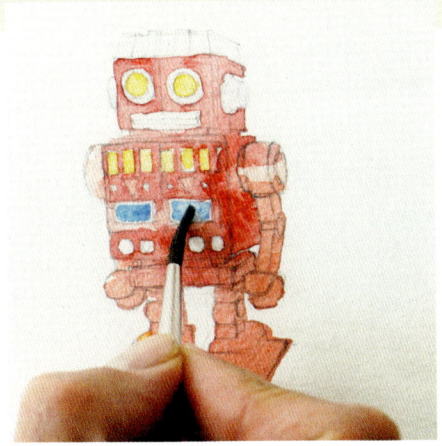
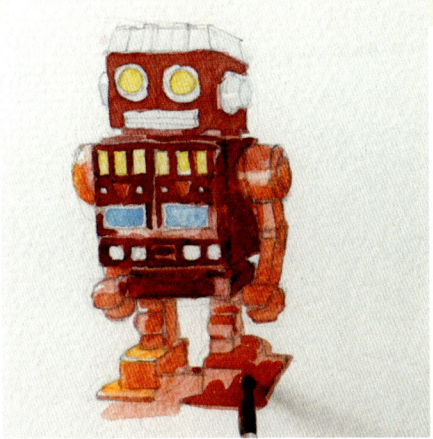

3 Paint in the blue rectangles with a wash of Manganese Blue Hue.

4 Paint the shadows and increase the sense of form by applying darker versions of the same Cadmium Red wash as before—deepen the color by simply adding more red to the wash.

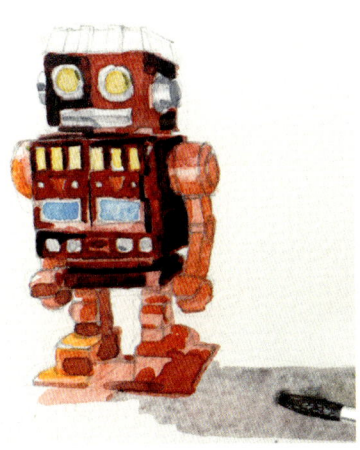
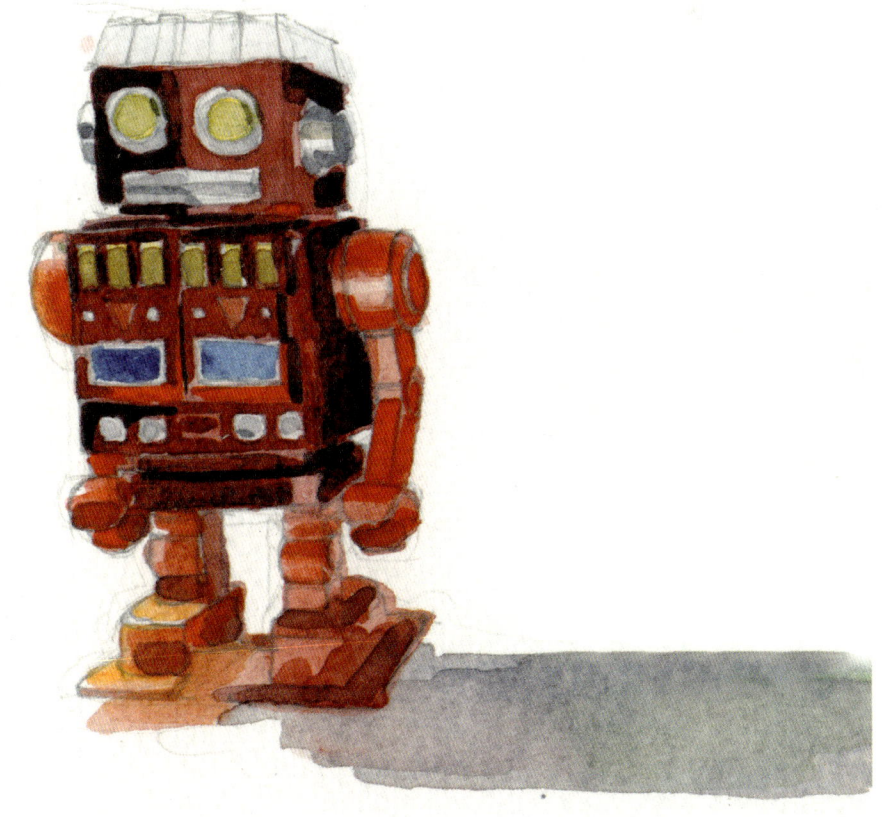

5 Paint the robot's "ears," "mouth," the rings around his eyes, the top of his head, and the little buttons on his front in washes of Payne's Gray. Start with very diluted washes and build up the tone with increasingly darker color, working wet on dry. Finally add a shadow using a mixture of Cerulean Blue and Alizarin Crimson.

13 | Peony on black background
Creating dynamic contrast

Materials

- Watercolor block, 14 x 10 in. (355 x 254 mm)
- 2B pencil
- Size 10 and 4 round brushes

Color palette

- Sap Green
- Raw Sienna
- Alizarin Crimson
- French Ultramarine Blue
- Payne's Gray

CHOOSING A FLOWER SUBJECT
Choose a single flower for this exercise. Try to pick one with a distinct shape or silhouette—tulips are good. Here, I've used a peony, going for a simple, almost black and white, color range. Just pick a good contrast between the background and your flower: you could even go with strong colors.

With this painting I'll be introducing a technique common to the Scottish Colorists. Painters such as Samuel Peploe often introduced a very dark background to their still lifes to increase impact, creating a strong dynamic contrast between the delicacy of the flower and the boldness of the backdrop. This tension between the two elements allows you to put less emphasis on modeling the individual aspects of the flower.

Rather than trying to model the flower's subtle gradations, we'll be focusing more on shapes and patterns to create a bold watercolor.

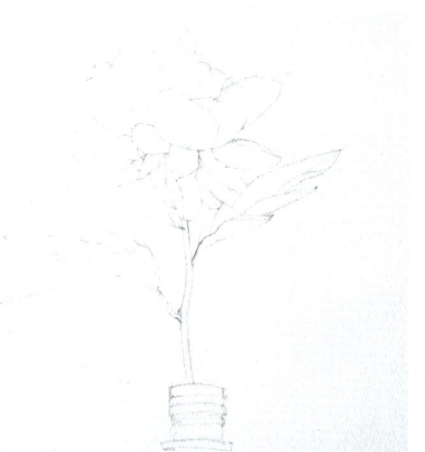

1 Draw the flower with a 2B pencil. Think of the overall shape first, then work out individual leaf shapes and petals. If you work in this manner, rather than start with a petal at a time, you could be surprised how it will fit into place. Use the idea "start with a shovel, finish with a needle"—begin with the big shapes before honing into small details.

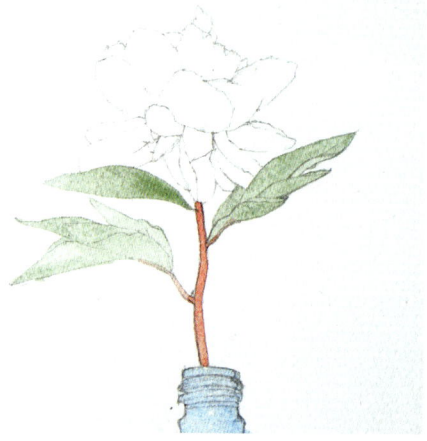

2 Using Sap Green, start with a wash over the leaves, using lots of water. Think of filling the area with a pool of water rather than painting. Then use a wash of Raw Sienna with a touch of Alizarin Crimson for the stalks. It's okay if the color runs into the leaves slightly. Finally add a wash of Ultramarine Blue for the bottle. Be careful to leave white highlights unpainted for later.

PEONY ON BLACK BACKGROUND

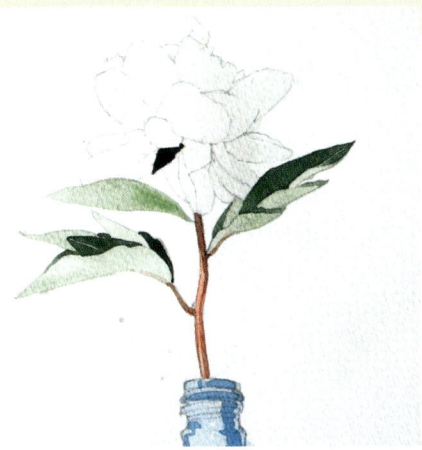

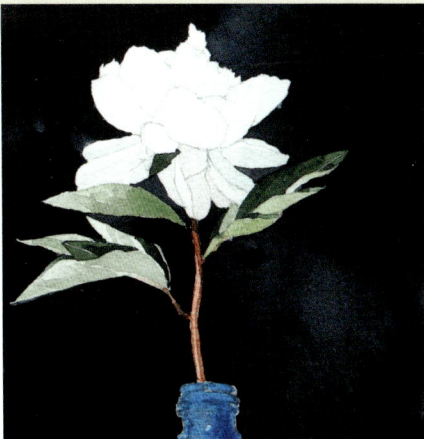

3 Next, add some depth to the leaves and stalk. It's good to think of the shadow in terms of defined shapes. Mix some Sap Green with Payne's Gray to create a dark green, then take your time and add the shadows. In the same manner, keep with the Raw Sienna and Alizarin Crimson that you used earlier, but use less water and more paint. If it helps, experiment on a piece of paper to get the richness of color right before you commit to your painting. Use French Ultramarine Blue for the shaded areas within the bottle.

4 Once the dark shadows are done, move on to the mid-tones. Mix a color in between the first Sap Green wash you used and the shadow. Test your color first, then add the mid-tones of the leaves. It's quite a nice effect to paint around the veins of the leaves, leaving them lighter. In the same way, but with Ultramarine Blue, add the mid-tones to the bottle. With a very diluted Payne's Gray, paint in the darker petals. Then comes the fun part—mixing a lot of Payne's Gray for your background. Use lots of water and lots of paint, and be sure to mix up more than you think you'll need. Start with your larger brush, letting the pigment pool into interesting areas. While the paint is still wet, jump in with your smaller brush to get close to the flower between the petals and leaves.

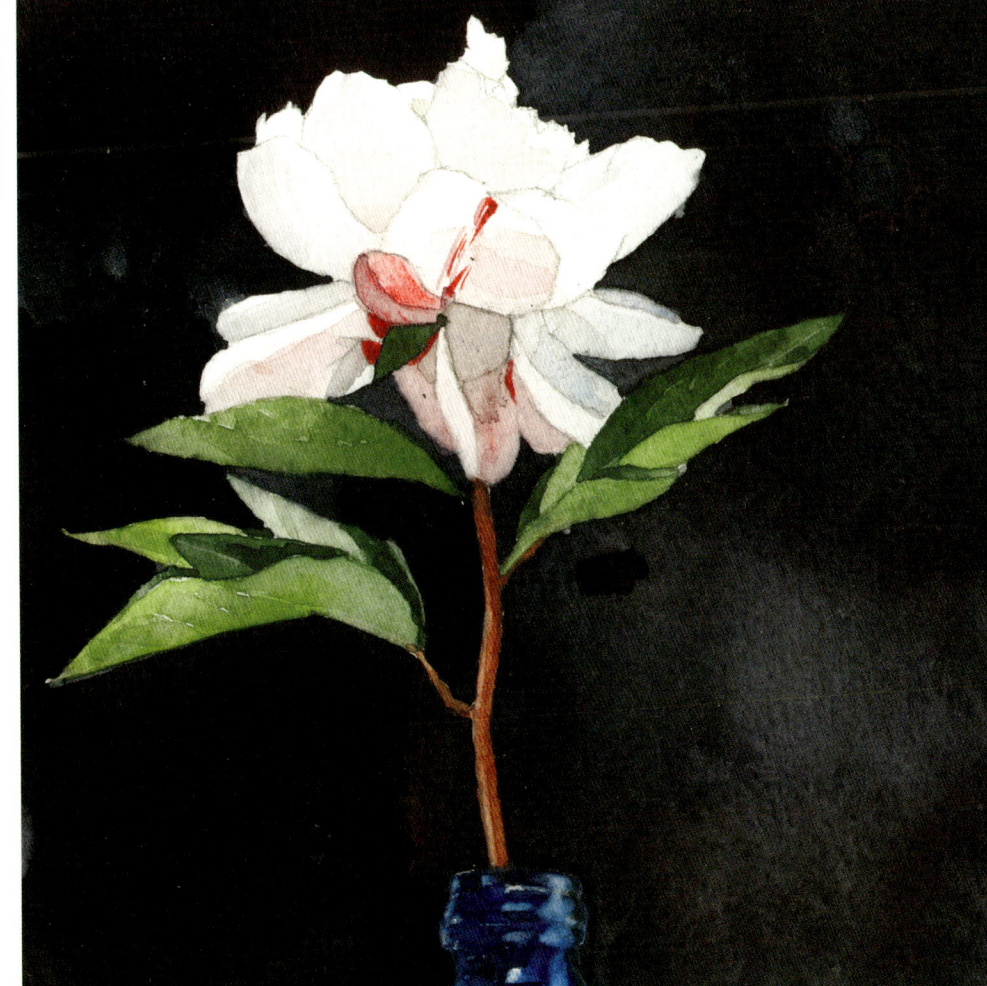

5 After the background has dried, add the highlights to finish this painting. Use Alizarin Crimson to paint the red highlights. Use your own judgment to decide if the petals need darkening at all.

Chapter 3
Landscapes

14 | Simple landscape
Washes for atmosphere

Materials

- Watercolor block, 14 x 10 in. (355 x 254 mm)
- 2B pencil
- Size 20 and 6 round brushes
- 1 in. (2.5 cm) chisel brush

Color palette

- Cerulean Blue
- Yellow Ocher
- Sap Green
- French Ultramarine Blue

This landscape is created using elementary watercolor washes. I've introduced some simple trees to add interest, but feel free to miss these out and focus on the land and sky if you like. Enjoy experimenting with the way the paint runs into the wet paper and the brushstrokes bleed into each other. Washes are unpredictable and that's part of the joy of them.

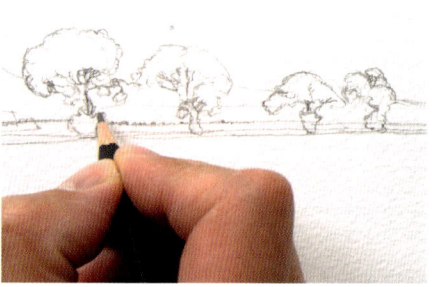

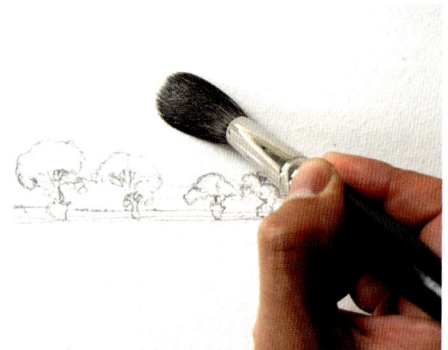

1 Start by drawing out your landscape with a 2B pencil. I placed the horizon about two-thirds down the page and, rather than having a blue–green split in the middle of the painting, I added a mountain in the background and some fields and hedges on the horizon; these elements help to create a sense of distance and space.

2 Using the largest brush, add a wash of clean water to the entire page—use quite a lot of water so that the paper is pretty wet.

SIMPLE LANDSCAPE 61

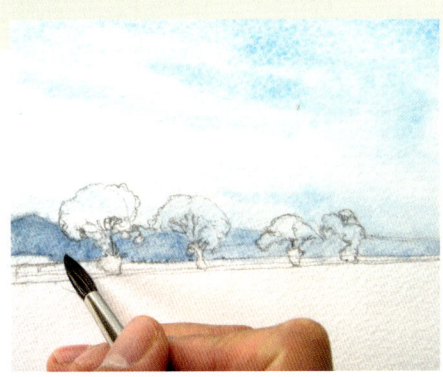 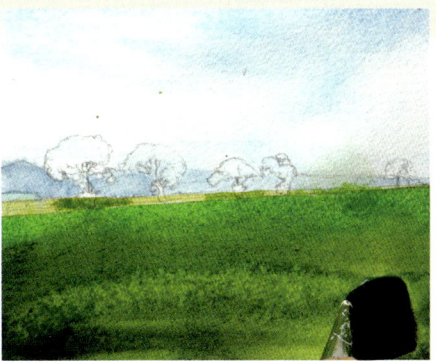 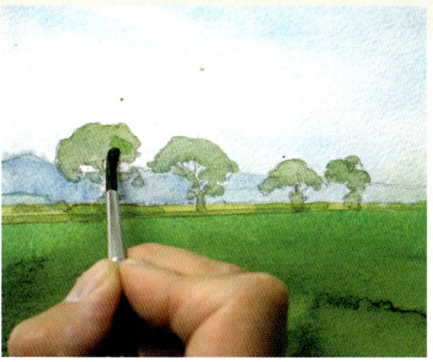

3 While the paper is still wet, add a wash of Cerulean Blue with the larger brush. Start with a stroke of paint at the top of the page, then, without recharging your brush, work the paint slowly down the page to the horizon. As the paper and the paint are wet, the brushstrokes won't have hard edges. I emphasized my brushstrokes to create long, wispy clouds.

Use the same blue and the smaller brush to paint the mountain.

4 Add the field in the middle with Yellow Ocher. Use a chisel brush to paint the green field at the bottom with Sap Green, and a mix of Sap Green with a touch of French Ultramarine Blue. Use big, confident strokes—you should only need two or three to cover the whole area.

5 When the mountains and sky are dry, return to the small round brush and add the trees and hedges with Sap Green. Leave these to dry, then add shadows to the trees and hedges with a darker green made from Sap Green with a touch of French Ultramarine Blue.

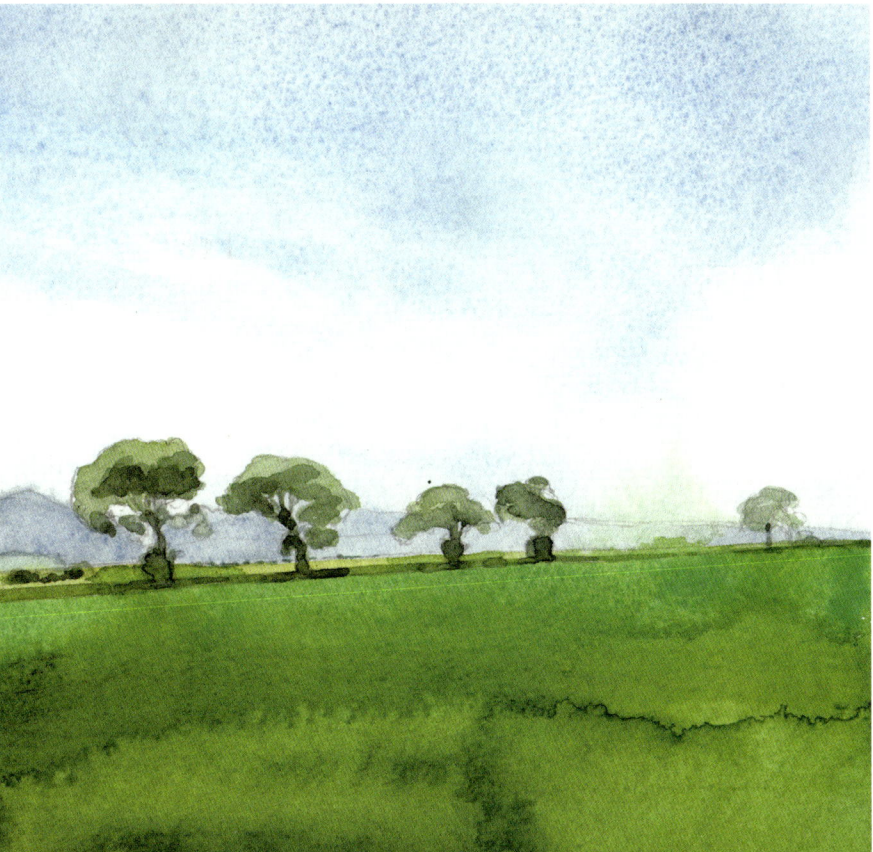

15 | Stormy seascape
Simple wash with gradation

Materials

- Watercolor block, 14 x 10 in. (355 x 254 mm)
- 2B pencil
- Size 12 and 8 round brushes

Color palette

- Cerulean Blue
- Quincridone Magenta
- Payne's Gray
- Manganese Blue
- Indigo

This project starts with a very simple gradated wash, then we push the idea a bit further to create an atmospheric painting of a stormy seascape.

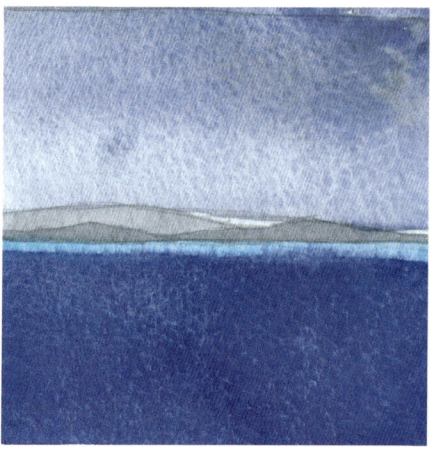

1 With every painting it's a good idea to work out how it will look in its simplest form, so it's helpful to do a small watercolor sketch first. If you go for dynamic washes you might be surprised how far you can take it and it still read as a landscape, and you'll have fun working in that tension that's a big part of watercolors. As you can see, the thumbnail study includes only the sky, mountains, a tiny stripe of turquoise blue, and the sea—that's it! It is common to have sky meeting land/sea slightly lower than halfway down the paper, although I'd recommend experimenting with the composition.

2 This is a very simple scene to draw, so just roughly mark the point you'd like the sea to meet the sky. When drawing the mountains, a handy tip is to block out the main shape and initially ignore all the tiny bumps and ridges. It's this basic shape that people recognize first. After that, you can add a bit more detail. If you don't do this, sometimes the line will get away from you and it won't fit! Using the larger brush, apply clean water across the whole scene.

STORMY SEASCAPE 63

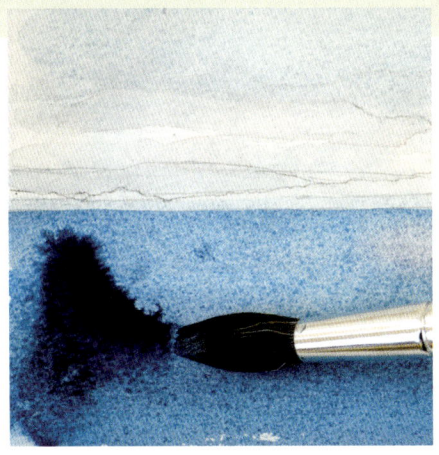

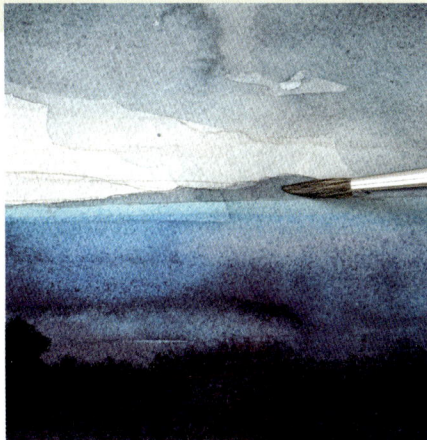

4 Imagine the mountains in rows, one in front of the other. The mountains closer to you will be darker than those farther away. An easy way to convey this and get a good gradation of color is to paint all the mountains with one light wash of Payne's Gray, using the smaller brush, then add more color to the wash and paint the mountains again except for the row farthest away. Repeat this process, applying successively darker washes to each mountain row so that they go from light to dark the closer they are to you. Let the washes dry between applications to achieve hard edges.

3 Apply a wash of Cerulean Blue over the whole painting. Add more water as you work down the paper until you come to the area of land, then more pigment as you come closer to the bottom of the page. This painting is mostly blue, but I've added a diluted wash of Quinacridone Magenta over the horizon and top part of the sea to add a bit of depth and interest.

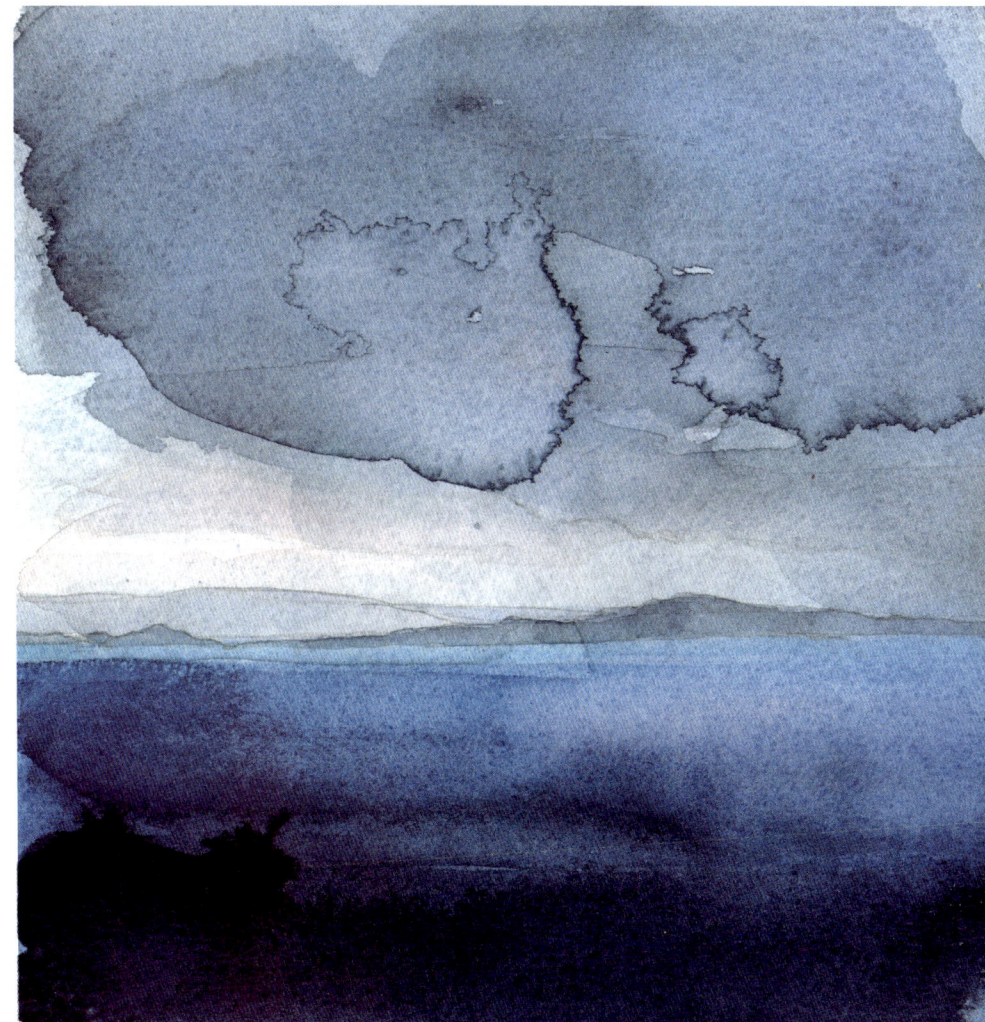

5 For the sea, apply a really strong wash of Manganese Blue, which is a very vivid color. Next, add water over most of the sea, leaving a small strip of the bright blue along the horizon. Then mix up lots of Indigo, add it to the wet paint, and allow it to bloom. There's a degree of randomness to this technique, so the effect you'll achieve will be different from what I've done here. Repeat this technique with the sky. Use different brushmarks and try painting a big cloud with water then drop a mix of color into it and watch it do its thing.

16 | Clouds
Creating a sense of distance

Materials

- Watercolor block, 14 x 10 in. (355 x 254 mm)
- 2B pencil
- Size 20 and 8 round brushes
- Water sprayer

Color palette

- Cerulean Blue
- Cadmium Orange
- Cobalt Violet
- Yellow Ocher
- Sap Green
- Perylene Green
- Burnt Sienna
- Cadmium Red

This lesson starts with a simple wash, then goes on to increase the complexity of the scene by building up the banks of cloud in the sky and the hills in the foreground. The clouds and the hills—lying in different spatial planes in the scene as they recede from the viewer—create a sense of depth. Adding the bird is not necessary, but elements like this can add character and give a sense of scale to your painting.

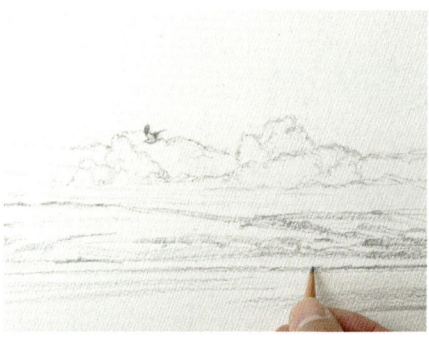

1 Draw the scene with your 2B pencil. It's worth spending some time on the clouds. Observe how clouds are structured and draw your own version, using loose marks to get a sense of roundness or fluffiness. Avoid hard marks and lines and try to keep a sense of lightness in your drawing.

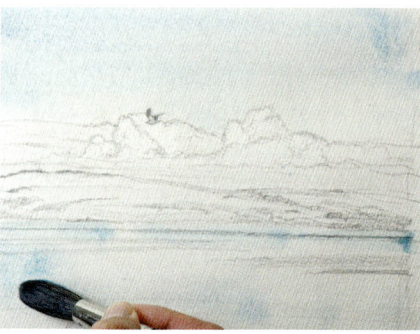

2 Using the larger brush, apply a diluted wash of Cerulean Blue over the sky and sea, brushing it on loosely. Leave the clouds and the land unpainted.

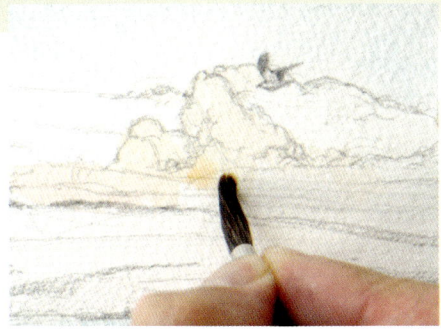 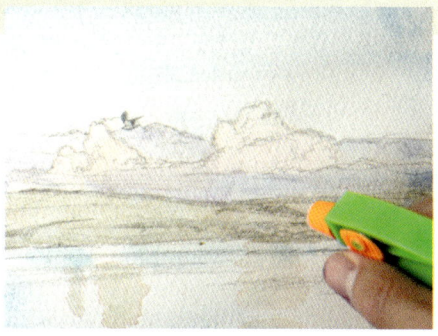 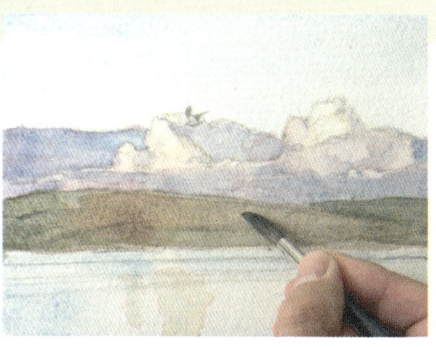

3 Now start working up the color in the clouds. Use a diluted pale Cadmium Orange wash for the clouds in the foreground, and a pale Cobalt Violet for the clouds in the background.

4 Use a mix of Yellow Ocher and Sap Green for the hills. To prevent hard edges from forming, use a water sprayer to keep the paper wet. Add patches of pale orange to the sea to suggest reflections. To darken the hills, apply further washes of Perylene Green and Burnt Sienna.

5 Define the clouds by adding more washes of Cobalt Violet and Cerulean Blue—leave the lightest part light and slowly darken the rest. While still wet, drop in pink (very diluted Cadmium Red). Apply patches of diluted Cobalt Violet and Cerulean Blue for the reflections.

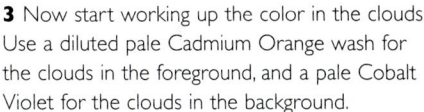

17 | Focusing on foreground
Masking areas of white paper

Materials

- Watercolor block, 14 x 10 in. (355 x 254 mm)
- 2B pencil
- Masking fluid
- Size 12 and 6 round brushes

Color palette

- Cerulean Blue
- Cobalt Light
- Sap Green
- Yellow Ocher
- Alizarin Crimson
- Perylene Green
- Quinacridone Magenta

Aerial, or atmospheric, perspective exploits the fact that colors are brighter and texture is more evident in the foreground of a scene. This bright, punchy landscape, with its shimmering sea and hazy background mountains, uses both color and textural detail to focus on the foreground. The main subject is the grass, moving slightly in the wind—it is so close it suggests the viewer is lying in it, enjoying a warm summer's day. Masking fluid is used to protect areas of the paper that you want to remain white, allowing you to paint freely over the top without worrying about losing those little white highlights.

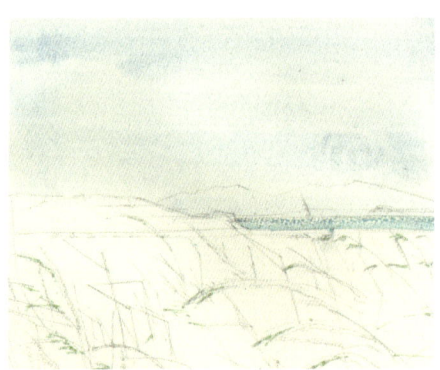

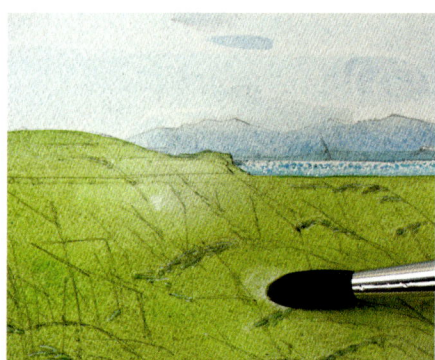

1 Lightly sketch the scene—the linework for the grass can be suggestive rather than accurate. Use masking fluid to make small dots in the sea and on some of the seedheads and stalks. Add a wash of Cerulean Blue with the larger brush for the sky, and a line of Cobalt Light with the smaller brush for the sea.

2 Use the larger brush to add a light Cerulean Blue wash over the mountain range in the background. If possible, make the wash lighter at the top by painting at a slight angle. Add a wash of diluted Sap Green over the land at the bottom—use plenty of water and allow it to dry unevenly, if you like.

FOCUSING ON FOREGROUND 67

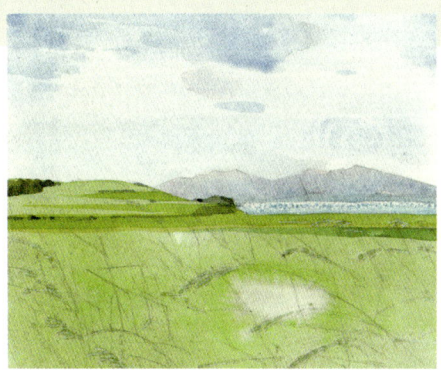 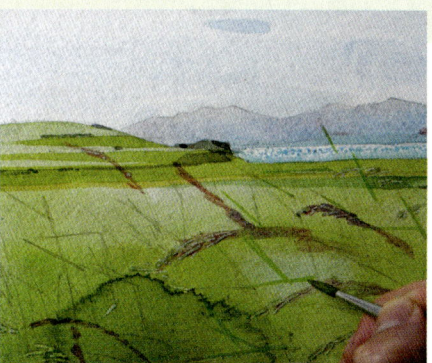 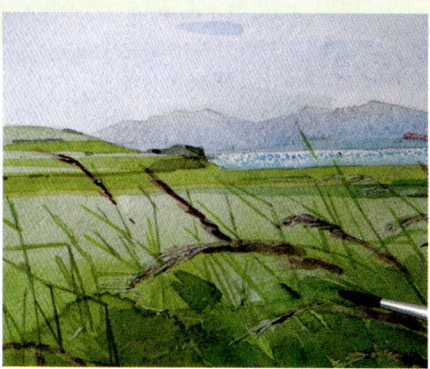

3 It can be helpful to think of landscapes in layers—here mountains, sea, mid-ground, grass—the farther away the "layer," the lighter it should be, and vice versa. Add depth, texture, and definition to the different layers by adding washes of Yellow Ocher, Sap Green, and Cerulean Blue. Allow to dry.

4 Apply a light wash of Quinacridone Magenta to the background over the mountains and sky. Use the smaller brush to paint the rough shapes of the seedheads with a diluted mixture of Alizarin Crimson and Yellow Ocher. Then add the stalks of grass with Sap Green. Paint the very dark seedheads and the darkest shadow areas of the grass with a Perylene Green wash.

5 Build up the foreground with more washes and glazes. Once you are finished and the paint is dry, rub off the masking fluid with your finger. If the white of the paper is too bright or jarring, add a very diluted wash of Alizarin Crimson over the seedheads.

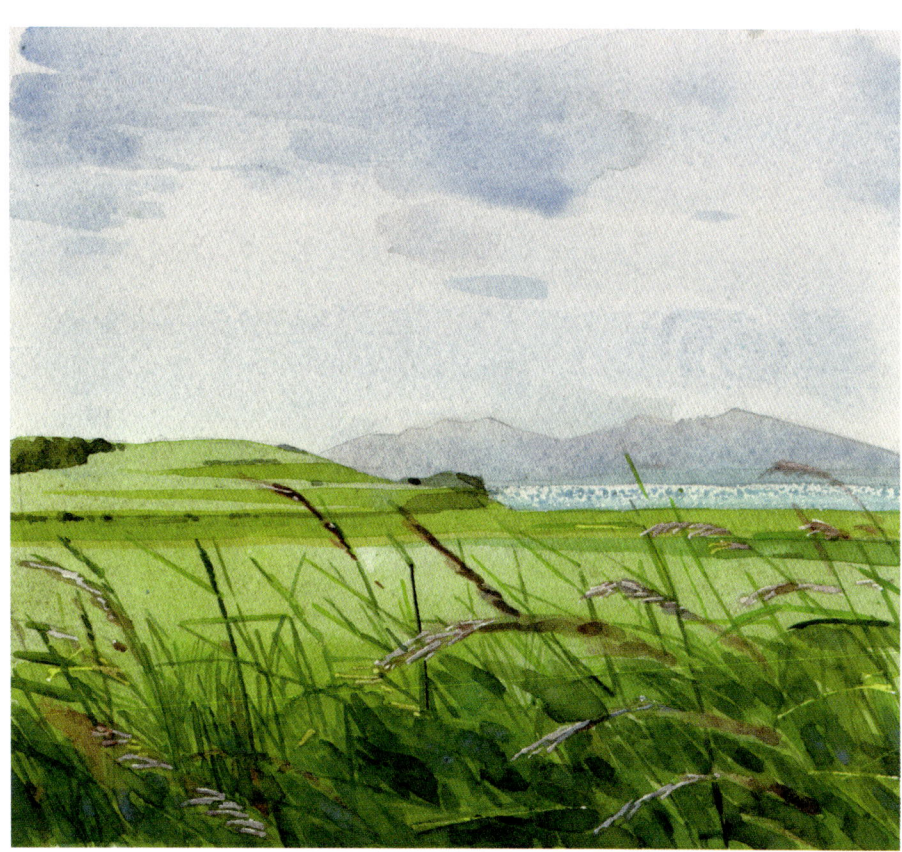

LANDSCAPES

18 | Poppies
Bright colors in landscapes

Materials

- Watercolor block, 14 x 10 in. (355 x 254 mm)
- 2B pencil
- Size 12 and 6 round brushes
- Water sprayer

Color palette

- Cerulean Blue
- Sap Green
- Cadmium Yellow
- Indigo
- Alizarin Crimson
- Payne's Gray

We'll be drawing on the experience of the earlier landscape paintings for this painting, using punchy colors and textural detail in the foreground and hazier, more muted ones in the background to create a sense of distance and provide the context in which the flowers grow. The complementary contrast of red and green gives the painting an added "pop."

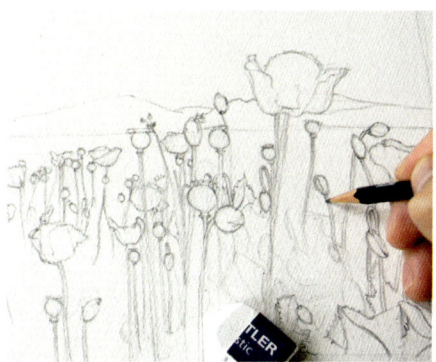

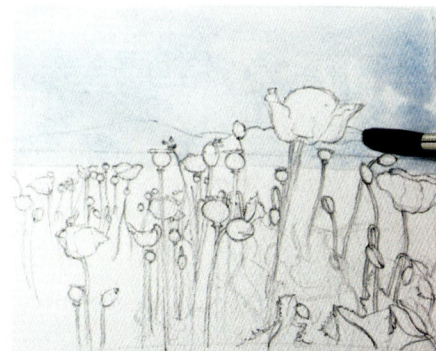

1 It can be daunting drawing a field of flowers, so roughly indicate the landscape with a few lines, and put most of your attention on the main flowers. Enjoy the way the stalks add a rhythm and pattern to your composition. Most of the leaves can be suggested so you don't have to draw them all—you could add insects and butterflies, too.

2 Use the larger brush to lay an initial wash of well-diluted Cerulean Blue over the sky and mountains in the background. Take care not to color the flowerheads.

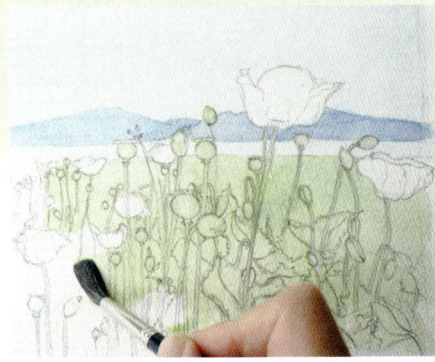 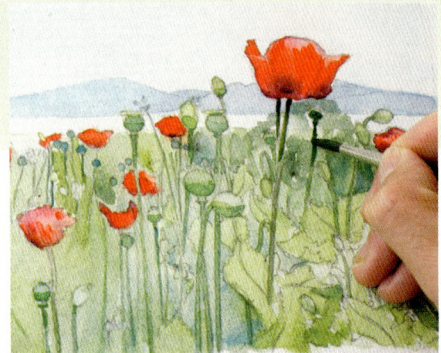 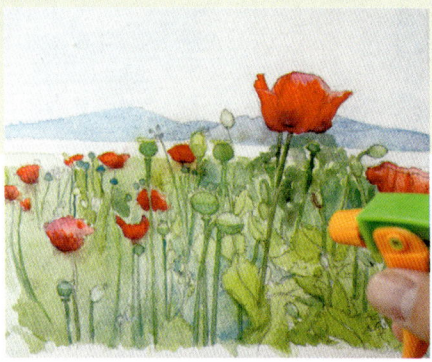

3 Paint the mountains in the background with a mixture of Cerulean Blue and a tiny amount of Alizarin Crimson. While the paint is still wet use the water sprayer to soften the edges.

Now paint most of the foreground with a wash of Sap Green with a touch of Cadmium Yellow, avoiding the main flowerheads.

4 Now enjoy adding the punchy red of the poppies using Cadmium Red. Mix Alizarin crimson with a touch of Indigo and, while the poppy paint is still wet, use the smaller brush to add this deeper red near the base of each flower—the color will bloom in a beautiful way. Start adding the stalks with Sap Green. Use Cerulean Blue and Perylene Green for the darker stalks.

5 While you are adding these colors, use a water sprayer so that the colors mix and flow into each other. There are no hard-and-fast rules with this technique—experiment and have fun with it!

19 | By the beach
Ideas for composition

Materials
- Watercolor block, 14 x 10 in. (355 x 254 mm)
- 2B pencil
- Size 12, 8, and 6 round brushes

Color palette
- Manganese Blue
- Yellow Ocher
- French Ultramarine Blue
- Payne's Gray
- Perylene Green
- Hooker's Green
- Lunar Black (optional)

Where you position the horizon in a landscape painting has a huge impact on the overall feel. Here, I've placed it about two-thirds of the way down, to focus attention on the sky and help convey the isolated setting of the cottage. The emptiness of the sky is balanced by the busier bottom third of the painting.

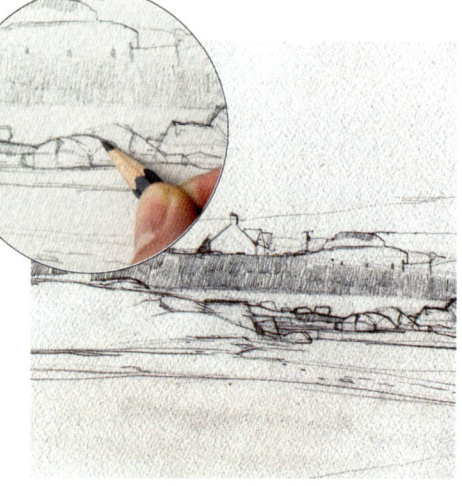

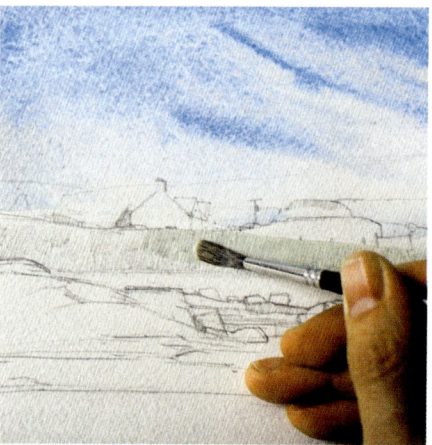

1 The only area you need to draw is the land featuring the house and the rocks. Enjoy working on the rocks, which are a haphazard collection of shapes. They will make a nice contrast to the bright sand later, when we get to painting them.

2 Brush clean water over the whole sky area using the larger brush, then apply a Manganese Blue wash over the wet paper. Use a stronger wash, with more pigment, at the top of the paper and work down toward the horizon line, adding more water as you go to thin the wash and lighten the color. To achieve the necessary brightness of the sky, I tend to do a couple of washes, waiting for each wash to dry before applying the next. While the wash is still wet, add a few small streaks of additional color diagonally across the sky near the horizon. These will look like small wispy clouds in the distance and introduce subtle diagonals and extra interest to your painting. Now use the medium brush to start painting the grass with a light wash of Yellow Ocher.

BY THE BEACH 71

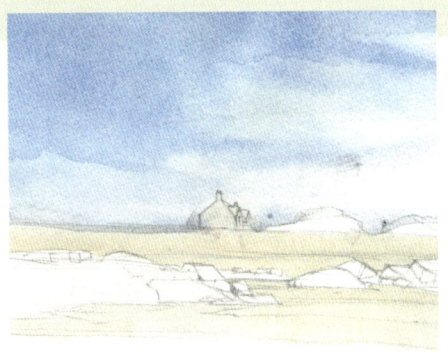

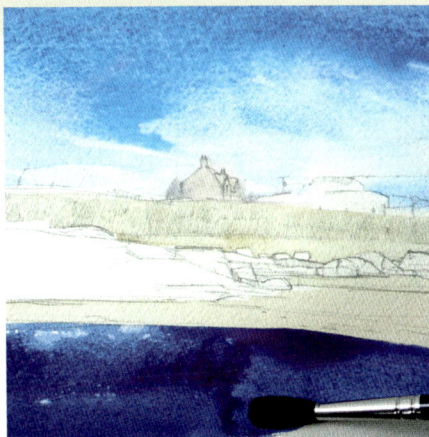

4 To paint the sea, sweep clean water over the whole area. Mix up a very strong vivid wash of French Ultramarine Blue. Add your blue to the wet area and watch the color spread—you can even use undiluted color to get a really rich effect. Take care not to be mechanical in your application of the paint. It's a big area so you can use expressive brushstrokes, and it's fine if they are visible.

3 Continue painting the sand and the side of the little cottage in the same Yellow Ocher wash you used in step 2.

5 Paint the rocks with an overall wash of Payne's Gray. Use this same color to paint the roof of the small cottage. Paint the trees with Perylene Green.

Now we'll be adding the texture of the grass. Make a mix of Hooker's Green and Yellow Ocher and start painting short strokes to get a nice repetitive rhythm, using the small brush. If you vary how much paint/water you use you'll get a good variation in depth of color. You're not aiming to do a row of neat identical lines, so change the direction of your strokes as you go—but more importantly use your own instinct as to what will look good.

Finally, paint in the shadowed parts of the rocks with a dark mix of Payne's Gray. Rather than seeing the rocks as individual shapes, try seeing them as a whole. Also add some small rocks on the sand. If you like, it's fun to use Lunar Black instead of Payne's Gray—it contains iron oxide, which causes the pigment to separate, creating a charcoal-like texture.

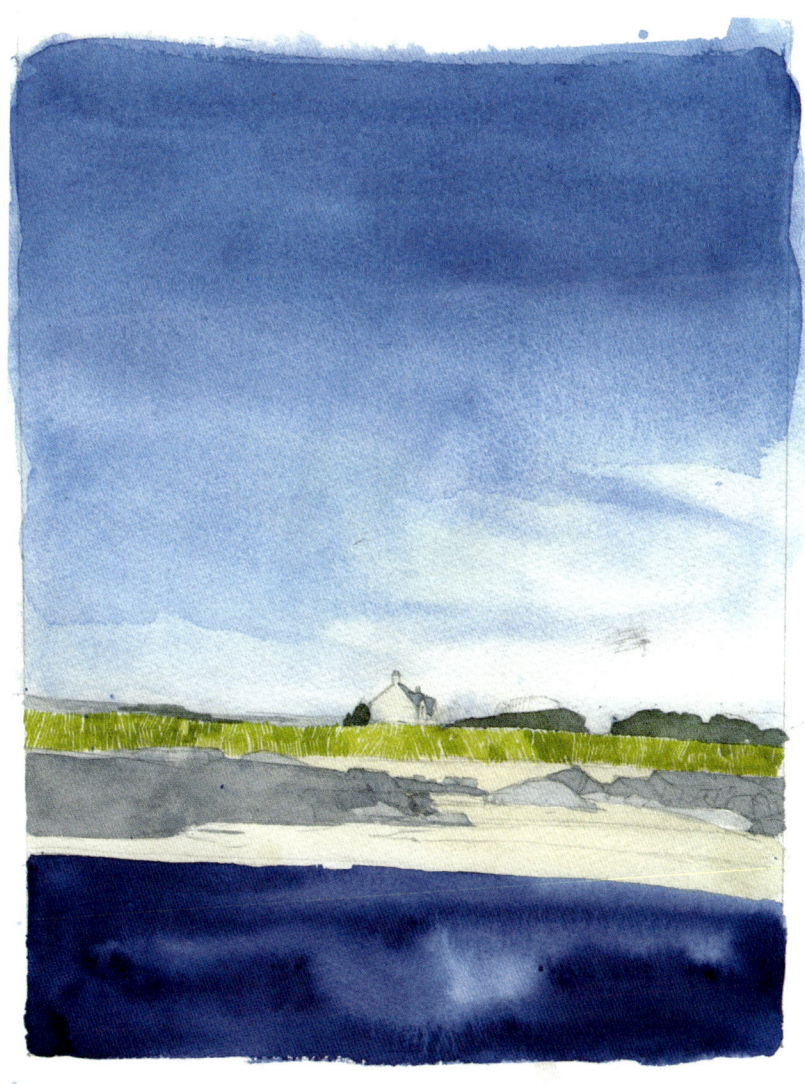

20 | Making moutains
Bold shapes

Materials

- Watercolor block, 14 x 10 in. (355 x 254 mm)
- 2B pencil
- Size 12, 8, and 6 round brushes

Color palette

- Cerulean Blue
- Alizarin Crimson
- French Ultramarine Blue
- Burnt Sienna
- Yellow Ocher

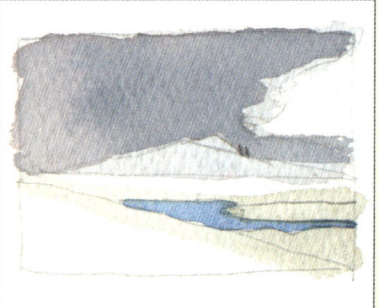

The small study shows how the painting will be split up composition wise. I've created a strong, blank diagonal shape that covers pretty much half the painting. The loch almost mirrors the mountains in its shape.

When painting a landscape, an artist may get caught up in ideas of creating a "pretty picture," and may believe that it's only figurative paintings that have a narrative. But by creating contrasts of drama and quietness in a landscape, you can add dynamism to your work.

This dynamic landscape features a stormy sky with a small, bright area and a deliberately blank area in the foreground, which implies the story that a storm is oncoming, or has recently passed.

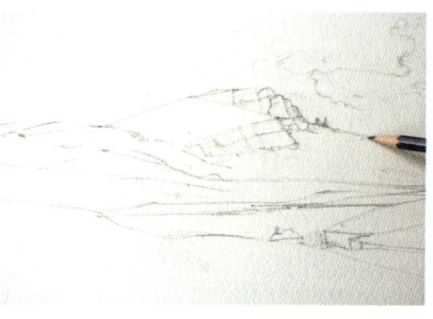

1 When you start drawing the landscape, keep your pencil marks quite loose. Try to simplify the mountains into a single, whole shape. Once you've done that, you can add small ridges and details.

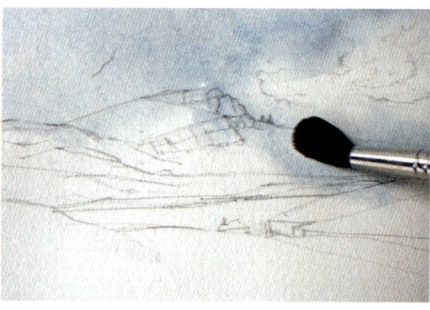

2 With the largest brush, paint clean water over the whole sky, except for the cloud area in the top right-hand corner. Mix up a light wash of Cerulean Blue with a touch of Alizarin Crimson and paint some of the clouds. I've used small, semicircular brushstrokes, gradually building up the shadow side of the cloud. Remember that this is a light part of the picture so be subtle and leave the brightest parts, where the sun is shining through, clear of paint. Using the same mixture, lay a wash over the rest of the sky, the darker clouds, and the mountains.

MAKING MOUNTAINS 73

3 Next, build up the dark clouds by adding more pigment, using the same mixture of Cerulean Blue and Alizarin Crimson. It's good to be a bit freer in how you use your brush here, since you are trying to convey stormy clouds.

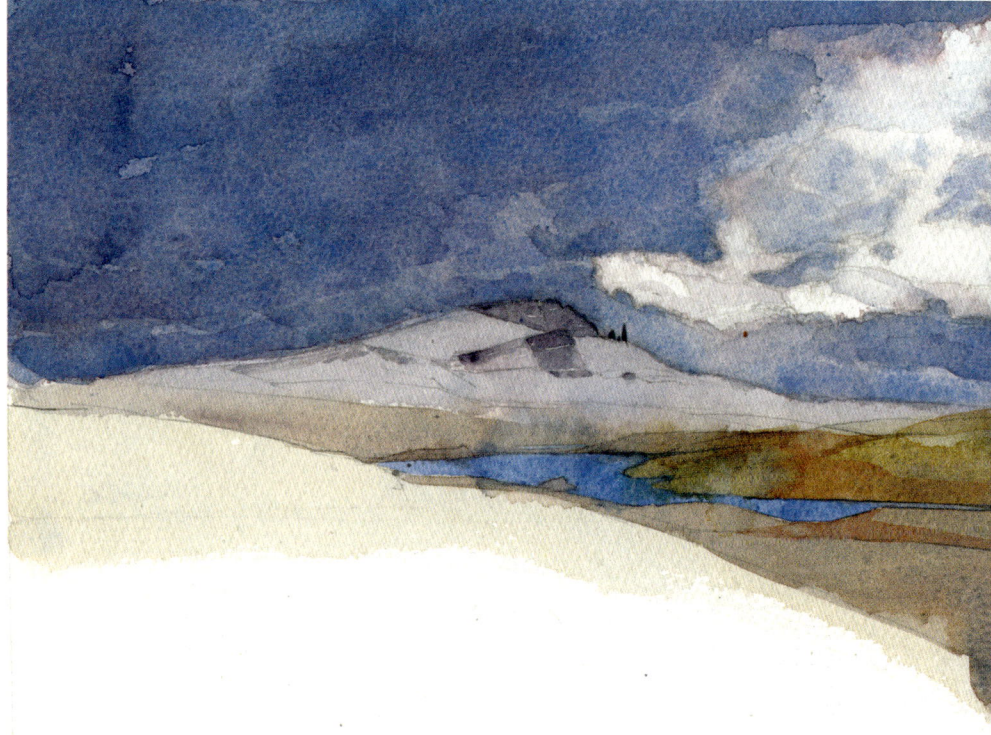

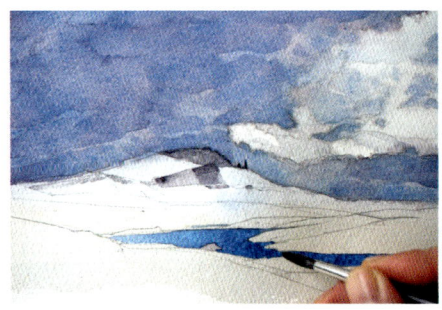

4 With a similar mixture but containing more Alizarin Crimson, so it's more purple, paint the exposed rock faces on the hills. Don't paint the single standing rock, the Old Man of Storr, too precisely. If you use a tiny brush and paint it too accurately, it could look as if it doesn't quite belong to the painting, and will stand out too much. Although it may feel daunting, I recommend using the medium brush to paint it as you'll just be using the tip. You can practice on a blank piece of paper first.

Painting the loch is very straightforward. Mix up a bright wash of French Ultramarine Blue and fill in the area with solid color. While the wash is still wet, add more paint to the area closer to you. This will add more depth to the scene.

5 Now it's time to paint the part of the landscape not covered by snow. Mix Burnt Sienna with a touch of Yellow Ocher and Cerulean Blue and paint the area with this mixture in a single wash. When the wash is almost dry, you can paint a few hills to add a bit more interest. It's absolutely fine if the colors slightly run into each other.

21 | Big blue boat
Finding interesting shapes

Materials

- Watercolor block, 14 x 10 in. (355 x 254 mm)
- 2B pencil
- Size 8 and 6 round brushes

Color palette

- Cerulean Blue
- Manganese Blue
- Burnt Sienna
- Yellow Ocher
- Payne's Gray
- Alizarin Crimson

This demonstration looks at landscape in a slightly different way by introducing an element that will take center stage in the composition. I've made this a study of a boat being repaired. I love the bright blue color and strong geometric shape, as they contrast with the subtle tones of the landscape.

Instead of a boat, you could look out for landscapes with outdoor sculptures, fountains, lighthouses, or street signs, all of which are interesting objects in their own right.

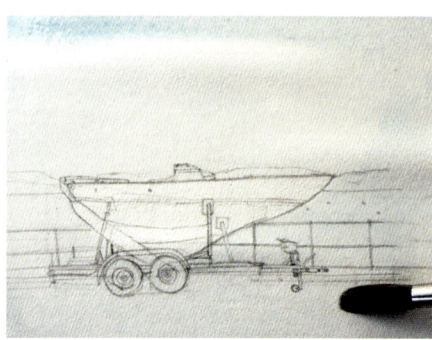

1 Start by drawing in the main outlines. The boat is a simple shape. If you focus on getting the shape of the hull right, you're halfway there. After that add the trailer, which is made up of the wheels and supporting struts—both are easy shapes. Keep the landscape behind the boat really simple; it needs only a couple of lines for the hills to work.

2 Use the larger brush to wet the whole paper, then add a wash of Cerulean Blue, starting from the top and making it more diluted as you work down the paper. Don't make it too blue, as it needs to contrast with the vivid color of the boat.

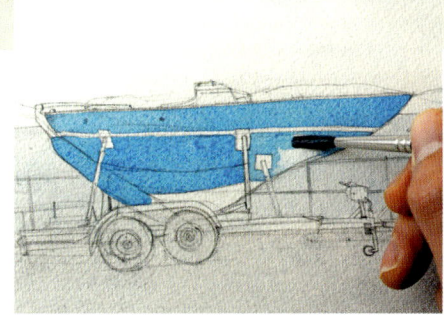 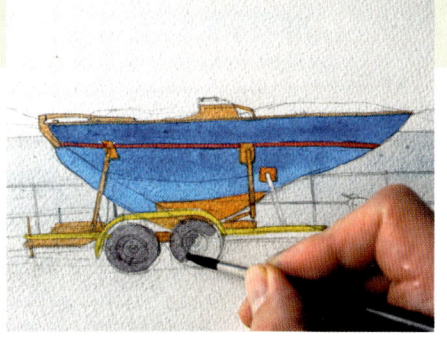 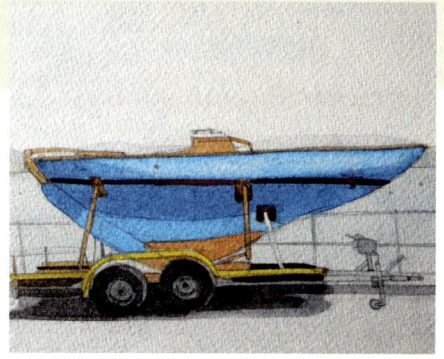

3 Next paint the blue of the boat. I used Manganese Blue, which is the brightest and most intense blue in my palette. If you don't have it, you can use Cerulean Blue instead; just make sure you use lots of pigment in your mixture. Leave to dry.

4 Use the smaller brush to paint in the remaining parts of the boat and the trailer. This is almost like coloring in. Use Burnt Sienna and Yellow Ocher for the trailer, and Payne's Gray for the wheels.

5 Use the larger brush to build up the landscape in the background. Use a very pale green wash of Cerulean Blue mixed with Yellow Ocher for the near hills, and a wash of Cerulean Blue with perhaps a touch of Alizarin Crimson for the more distant hills.

Use a wash of Payne's Gray for the shadows under and around the boat, and Payne's Gray with a touch of Cerulean for the railing.

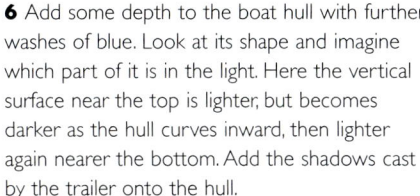

6 Add some depth to the boat hull with further washes of blue. Look at its shape and imagine which part of it is in the light. Here the vertical surface near the top is lighter, but becomes darker as the hull curves inward, then lighter again nearer the bottom. Add the shadows cast by the trailer onto the hull.

Finally, add small dots to indicate buoys in the sea behind the boat. These can be yellow, pink, or orange.

76 | LANDSCAPES

22 | Reeds
Pure texture and subtle washes

Materials

- Watercolor block, 14 x 10 in. (355 x 254 mm)
- 2B pencil
- Size 8 and 6 round brushes
- Water sprayer

Color palette

- Cerulean Blue
- Payne's Gray
- Quinacridone Magenta
- Cobalt Turquoise Light
- Yellow Ocher
- Burnt Sienna
- French Ultramarine Blue
- Perylene Green

So far we've been making the most of strong, dynamic compositions that show off the more random and unplanned aspects of watercolor. In this demonstration we will also use pattern and texture—in this case, the reeds—as more of a feature.

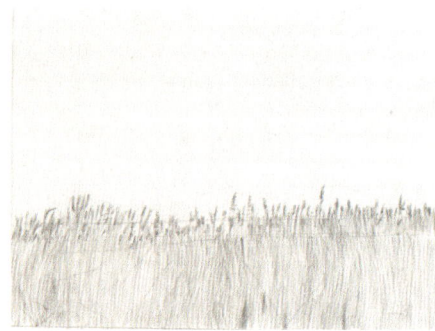

1 This study shows a composition that will be very familiar to you by now. The sky is more subtle than in other projects. Here it's a story of simple bands of color that you can experiment with. My favorite aspect of this picture is the turquoise sea in the background and how it works with the light ocher tones in the foreground.

2 There isn't much drawing to do here, apart from determining where your horizon will sit and adding a section for the sea in the background. The reeds are easy to draw, but it's worth noting that reeds don't just run vertically up and down: if you look at them in real life, you'll see that they sag in the middle and lean in different directions, with the odd one breaking the pattern and crossing others. Don't just copy them one by one, but try to notice a rhythm and a pattern and draw that. Your interpretation of a scene will make your painting sing.

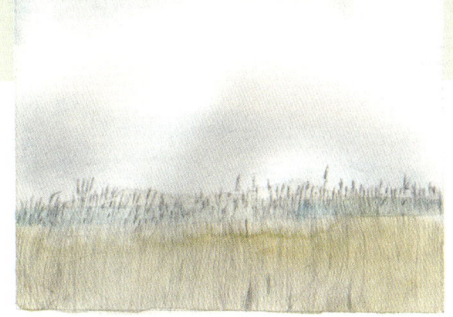 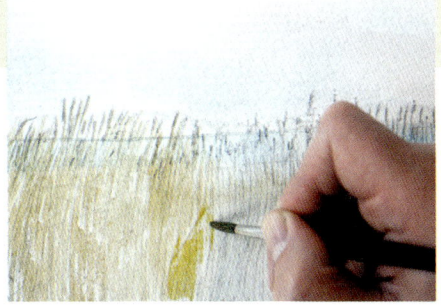 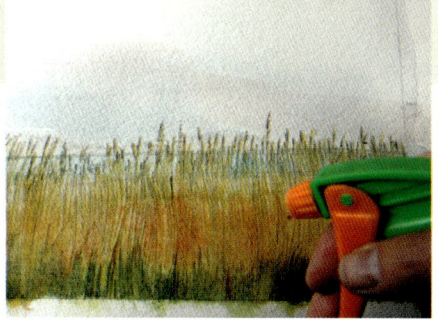

3 Use the large brush to start painting subtle washes. Don't wait for each wash to dry before adding the next—the colors will look great if they slightly run into each other. For the sky, use a very diluted mix of Cerulean Blue, Payne's Gray, and Quinacridone Magenta. If it's too light, apply the wash again. For the sea use a very diluted wash of Cobalt Turquoise Light—this is a strong color, so take care that it doesn't overpower the painting. Paint the reeds with a wash of Yellow Ocher. Leave to dry.

4 Add a small stripe with French Ultramarine Blue above the turquoise band. Mix up some Yellow Ocher with a touch of Burnt Sienna and paint over the stalks of the reeds. Enjoy the rhythm of repeating similar marks again and again. Don't try to go over the lines painstakingly—just relax, vary your lines, and aim for something quite approximate. Treat the reed heads in a similar way, but using a darker mix and small marks. Trust your judgment as to what will look right. Leave to dry.

5 Add a wash over the middle section of the reeds with Burnt Sienna. Wash over the bottom of the reeds with Perylene Green. You can use a water sprayer to help the colors mix into each other. A sprayer is useful for breaking up colors, but use it judiciously, since a small spray of water can go a long way.

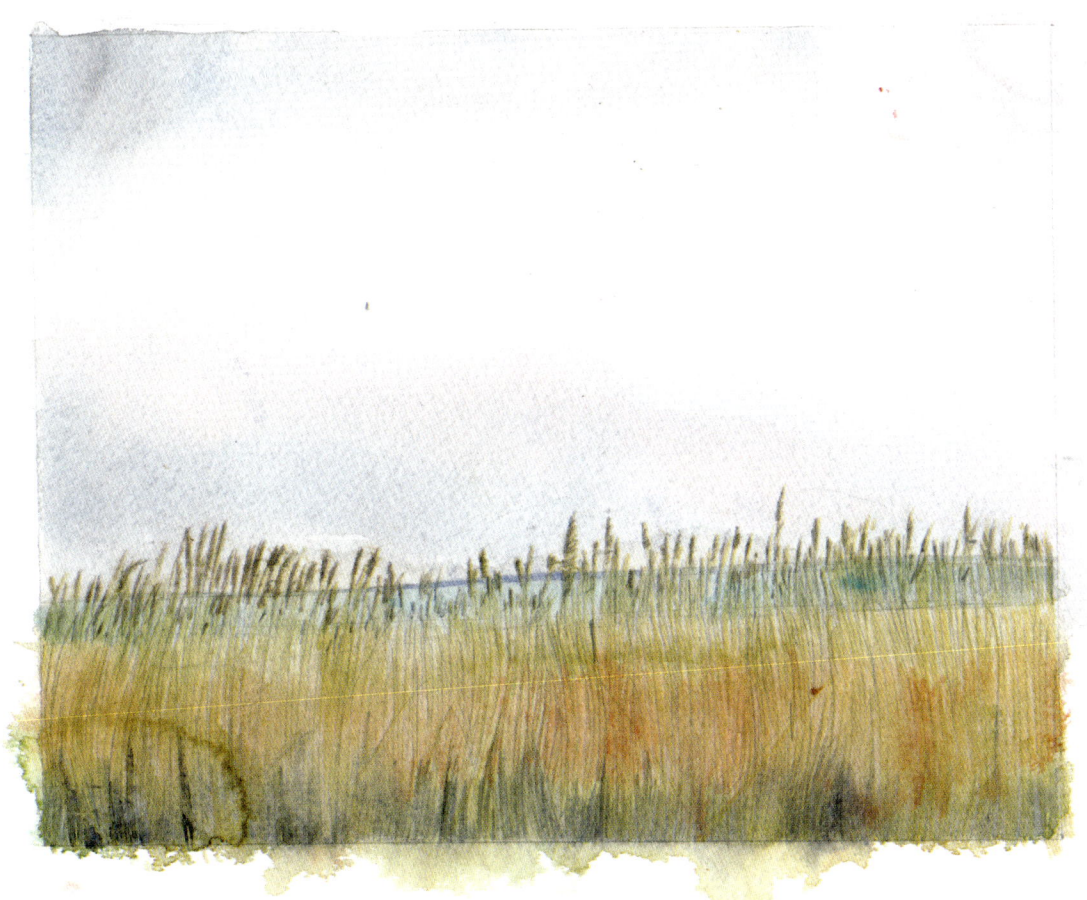

23 | Trees
Working with one color

Materials

- Watercolor block, 14 x 10 in. (355 x 254 mm)
- 2B pencil
- Size 12, 8, and 6 round brushes
- Hair-dryer

Color palette

- Lunar Black

Creating an interesting watercolor painting using just one color is a challenging exercise, but also a fun one. You can take advantage of the limitations of working tonally to create a powerful painting that has its own unique atmosphere.

We will be using Lunar Black, a watercolor that contains iron oxide, which separates as it dries, creating an effect that lies somewhere between watercolor and charcoal.

The study shows the simplicity of the composition, with the tree creating a diagonal with plenty of space to the right for loose cloud effects.

1 Using a 2B pencil, start by loosely defining the trunk, then focus on just the main branches. Think of them as intertwining limbs, with the larger ones defined by shape and the smaller ones by volume—if you think of the smaller branches more like a mass, they become easier to draw. The mountain in the background is a simple line, and the grass in the foreground indicated by loose shading.

2 Using the largest brush, apply water over the whole drawing, then add a light wash of Lunar Black across the whole surface. Let dry. With the medium brush, paint another wash over the sky, with more emphasis on the stormy part. Now add another wash of Lunar Black over the mountains and grass.

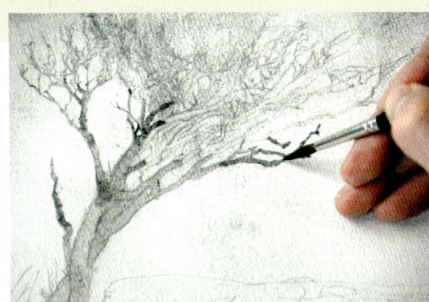 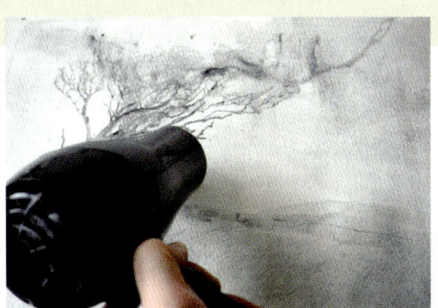 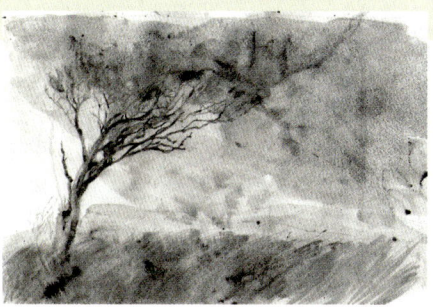

3 Now start painting the tree. I like to begin by filling in the branches, using quite a lot of water and pigment, and the small brush. Alternatively, add lots of water and then add pure paint for a varied effect. Enjoy this stage, adding variety to the branches and creating an intricate pattern with the way they intermingle.

4 Now for some magic. When you've painted quite a lot of the branches and some are still wet, use a hair-dryer to blow the wet paint about and create slightly random branches.

Continue to add more volume to the cloud area, painting with the largest brush. The effect is meant to look quite messy, and the way the Lunar Black separates will accentuate this.

5 Once you're happy with the clouds and tree, it's time to work on the grass. Using the medium brush, make repetitive brushstrokes to hint at separate grass blades. You can be as messy as you like, and change the direction of your strokes to create variety. As a final touch, add crows being blown about in the wind. These are just small marks and aren't meant to be too accurate.

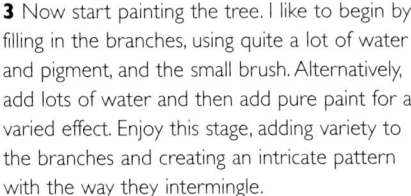

80 | LANDSCAPES

24 | Meadow
Reserving colors

Materials

- Watercolor block, 14 x 10 in. (355 x 254 mm)
- 2B pencil
- Size 14 round brush
- Masking fluid
- Water sprayer

This view was inspired by the paintings of Impressionists such as Monet, and the way they painted large fields of flowers. Look out for similar wildflower meadows in parks, gardens, or fields. This is a much looser style of painting, using wet-on-wet techniques and masking fluid for the buttercups. You can use masking fluid from a bottle, applied with a brush, but one of the handy masking fluid pens will make the job much easier.

Color palette

- Cadmium Yellow
- Sap Green
- Alizarin Crimson
- Cerulean Blue
- Perylene Green

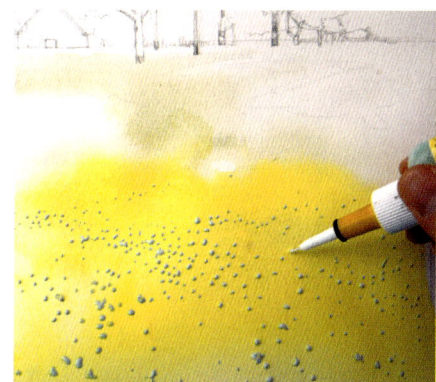

1 Start with a light pencil outline. This should be really minimal, as you only need to suggest the tree trunks and the house.

2 Apply initial washes of Cadmium Yellow. This will be the color of the flowers when the masking fluid is removed. Because you'll later be painting green over this yellow, you'll get even brighter green grass—an added bonus!

Once the washes are dry, add dots of masking fluid for the flowers, with large dots in the foreground and smaller ones farther back to help create an impression of distance. Apply these as randomly as you can—if your unconscious tendency is to work neatly and in lines, fight this! Leave to dry thoroughly.

MEADOW 81

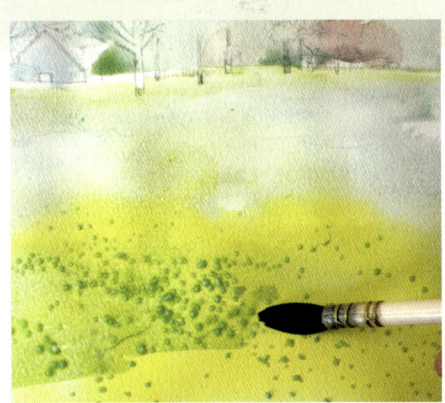

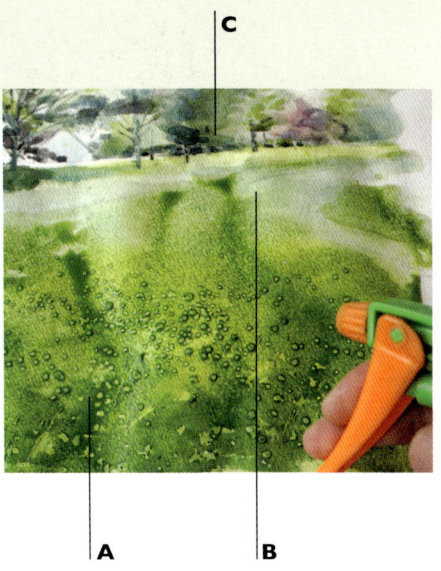

3 Apply Sap Green washes over the yellow. Also start to paint the foliage and the house in the background. I used a little heavily diluted Alizarin Crimson and Cerulean Blue for a bit of variety. It's great if the colors run into each other, since this isn't a precise painting.

4 Build up the tones. Add Perylene Green washes to the trees and darken some of the shadows that the trees cast—Cerulean Blue works really well for this. Add more green washes to the meadow.

What I've done here is to think of the trees in the background as one layer and the meadow in the foreground as the other. If you think of (A) darker foreground and (B) lighter mid-ground, with (C) the trees in the distance, you will be OK and the painting won't lose its readability. But don't be tempted to make the foreground too dark by adding black, as this can kill a painting.

Use a water sprayer to keep the foreground colors wet and help them mix into each other.

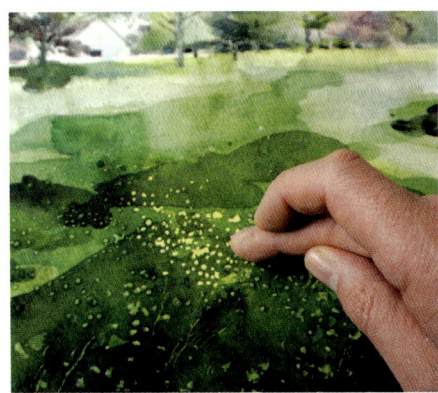

5 When all the washes are thoroughly dry, carefully rub off the masking fluid—if some of the paint is still slightly wet, you risk tearing the paper. The little dots you reserved with the fluid will have masked all the colors except the original yellow wash, and will now appear as the yellow buttercups sprinkled across the meadow.

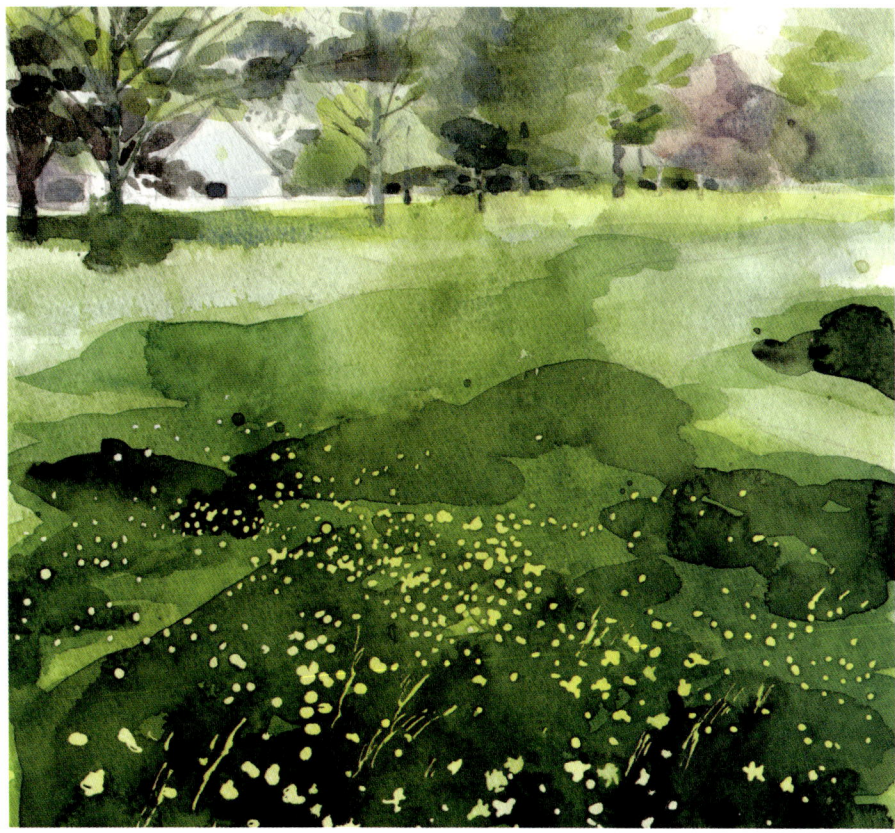

LANDSCAPES

25 | Figures in snow
Telling stories

Materials

- Watercolor block, 14 x 10 in. (355 x 254 mm)
- 2B pencil
- Masking fluid
- Size 6 round brush
- Small artist's sponge or paper towel

Color palette

- Indigo
- Yellow Ocher
- Cadmium Red
- Alizarin Crimson
- Cerulean Blue
- Payne's Gray

Telling stories with paintings can be done really simply. Only a few elements are needed to suggest a mood or a narrative, and the viewer can be left to imagine the rest—in this case, the coldness of the air and the fun of walking along in crisp, fresh snow.

When you're out and about, look for possible settings and observe how people's gestures and movements could make for interesting paintings. Experiment with your composition to tell your story. Here, placing the couple in the top right with an expanse of snow in front of them suggests that they're entering the picture—place them bottom left and they would look as if they are leaving.

1 Draw the composition with your 2B pencil. The lines should be light and you can keep the drawing quite loose.

2 Now it's time to mask out the places where there will be white, pristine snow. Think how the snow might settle on surfaces—for example, it might build up in those parts of the umbrella that are facing the direction of the falling snow, or on the shoulders of the whippet. Remember to add little dots of masking fluid for the flakes of snow falling past the walking figures.

FIGURES IN SNOW 83

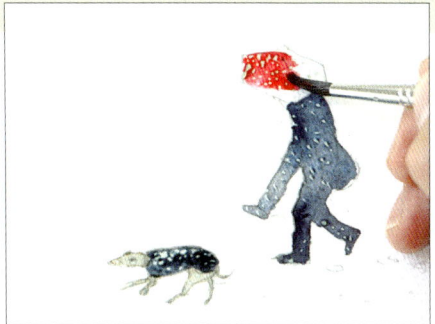

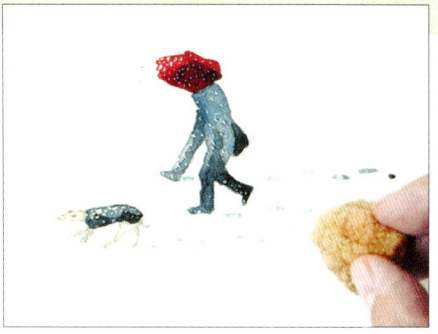

3 Paint the two figures with a wash of Indigo. Even though this is such a simple shape, I used quite a lot of pigment and water here because I want the color to dry in an uneven manner—remember this is watercolor work, you're not coloring in! Let dry.

For the darker parts—the pants, the shoulder bag, and so on—apply some extra washes to darken the color. Paint the whippet's coat with the same Indigo wash.

4 When the previous washes are dry, paint the whippet's body with a wash of Yellow Ocher.

In the real scene I think the umbrella was black, but you can make things up if you think it will make a better painting. Here, I enjoyed using a vivid Cadmium Red for the umbrella.

For the darker sections of the umbrella, use a mix of Cadmium Red and Alizarin Crimson.

5 For the footprints in the snow, use a wash mix of Cerulean Blue and Payne's Gray—a generous mix of pigment and water. While it is still wet, dab most of the color away with a sponge or paper towel, leaving a nice, subtle texture.

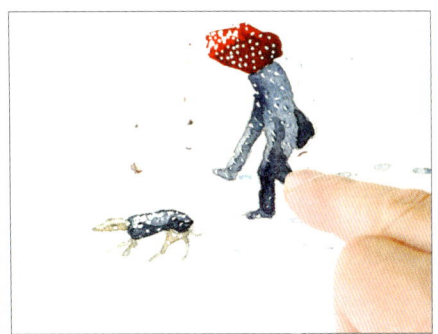

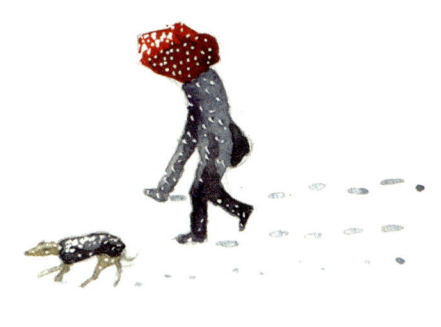

6 Finally, when all the paint is dry, gently rub off the masking fluid to reveal the little flakes of falling snow.

84 LANDSCAPES

26 | Birch trees
Abstract patterns

Materials

- Watercolor block, 14 x 10 in. (355 x 254 mm)
- 2B pencil
- Size 8 and 6 round brushes

Color palette

- Davy's Gray
- Moon Glow
- Perylene Green
- Yellow Ocher
- Cerulean Blue
- Burnt Umber
- Alizarin Crimson
- Payne's Gray

By carefully selecting what you paint and focusing on both natural and manmade patterns and rhythms, you can make some interesting images. This deceptively simple composition features silver birch trees in front of a building. The vertical lines of the tree trunks are broken up by the horizontal lines of the manmade structures behind.

Note how some of the colors used here granulate—for example, Moon Glow. This granulation adds a pleasing, natural-looking texture to what is otherwise a fairly geometric composition.

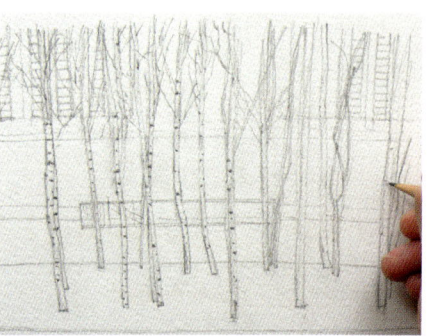

1 Make a fairly detailed drawing of the composition. The small marks on the trees and the more random branches add interest to the painting, so it's not all verticals and horizontals.

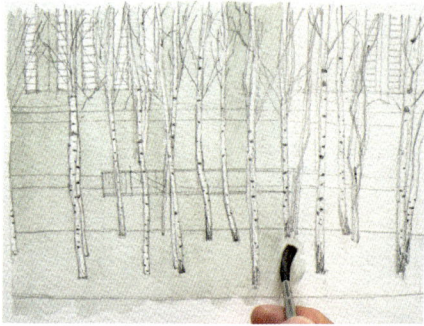

2 Use the larger brush to take a wash of Davy's Gray across the paper, leaving the tree trunks unpainted. Let dry.

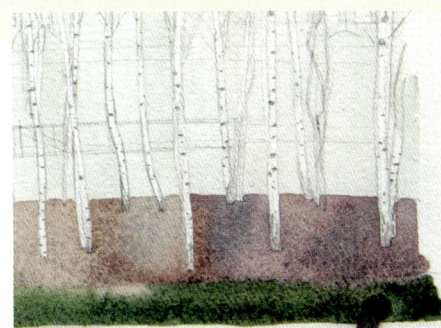 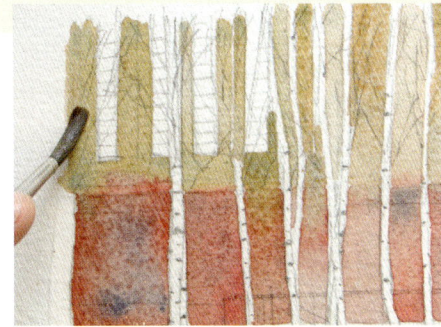

3 Apply a wash of Moon Glow for the earth at the base of the trees, again leaving the trunks unpainted. In reality, the color is browner but I wanted to exaggerate the red-purple tint and increase the complementary contrast with the green of the grass in the foreground—paint this with a wash of Perylene Green.

Apply these two washes at the same time, allowing the colors to run into each other.

4 Now mix a diluted wash of Yellow Ocher, Cerulean Blue, and Burnt Umber and paint this in a band across the top of the paper. Take the color between the tree trunks and windows, which you should leave unpainted.

While the previous wash is still wet, apply another band just below it—this time a wash of Moon Glow with a touch of Alizarin Crimson. Again, let the colors run into each other.

5 Finally paint a band of Payne's Gray across the middle of the painting, between the earth and the base of the building in the background.

Use diluted Cerulean Blue and the small brush for the window panes in the background, with little dabs of denser blue to suggest the window bars. Leave most of the trunks unpainted, but add a wash of Yellow Ocher to some for variety.

Chapter 4
Cityscapes

27 | Your house
Simplifying what you see

Materials

- Watercolor block, 14 x 10 in. (355 x 254 mm)
- 2B pencil
- Size 20, 12, and 6 round brushes

Color palette

- Yellow Ocher
- Lunar Black
- Burnt Umber
- Payne's Gray
- Cerulean Blue
- Alizarin Crimson

Looking at a building straight on, so that you only see the facade, removes most of the perspective, making it easier to draw. To practice painting buildings, I recommend drawing your own house, or a house in your neighborhood. Don't try to include every single brick or tile in your initial drawing—a general impression of the pattern, showing how the rows of bricks are staggered and how the tiles overlap, is more than sufficient.

1 Use a 2B pencil to draw the basic outlines of the house. Keep your lines freehand rather than using a ruler—a bit of wobbliness is okay.

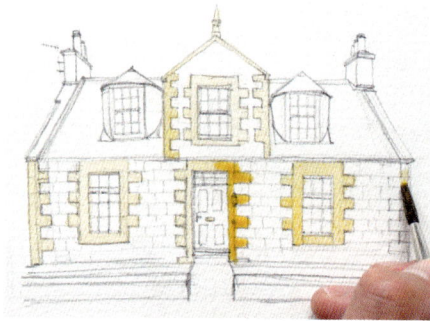

2 Use Yellow Ocher and the smallest brush to paint the areas around the windows and door. Remember, you're not just "filling in"—try varying the amount of paint and water you use to create interesting effects.

YOUR HOUSE 89

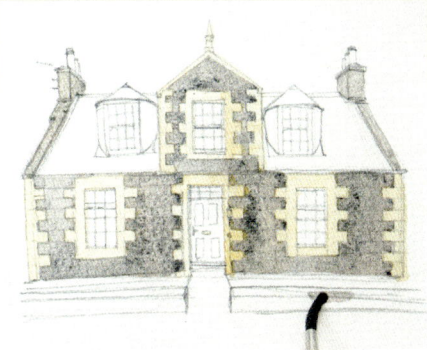 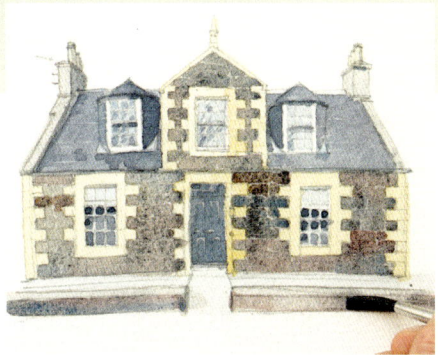 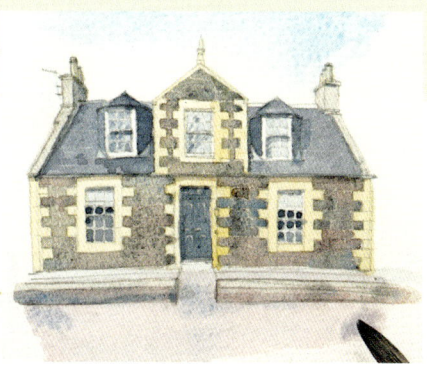

3 Paint the brickwork using Lunar Black diluted with Burnt Umber. The paint will granulate, creating a stone-like effect. Paint the pavement using Payne's Gray and Cerulean Blue.

4 Paint the roof using Payne's Gray with a touch of Cerulean Blue. Paint the bricks using a mix of Payne's Gray with Cerulean Blue, and another mix of Payne's Gray with a touch of Alizarin Crimson. Paint each brick, leaving a gap between them. Alternate between the two colors, allowing them to mix into each other. Add shadows to the windows and tiles using Payne's Gray.

5 Use the medium brush to add the sky with a simple wash of Cerulean Blue. The pavement is a mix of Cerulean Blue and Alizarin Crimson, which granulates nicely, adding interest. Use the largest brush to apply the color, and let the paint run out, leaving an interesting texture.

28 | A city building
Exploiting granulation

Materials

- Watercolor block, 14 x 10 in. (355 x 254 mm)
- 2B pencil
- Size 10 and 4 round brushes

Color palette

- Yellow Ocher
- Cerulean Blue
- Alizarin Crimson

Watercolor behaves in various quirky ways that are unique to this particular medium. One of these is the natural tendency of certain colors—like the Cerulean Blue used here—to granulate (see page 28). In this painting, I have deliberately used granulating color to show how effectively it can suggest the textured surface of this sandstone brick wall.

I also show you how to convey shadow—not as a solid block of dark color, but rather as a translucent overlay of a rich but muted shade.

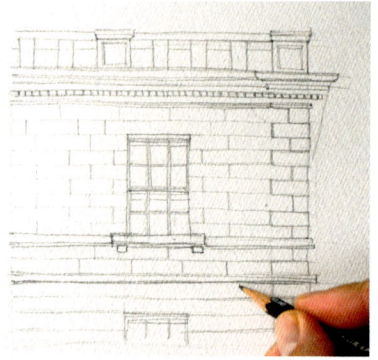

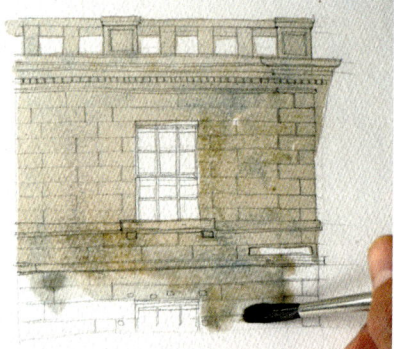

1 To act as a guide for your painting, start with a light outline of the building and the bricks, using your 2B pencil. You don't need to copy each individual brick slavishly. Instead, see the brickwork as a geometric pattern of alternating rectangles. Where there are key features—for example, the corner bricks, the window sill, and the decorative details along the parapet—you could make your lines a bit darker to give added definition and depth.

2 Now add the first wash of color, using a mix of Yellow Ocher and Cerulean Blue and the largest brush. Let the paint go over most of the area and see how it granulates. Spread this wash all over the brickwork area, but leave the windows, the spaces in the rooftop balustrade, and the street sign, unpainted. Take advantage of the way the pigment naturally granulates to suggest the texture of the bricks. To add variety, you can drop in some patches of additional color while the wash is still wet.

A CITY BUILDING 91

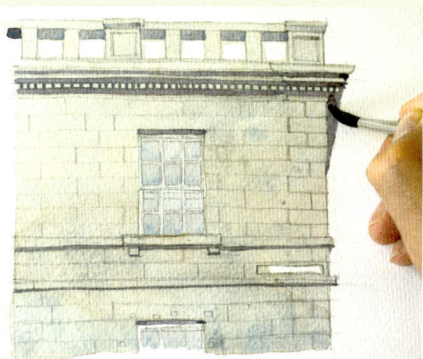

3 Paint the window panes with a pale wash of Cerulean Blue. Then, when the previous washes are dry, add the shadows. It's tempting to use black for shadows, but this will create too solid an effect. Shadows aren't solid but translucent, so using a muted, darker version of the base color will look more convincing. For the shadows here, mix a wash of Cerulean Blue and Alizarin Crimson and apply it with the smaller brush.

4 Continue building up the colors of the brickwork. Mix three new washes using different combinations of your basic colors. Apply a different wash to individual bricks to deepen the tones and to create a patchwork of subtle color variations. Because the pencil outline is quite accurate, it means the painting can be relatively loose. Don't try to paint each brick precisely or to control the spread of the paint too tightly. Instead, exploit any accidental effects, such as granulation or backruns, and allow them to become part of the character of your painting.

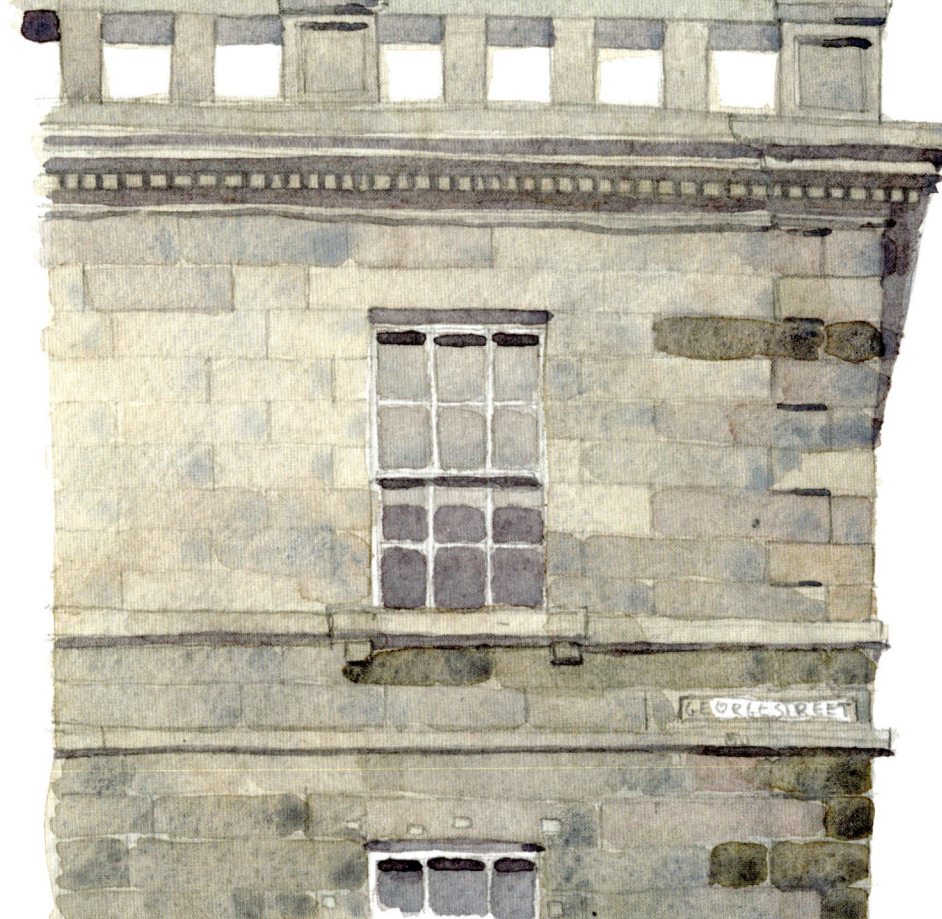

5 Continue deepening the tones and adding depth and definition—but take care not to overwork your painting or it could lose that loose, spontaneous quality that is so much part of the appeal of watercolor. Draw the street sign using a pencil.

29 | Store front
Sparkling sunlight

Materials

- Watercolor block, 14 x 10 in. (355 x 254 mm)
- 2B pencil
- Size 8 and 6 round brushes

Color palette

- Payne's Gray
- Alizarin Crimson
- Sap Green
- Lemon Yellow
- Perylene Green
- Burnt Umber
- Cerulean Blue

When you're walking around a city or town, keep a lookout for interesting scenes that could make a good painting. Even if you don't have the time, or the conditions aren't right, make a mental note and come back when you're in the mood or the weather improves. This doorway of a vintage clothing store always struck me as a good subject, with its bright green walls, ramshackle wooden boards, and charming awning, but I needed a bright sunny day to make the colors zing. So, as well as painting the scene, we'll be looking at how to show sunlight.

1 Lightly sketch the scene. When drawing the wooden boards, it's tempting to make them too precise and accurate, but some wobbly lines will add to the charm.

2 Use a mixture of Payne's Gray and Alizarin Crimson, and the larger brush, to add a wash to the cobbled pavement—paint fairly loosely and don't worry too much about painting within the lines. Use this color and brush to paint the blackboard, the top part of the tailor's dummy, and to add a light wash to the windows.

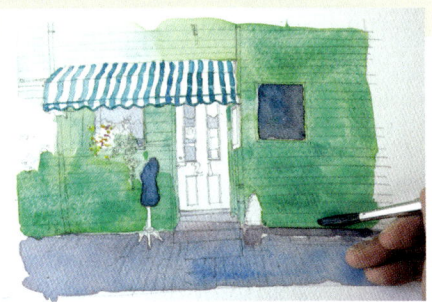 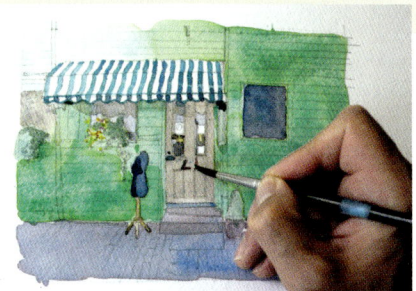 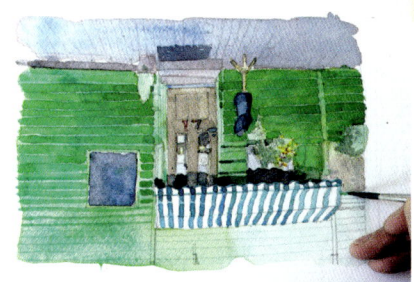

3 Consider the light source. The sunlight is coming in from the left, so that will be the brightest part of the painting. Mix a wash of Sap Green with a touch of Lemon Yellow, and paint a very diluted version of it in the top left corner, gradually adding more color as you work down the page. Mix a darker green by adding a touch of Perylene Green to Sap Green and paint the stripes of the awning, with each stripe getting darker as you move to the right.

4 Use the smaller brush to paint the door with a wash of Burnt Umber. Add depth by painting the cast shadows of the striped awning (using the Sap Green and Lemon Yellow mix with a touch of Cerulean Blue) and the steps (using the Sap Green and Lemon Yellow mix with Alizarin Crimson).

5 Create a richer version of the Sap Green and Lemon Yellow mix to paint the wooden boards. To make this easier, I turned the painting upside down. Paint each board with a small gap in between each one—as you get closer to the light source, the lines get finer and finer.

Leave to dry, then add cast shadows to the drainage tubes with a darker green (mixing Sap Green and Perylene Green). Finally, add any details, such as the flowers and sign.

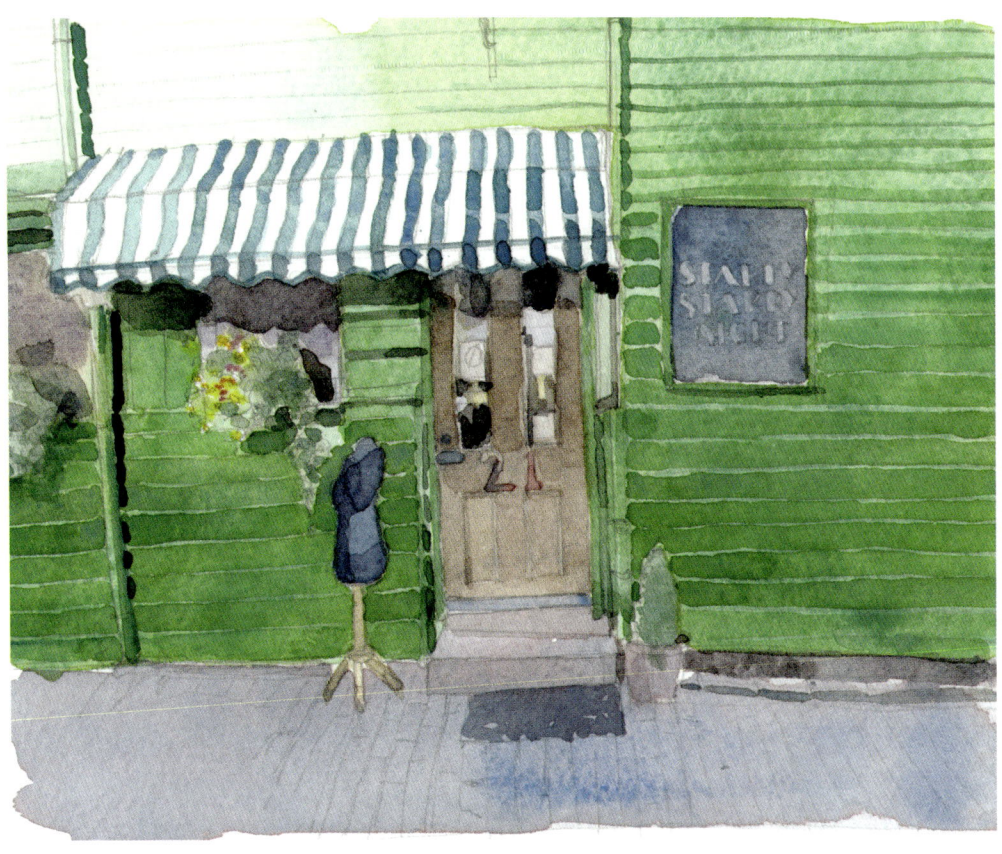

94 CITYSCAPES

30 | Period building
Symmetry and proportion

Materials

- Watercolor block, 14 x 10 in. (355 x 254 mm)
- H pencil
- 2B pencil
- Size 20 and 6 round brushes

Color palette

- Lunar Black
- Payne's Gray
- Buff Titanium (if you don't have this, use diluted Yellow Ocher with a touch of White)
- Burnt Sienna
- Alizarin Crimson
- Yellow Ocher
- Cerulean Blue

With some subjects, such as landscapes and flowers, you can get away with certain elements being a bit too big or too small, or not being in exactly the right place. When you're drawing and painting buildings, however, it's crucial to get the proportions right and assess where the various features—doors, windows, and archways—sit in relation to each other.

1 Use an H pencil to draw the initial guidelines—the placement of the floors, columns, and windows. Then use a 2B pencil to add the architectural details. Starting with an H pencil is a more forgiving method for roughly laying out an architectural drawing like this. If you draw lightly, you can leave guidelines that can be easily rubbed out. Moving on with a 2B pencil, you can concentrate on making expressive lines with the faint underdrawing below as a guide.

2 Add a light wash of Lunar Black or Payne's Gray to the brickwork using the larger brush. Leave to dry.

PERIOD BUILDING 95

5 Now focus on details. You can define areas like the bench, reflections in the windows, and adding a figure.

6 Add the sky and pavement: The sky is a mix of very diluted washes of Yellow Ocher, Cerulean Blue, and Alizarin Crimson; the pavement is a mix of Cerulean Blue and Alizarin Crimson.

3 Start adding washes of colour to the whole of the building. Use the smaller brush and Buff Titanium (or very light Yellow Ocher with a touch of White) for the moldings around the windows and Burnt Sienna for the brickwork.

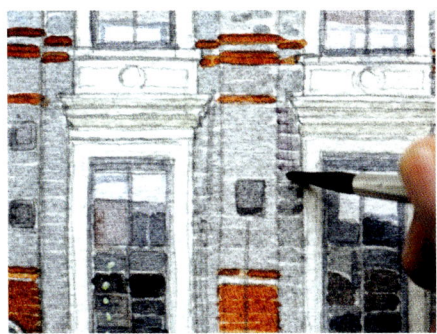

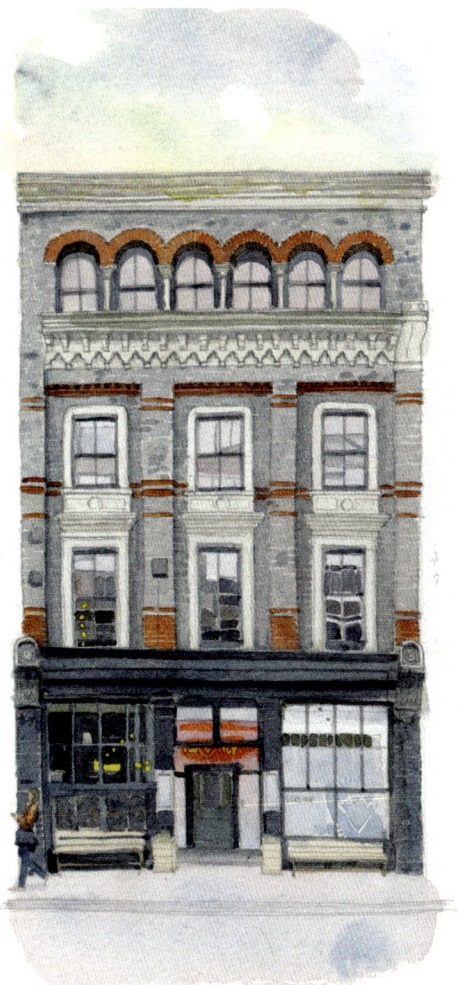

4 To add depth and texture, use a diluted mix of Payne's Gray and Alizarin Crimson and the smaller brush to paint the bricks using a dashed line – strokes can be quite loose. Once dry, go back over some areas to make them darker.

96 CITYSCAPES

31 | Street scene
Painting multiple buildings

Materials

- Watercolor block, 14 x 10 in. (355 x 254 mm)
- H pencil
- 2B pencil
- Size 20 and 6 round brushes

Color palette

- Yellow Ocher
- Cerulean Blue
- Alizarin Crimson
- Cobalt Turquoise Light
- Payne's Gray
- Burnt Umber

Painting a street reveals the character of a town or a city and the difference in buildings can show how architecture has changed over the ages. Removing the perspective makes it a little easier to draw and adds a storybook feel to your painting. This sequence focusses on the turreted building.

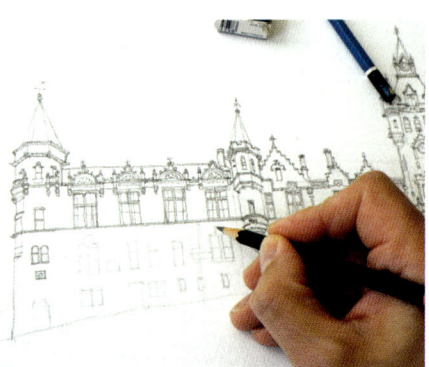 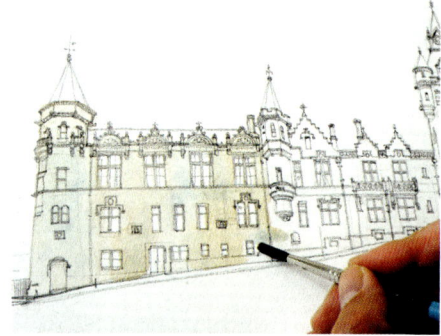

1 Use an H pencil to get the initial placement of the buildings, then add the details with a 2B pencil. This can take time, so don't rush it.

2 Paint the brickwork with a light wash of Yellow Ocher and Cerulean Blue using the smaller brush. This area is painted quite loosely with lots of water and paint. This allows the colors to dry in an unusual and interesting manner similar to the original texture of the building made out of light sandstone on page 90.

STREET SCENE 97

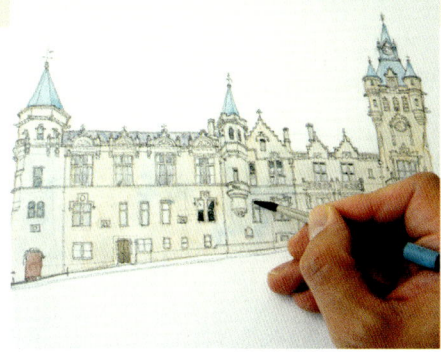 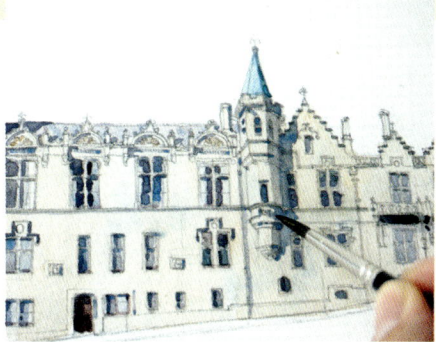 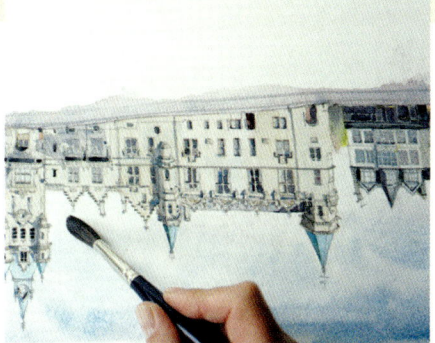

3 Paint the roof and windows with the smaller brush. The gray roof is a mixture of Cerulean Blue and Alizarin Crimson; the bright green, copper roof is Cobalt Turquoise Light; and the windows are Payne's Gray. The doors are painted with Alizarin Crimson, I added some Burnt Umber to the wash to tone this color down.

4 Add depth and detail with the smaller brush. Work out which parts of the building are in shadow and paint these in a darker version of the original colors. Use Yellow Ocher and Cerulean Blue with a little Burnt Umber and Payne's Gray for the brickwork and a deeper version of the Cobalt Turquoise Light for the green roofs. Paint cast shadows with a dark mix of Cerulean Blue and Alizarin Crimson.

5 Add the pavement with the larger brush and a mix of Alizarin Crimson and Cerulean Blue. Paint the sky with a light version of Cerulean Blue—I turned the painting upside down so that my hand didn't mess up the building.

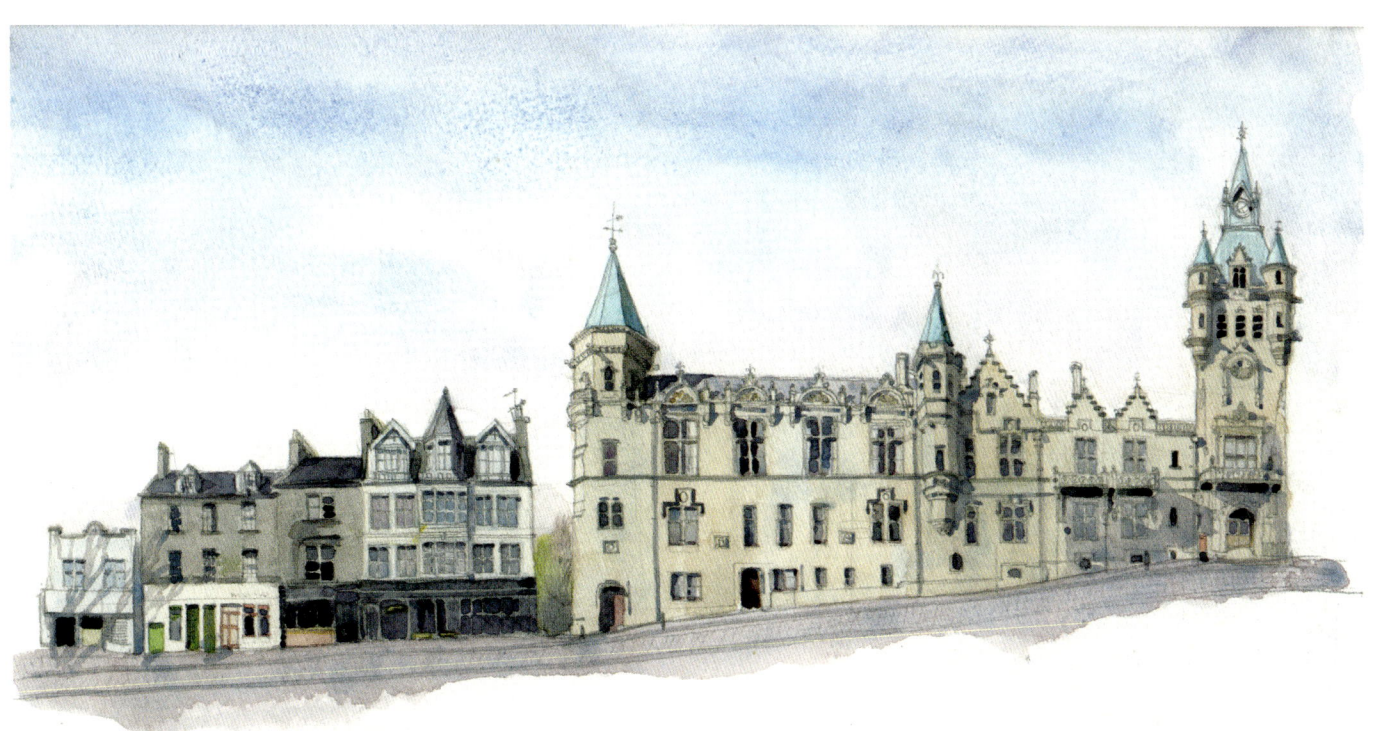

32 | Cluster of buildings
Perspective for beginners

Materials

- Watercolor block, 14 x 10 in. (355 x 254 mm)
- 2B pencil
- Size 12 and 6 round brushes

Color palette

- Cerulean Blue
- Alizarin Crimson
- Payne's Gray
- Burnt Sienna
- Yellow Ocher

This painting includes a cluster of buildings and uses one of the main principles of linear perspective—namely that parallel lines (here, the roof lines and the chimney pots) appear to recede toward a point on the horizon known as the "vanishing point." When you're walking about in small towns, look for collections of houses that will make pretty compositions.

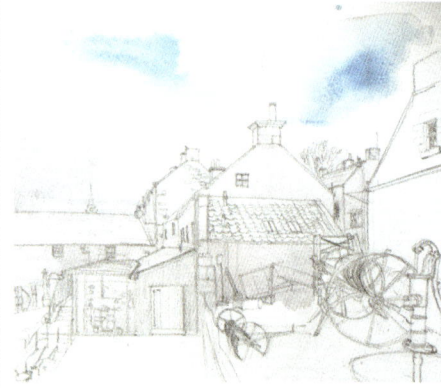

1 Use a 2B pencil to lightly sketch the scene. Note that objects appear to dimish in size the farther away they are. Details become less obvious and colors become paler. In addition, parallel lines going away from you appear to meet at a point on the horizon known as the "vanishing point."

2 Instead of adding clean water to the whole sky, use the larger brush to create small puddles of water in a couple of places and drop some Cerulean Blue into them. Add a wash of Cerulean Blue and Alizarin Crimson over the buildings and let it wash over part of the sky.

CLUSTER OF BUILDINGS 99

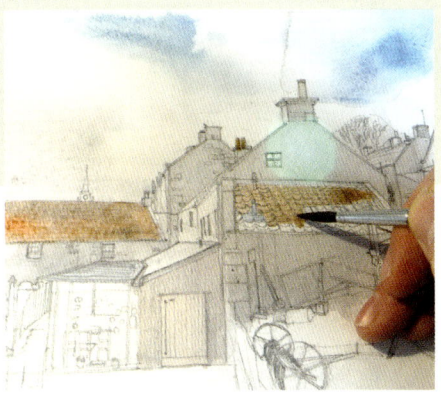 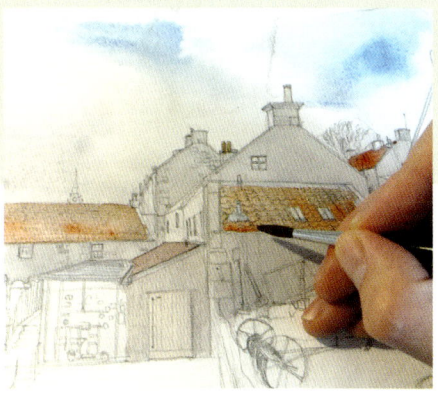 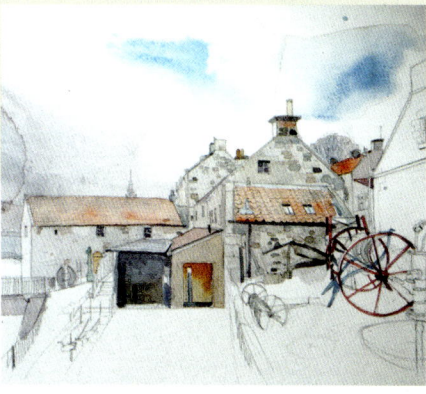

3 Once your first washes are dry, use the smaller brush to paint the gray roof with a mix of Cerulean Blue and Payne's Gray, and the red roofs and chimneys with Burnt Sienna. The foreground buildings have been given another wash of Cerulean Blue, Alizarin Crimson, and a touch of Burnt Umber (you're looking to create a warm gray); this will help the buildings in the background recede.

4 Add texture to the bricks and stones by building up washes of mixtures of Burnt Sienna, Payne's Gray, and Yellow Ocher in different areas.

5 Paint the farm equipment using Cerulean Blue and Alizarin Crimson. I left quite a few portions of this picture unpainted and with the pencil showing, for purely esthetic reasons.

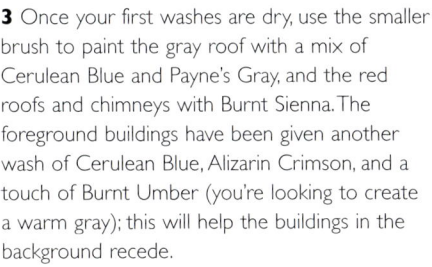

CITYSCAPES

33 | Townscape
Building up a complex scene

Materials

- Watercolor block, 14 x 10 in. (355 x 254 mm)
- 2B pencil
- Size 6, 12, and 20 round brushes
- Water sprayer
- Paper towels

Color palette

- Cerulean Blue
- Cobalt Violet
- Yellow Ocher
- Gamboge
- Alizarin Crimson
- Indigo
- French Ultramarine Blue

Painting a townscape can be daunting, as there's so much to draw—so instead of focusing on the details, try to get the overall structure of the buildings down first. For example, look for the key lines and shapes and sketch these in first, then add the smaller buildings and the roofs, chimneys, and windows. Try to see the building as basic blocks to start with. Look at which sides are in the light and which are in shadow.

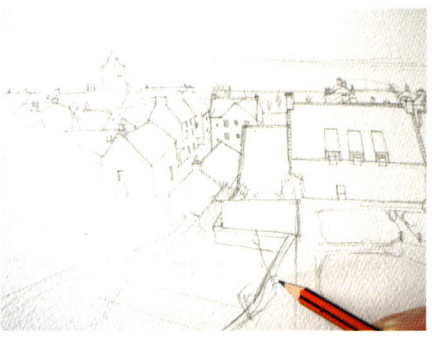

1 Use a 2B pencil to draw the main structure of the townscape and shapes of the buildings.

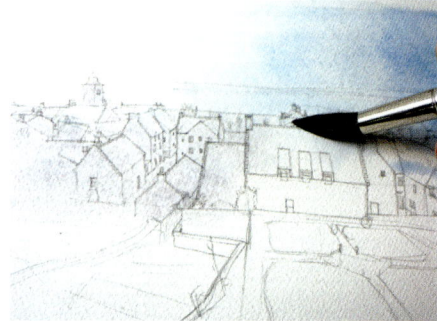

2 Use the largest brush to add an initial wash to the buildings using Cerulean Blue and Cobalt Violet.

TOWNSCAPE 101

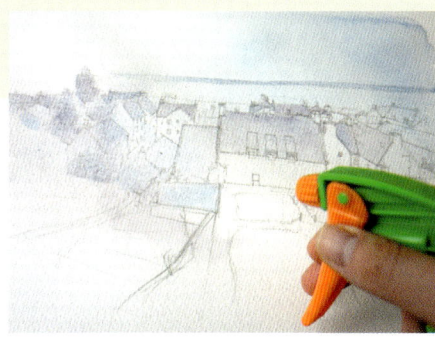
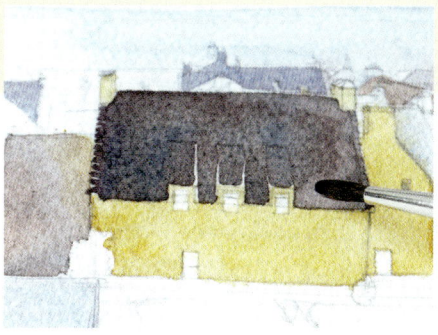
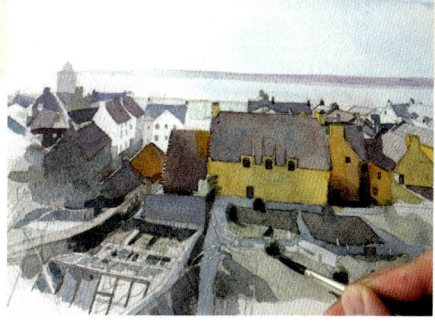

3 Using the same colors, start painting the background landscape and sky and the roofs of the houses. Spray the painting with water and dab with paper towels or sponges to allow the colors to merge into each other.

4 Once the paper is dry, paint the walls using a mix of Yellow Ocher and Gamboge. Then build up the roofs with a mix of Alizarin Crimson, Cerulean Blue, and a touch of Indigo.

5 For the darker yellow walls, add a touch of French Ultramarine Blue to Gamboge (experiment, as these colours can be very strong). Finally, use the smaller brush to paint the garden, using a complementary palette to the buildings. Block in the main colors, then add depth and shadows.

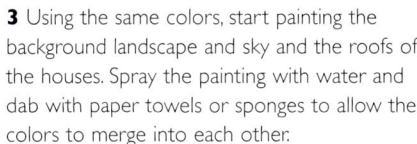

34 | Bridge
Finding your interpretation

Materials

- Watercolor block, 14 x 10 in. (355 x 254 mm)
- 2B pencil
- Size 12 and 6 round brushes

Color palette

- Cadmium Yellow
- Cadmium Orange
- Quinacridone Magenta
- Cobalt Violet
- Cerulean Blue
- Burnt Sienna
- Alizarin Crimson
- Indigo

Painting iconic structures can be quite a difficult, but rewarding, task. If you live near a famous building or bridge you'll have seen plenty of photos depicting it, so it can be difficult to come up with an original interpretation. Try finding a new viewpoint, or interpreting what you see slightly differently. This scene, for example, featured vivid green grass and a bright blue sky, but I chose to use a more muted color scheme for the painting. I also took some artistic license and added a sunset to the view, rather than the blue afternoon sky of the day.

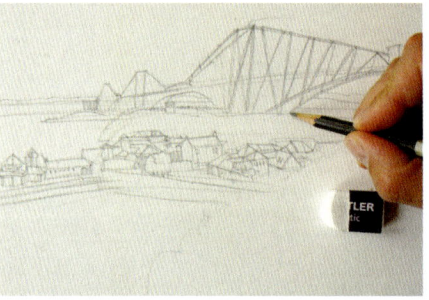

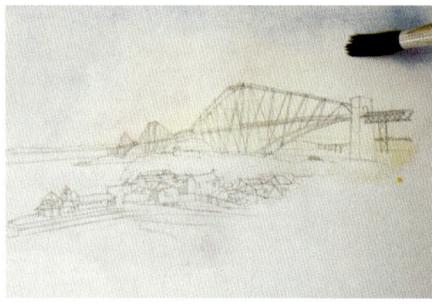

1 Sketch out the main outlines, paying particular attention to the structure of the bridge. Getting this right and making it look believable is half the battle. You don't need to draw every building—you can focus on just a few roofs to give the impression of the collection of houses in the middleground.

2 Use the largest brush to wet the whole surface of the paper with water. While still damp, float in a wash of Cadmium Yellow and Cadmium Orange by the bridge, where the sunlight is.

Still working wet in wet, drop in a small amount of Quinacridone Magenta, followed by a mix of Cobalt Violet and Cerulean Blue. The colors will bleed into each other to create a soft, diffused effect.

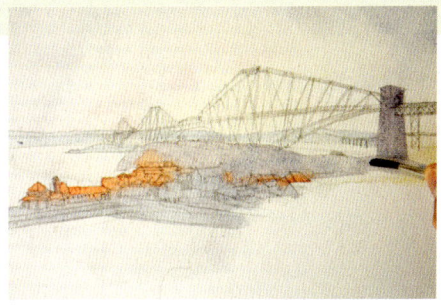 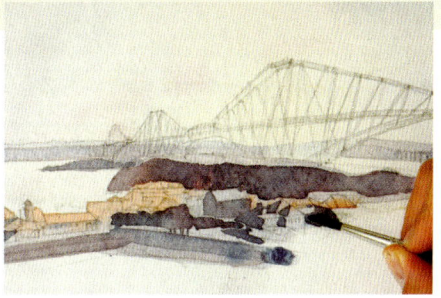 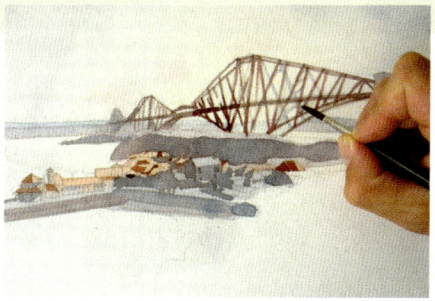

3 Next, apply a wash of Cerulean Blue to the distant hills. Use the Cerulean Blue and Cobalt Violet mix for the ground and bridge support. While the paint is still wet, use the smaller brush to paint the roofs with a mix of Burnt Sienna and Cadmium Orange. It's OK if the colors bleed into each other.

4 Go over the landscape area with a darker mix of Cerulean Blue and Alizarin Crimson. Add some Indigo in places to break up the regularity.

5 Use a darker mix of Alizarin Crimson for the bridge. Paint the shadow sides of the rooftops with Burnt Sienna and the windows and building shadows with a mix of Cerulean Blue, Alizarin Crimson, and Indigo. Use a diluted version of this mix for the struts of the bridge on the far side.

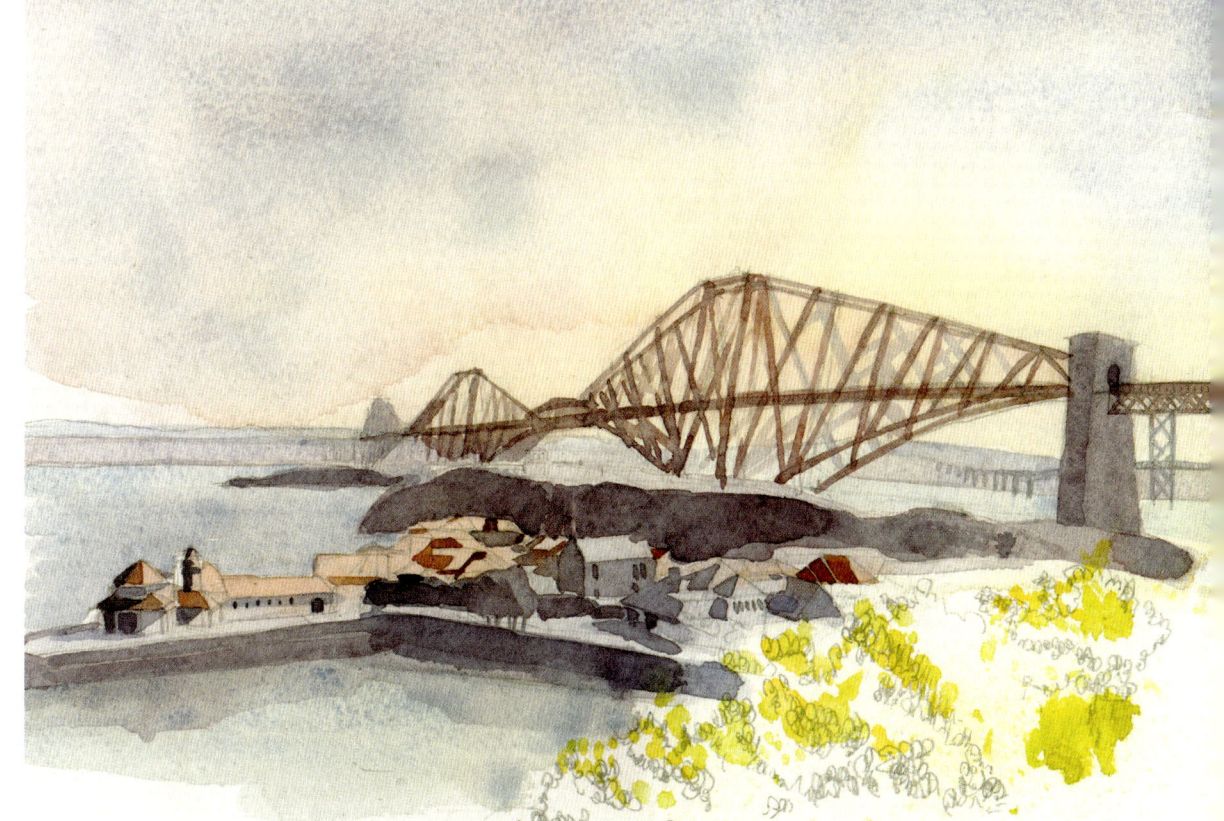

6 At the last moment, I decided to add some gorse flowers in the foreground. To do this, just indicate them with a few pencil marks and a wash of Cadmium Yellow.

35 | Castle
Introducing a sense of scale

Materials

- Watercolor block, 14 x 10 in. (355 x 254 mm)
- 2B pencil
- Size 12 and 6 round brushes

Color palette

- Cerulean Blue
- Yellow Ocher
- Burnt Sienna
- Alizarin Crimson
- Indigo
- Burnt Umber
- Cadmium Yellow
- Sap Green

Painting large, dramatic buildings can be a challenge. To emphasize the scale of this castle, I included the nearby house and the ice-cream vendor. I highlighted the bright, summer's day by using a tangy green for the tree, including long shadows, and featuring a clear blue sky.

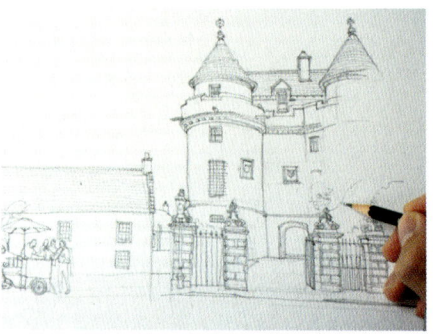

1 Sketch the scene with a 2B pencil. Block the big building shapes in first, before you move on to the details.

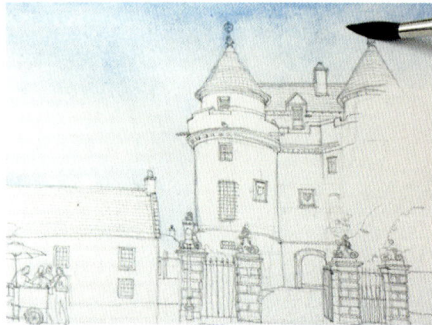

2 Using the larger brush, wet the sky area of the paper with clear water. Add Cerulean Blue to the top of the page, and work downward to achieve an evenly gradated wash.

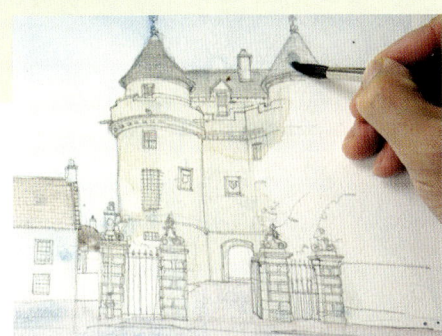 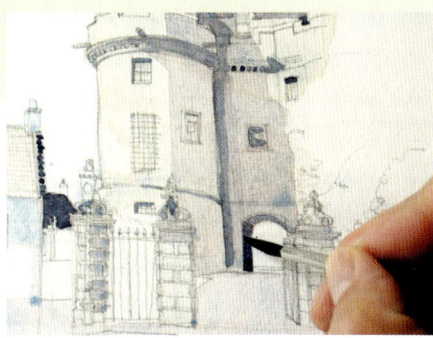 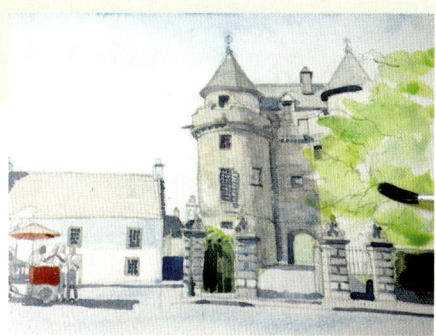

3 For the castle, use a mix of Yellow Ocher and Cerulean Blue for the stonework, and a darker version for the roof. Leave the walls of the white house unpainted but use a diluted version of Burnt Sienna for the roof and Cerulean Blue for the shadow. Use a mix of Cerulean Blue and Alizarin Crimson for the road.

4 Using the smaller brush, add shadows to create depth—think about what's facing the sun and what's in shadow to work out where to paint. Use a mix of Cerulean Blue and Alizarin Crimson for the castle's towers, and a diluted version of Indigo for the shadows. Be careful with Indigo, since it can dominate—adding a touch of Alizarin Crimson can help tone it down.

5 Add texture to the stonework of the castle with washes of Yellow Ocher, Cerulean Blue, and Burnt Umber, building these up in irregular blocks. The tree is a wash of a mix of Cadmium Yellow and Sap Green—use lots of water so that it dries in an interesting manner. The ice-cream van is suggested in two shades of Alizarin Crimson. Finally, add cast shadows with a darker mix of Cerulean Blue and Alizarin Crimson.

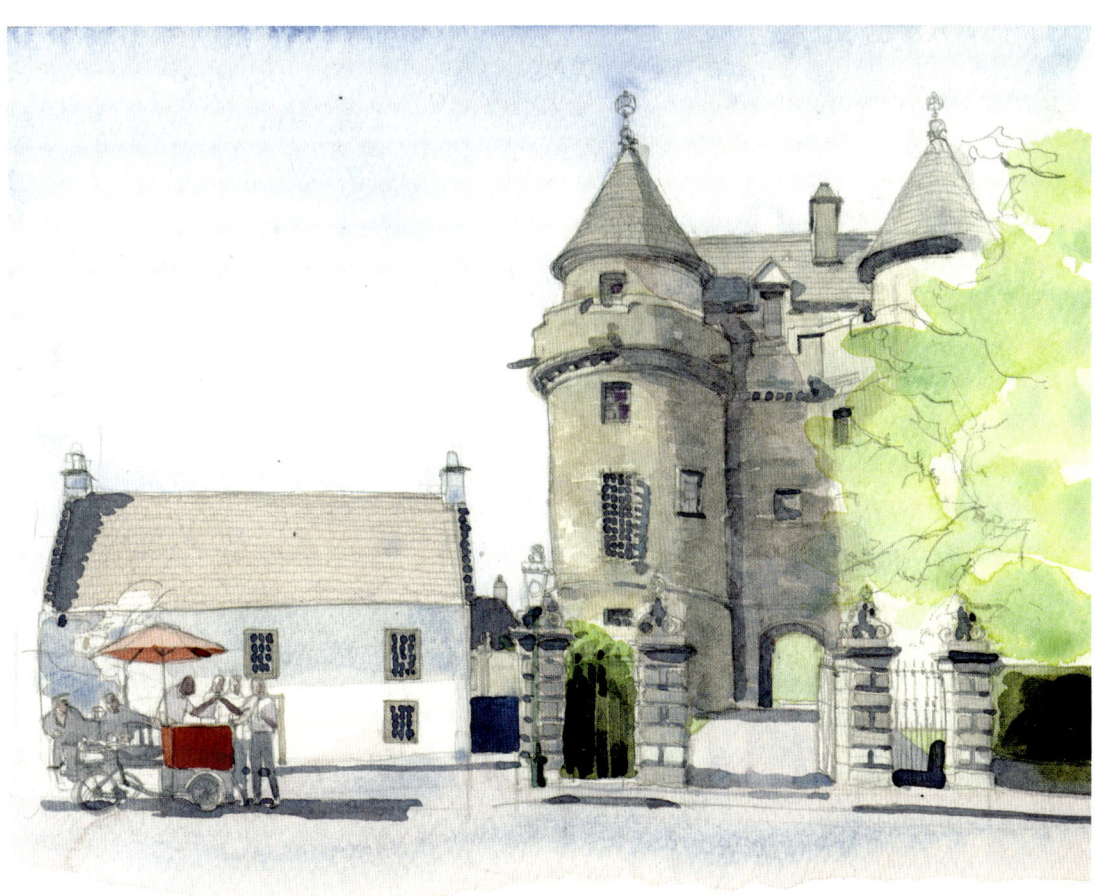

Chapter 5
Animals

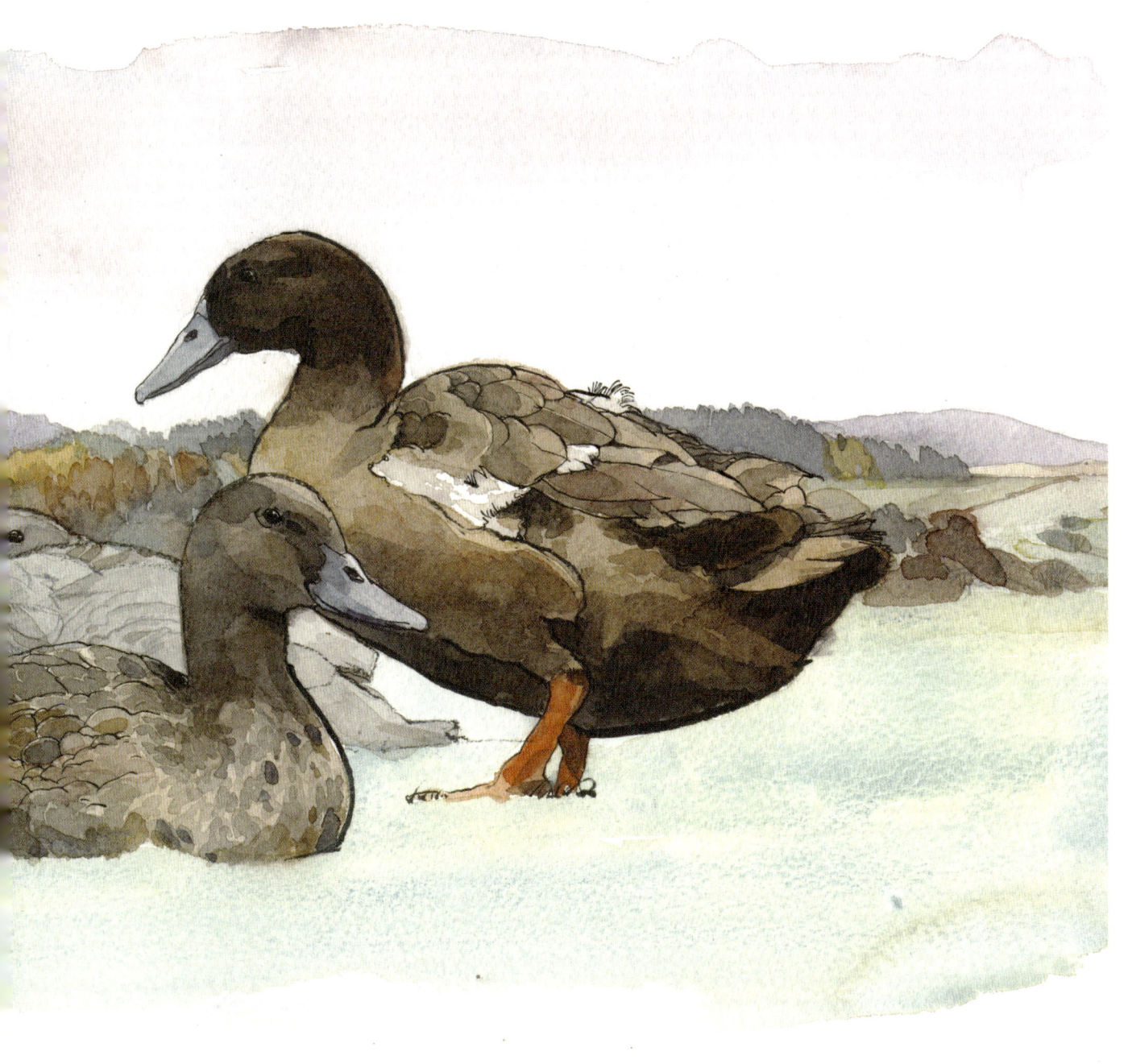

36 | Bunnies
Grouping subjects

Materials

- Watercolor block, 14 x 10 in. (355 x 254 mm)
- 2B pencil
- Size 8 and 6 round brushes
- ¼ in. (6 mm) flat brush

Color palette

- Yellow Ocher
- Cerulean Blue
- Alizarin Crimson
- Quinacridone Magenta
- Burnt Umber
- Indigo

When you group a few subjects together, they can make interesting and dynamic compositions. Observe how animals relate to each other when they're resting or at ease, whether it's dogs, cats, or even—as in this case—bunnies. The opposing curves of the animals' bodies in this composition reminded me of a traditional Chinese yin-yang symbol.

1 Draw the pair of rabbits, keeping your lines light as always. Remember that the rabbits are three-dimensional objects, and think about where their forms curve away from you. This can be difficult, but it might help to check the shape of your own hand or arm for reference.

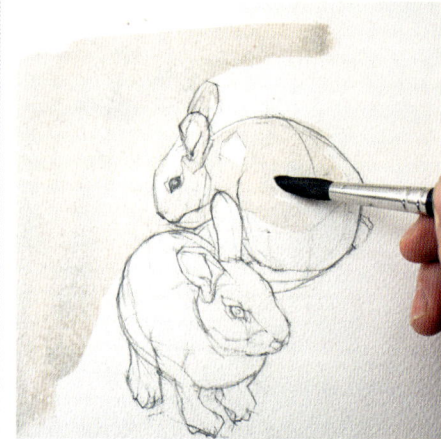

2 Use the larger brush to apply the main wash, a diluted mix of Yellow Ocher with a touch of Cerulean Blue and Alizarin Crimson. Cover the whole paper with this wash, except for the parts where the sunlight hits the rabbits' bodies—leave these parts white.

BUNNIES 109

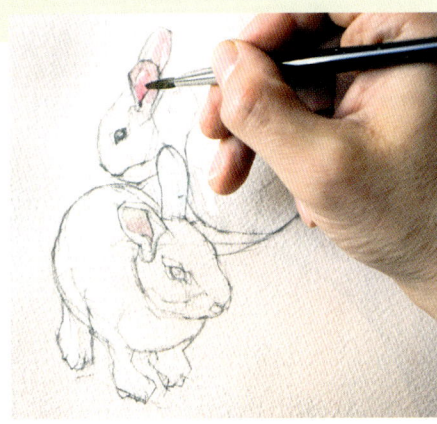

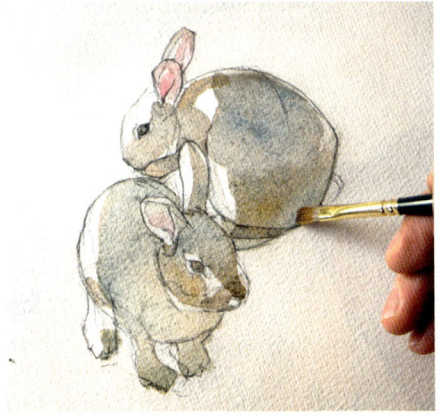

4 Now start painting the rabbits' bodies, using a flat brush and the same wash as in step 2, remembering to leave the highlighted parts unpainted. A flat brush can change the appearance of your washes. For example, if you want to accentuate flat areas of color a flat brush can help. Apply the color in layers to add more depth and slowly build up the forms. Deepen the tones as you work by adding touches of Cerulean Blue, Alizarin Crimson, and Burnt Umber to your original wash. Paint the eyes with a wash of Indigo and Burnt Umber, leaving a tiny spot for the highlights.

3 When light passes through a thin part of your body, such as your ears (or your fingers if you hold them up to the sun), it glows with a bright pink radiance. This effect is called subsurface scattering, and it's one of my favorite light effects. You can see it here in these rabbits' ears. For their ears, use the smaller brush to apply a wash of Quinacridone Magenta. While it is still wet, drop a deeper Magenta mixture into it and it will spread really nicely.

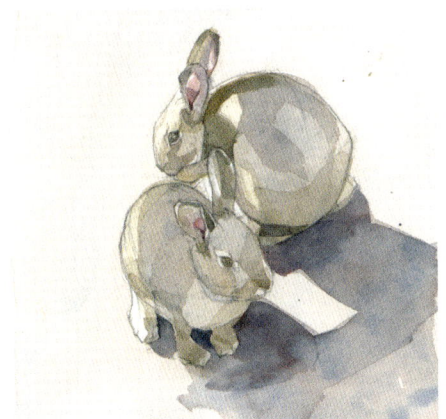

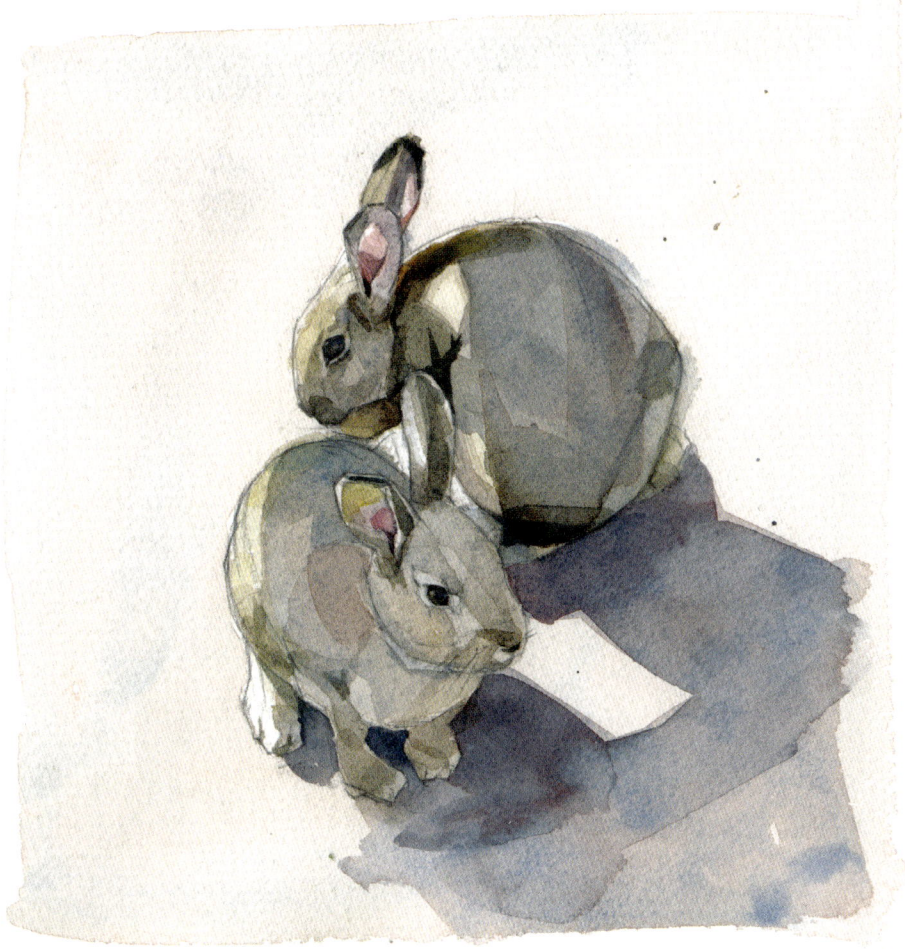

5 Keep adding depth to the washes to increase the sense of three-dimensional form. For the shadows under the rabbits, use a wash of Indigo with a touch of Alizarin Crimson. Don't try to control your application of the paint too much—allow it to pool and form edges naturally. This will contribute to the character of your painting and create a lovely, loose effect.

34 | Lily the whippet
Editing out

Materials

- Watercolor block, 14 x 10 in. (355 x 254 mm)
- 2B pencil
- Size 4 and 10 round brushes

Color palette

- Yellow Ocher
- Burnt Umber
- Payne's Grey
- Alizarin Crimson
- Raw Sienna

This portrait focuses on what to paint and what to leave out. With some pet portraits there is a temptation to render each hair and detail of the coat, which can end up making your painting look flat and overly fussy. What is important is to show a part of your pet's personality with a look or gesture that is meaningful to you.

With this demonstration I've used a photograph as my source material. When you're looking through your photos, try to pick one that shows your pet's character. It could just be a glance—a happy one or even a furtive, guilty one such as this of Lily the whippet.

 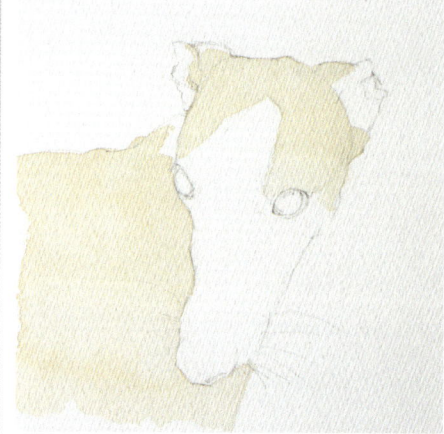

1 Start by making a rough outline using your 2B pencil. First of all, draw the big shapes such as the roundness of the skull and the tube-like shape of the muzzle. Once these are done, pay some attention to the eyes. Again, keep it loose to begin with so you get the placement done. Here I've focused on Lily's eyes, ears, and nose as my primary areas of interest. You can freely make marks to suggest the body.

2 Now begin your painting with your first watercolor wash. This is a simple Yellow Ocher wash with a touch of Burnt Umber to tone down the yellow. Use the larger brush with plenty of water (much more than you think you'd use). Don't be worried about going over or missing the pencil lines, just have fun with this stage.

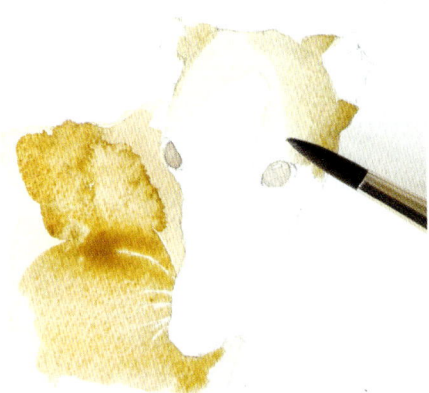

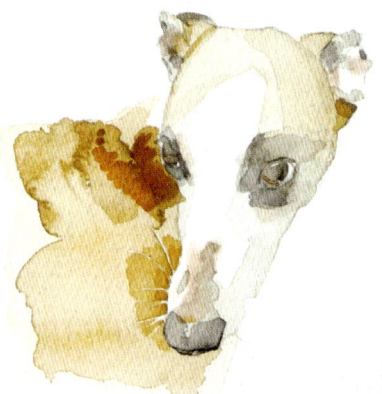

4 Continue adding more depth. Think of it like developing a photograph from film—you're slowly letting the painting reveal itself. Use Payne's Grey, as it's slightly softer and less harsh than using black paint. Keep your paint quite diluted with lots of water. Add some paint to the nose and eyes, then leave to dry. Next, create the areas where the fur is less visible and you can see the skin underneath by painting the areas light pink with a very diluted Alizarin Crimson. Finally add more Yellow Ocher/Raw Sienna to the coat—I've chosen to paint around the whiskers to show their negative shapes which look interesting.

3 Continuing with this technique, add a little more depth to your first wash. Add more Burnt Umber to your watercolor wash. Here we want to make the whippet's head darker as it turns away from the light. Then add more paint to the body. It's okay if the paint pools, as it will dry into interesting patterns. Finally, use pure Burnt Umber to paint the pupils of Lily's eyes.

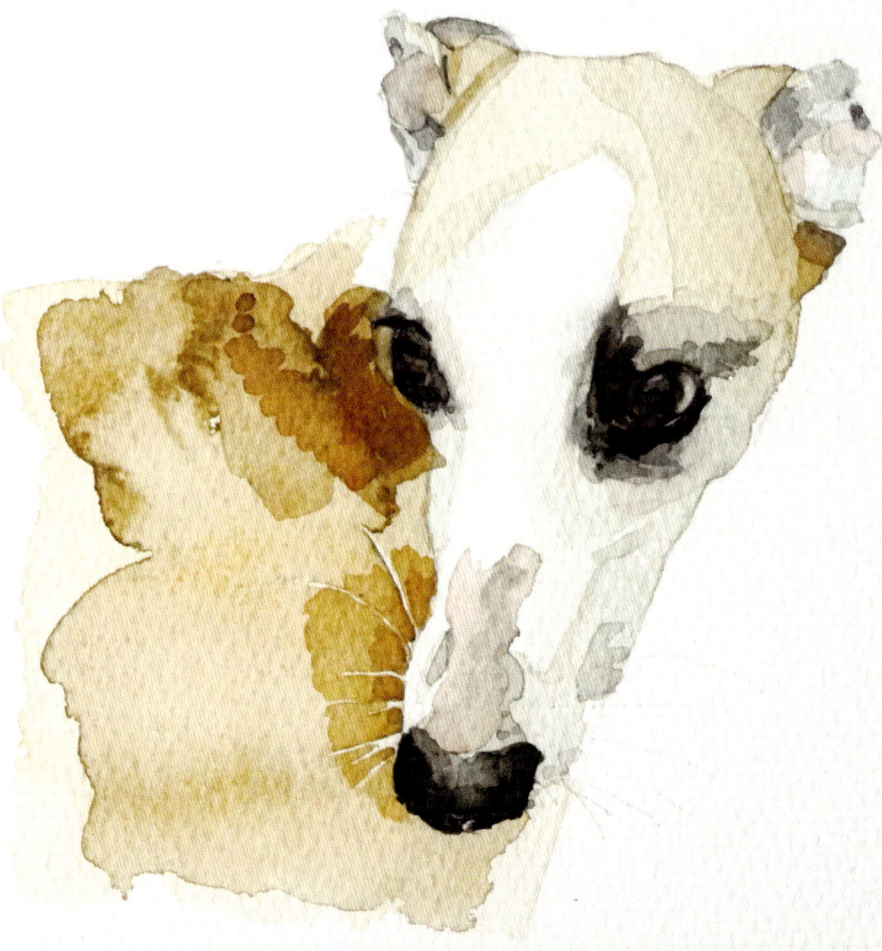

5 Add the last touches. Here, you want to add a little more depth to your painting. Using the smaller brush, I've used a bit more Payne's Grey to make Lily's eyes and nose darker, as well as small accents on her ears. Just take care and do one area at a time. Once you think it's done, use your instinct—just stop.

112 ANIMALS

38 | Farm scene
Expressive brushwork

Materials

- Watercolor block, 14 x 10 in. (355 x 254 mm)
- 2B pencil
- Size 8 and 6 round brushes

Color palette

- Sap Green
- Payne's Gray
- Cerulean Blue
- Alizarin Crimson (or Quinacridone Magenta)
- Yellow Ocher
- Burnt Sienna
- French Ultramarine Blue

A good way to show expressive brushwork is to paint selective parts of your picture very accurately, so that they act as a counterpoint or balance to the more expressive elements—in this case, the chicken's feathers. I've organized this composition in a slightly less realistic way than usual. If I'm honest, I was thinking about the iconic silhouette from the *Charlie's Angels* 1970s' television series, and have used it here as inspiration for this chicken gang.

1 Drawing this scene is quite tricky, but once you've got the eyes and beaks of the birds working well it gets much easier. I spent a bit more time drawing the feathers than is probably necessary. I'd recommend suggesting them rather than individually drawing each one.

2 Once you've drawn the scene, use the larger brush to add a wash to the background with a very light, diluted mix of Sap Green and Payne's Gray. Take the wash over the background chickens as well. Leave to dry. Next, apply a gray wash, made from Payne's Gray and a touch of Cerulean Blue, to the background chickens.

FARM SCENE 113

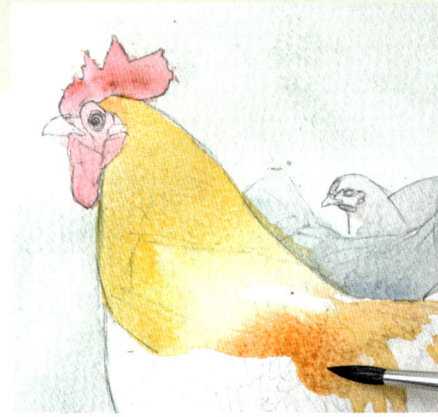

3 With diluted Alizarin Crimson, paint in the crests of the chickens and rooster—be careful, though, as this color can be really strong. Start building layers of color on the rooster's neck. I started with Yellow Ocher, leaving part of the neck unpainted and making it darker as I progressed around and down the neck. It took a few washes to get the color I wanted, working from Yellow Ocher to Burnt Sienna.

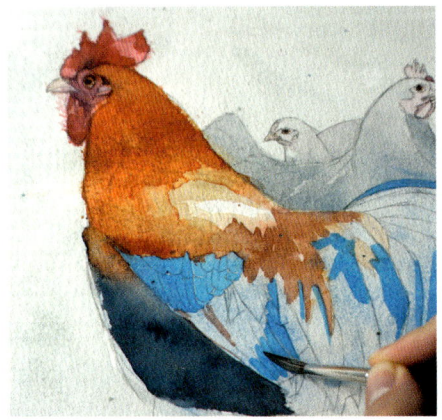

4 Now it's time to move onto the feathers. Mix up your Cerulean Blue and start doing bold brushmarks to achieve this effect. You can afford to be quite free, adding some purple feathers too, by mixing Alizarin Crimson with French Ultramarine Blue, and letting the colors run into each other. Once you've achieved the bright colors you want, use Payne's Gray on the blank areas. Think of these areas as feathers, too, and imagine each brushstroke as a feather.

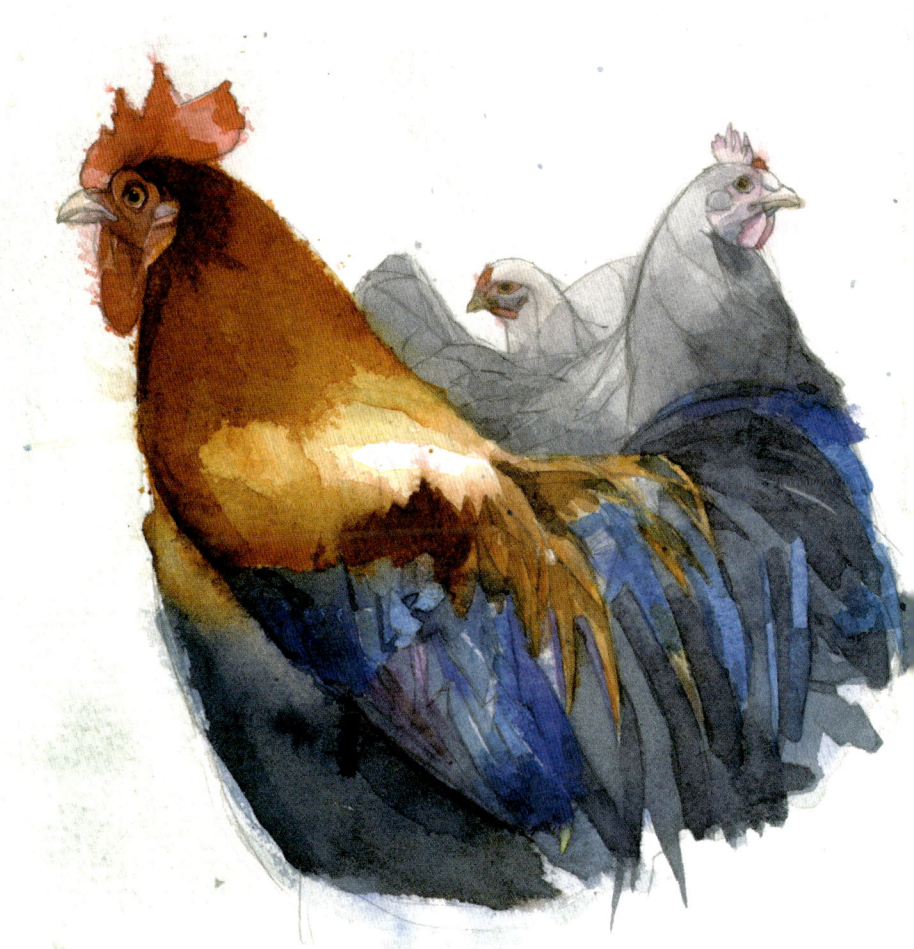

5 Once you've painted the main initial washes, you have to start defining the form. For example, I added more washes to the neck so that it goes from being darker around the head to the light area where the brown feathers meet the blue feathers. Now complete the finer points by adding the eyes and deepening the crests with a slightly darker Alizarin Crimson (try adding a touch of Cerulean Blue). Darken a few feathers, too, if you think the painting needs it.

39 | Cormorant
Painting a museum specimen

by Lara Scouller

Materials

- 16 x 22 in, (400 x 550 mm) NOT 200lb (425gsm) watercolor paper
- Size 3 mop brush
- Size 3 wash brush
- Large and small squirrel-hair flat wash brushes
- Watersoluble 4B pencil

Color palette

- Yellow Ocher
- Burnt Umber
- Payne's Gray
- Cerulean Blue
- Emerald Green
- Lamp Black
- Alizarin Crimson

Painting a museum specimen allows you to spend a concentrated period of time painting an animal that won't fly or run away at the first flick of a paintbrush. I have chosen a cormorant because of its dynamic composition and sculptural appearance. This prehistoric-looking waterbird has, in certain light, a purple and greenish sheen to its almost all-black feathers, which are patterned with touches of brown. The glossy quality of the feathers is perfect for glazes and shows off the watercolor medium at its best.

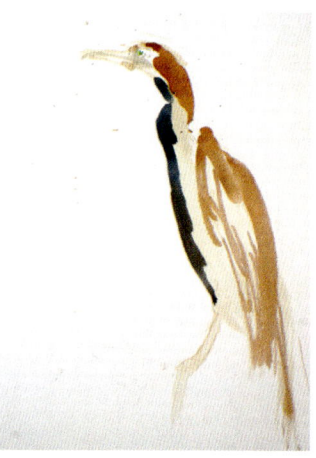

1 Stretch the paper (see page 140) to help prevent it from buckling when washes are applied. Use the mop brush, a lot of water, and a touch of Yellow Ocher mixed with Burnt Umber to roughly sketch in the composition. You don't need to worry about the accuracy at this early stage—the sketchiness will help create a sense of movement. If possible, stand up when painting to allow for more gestural brushstrokes. Let dry.

2 Add a second wash of color for your midtones. Allow the brush to describe the shape of the bird. Use less water this time and introduce Payne's Gray mixed with a small amount of Cerulean Blue to create the shadowy, cool parts of the underside of the neck and breast. Use Burnt Umber mixed with a small amount of Yellow Ocher on the back of the neck, where the feathers are browner. Keep your brushstrokes broad and loose. Use watered-down Emerald Green for the eye, leaving some paper showing through for the highlight.

3 The third wash requires less water and more paint than before, to intensify the color. Mix Lamp Black with a little Payne's Gray and Alizarin Crimson to create a cool purplish tone for the neck. (I've held back using Lamp Black until this stage, since adding it too early on can deaden the transparency of the watercolor.)

4 I've kept the webbed feet fairly loose throughout the painting, so as not to detract from the detail of the head. For this stage, I've used watercolor sticks to dot small areas of texture around the eye and beak. This adds a focal point and draws attention to parts of the bird that I want to come forward. Watercolor sticks work best when the surface you are working into is still wet. They are great for adding detail into the painting, especially when describing the scalloped feather patterns on the wing. Use a watersoluble 4B pencil to sharpen up the tip of the beak and gape.

40 | Flamingos
Painting live animals

by Lara Scouller

Materials

- 11 × 17 in. (A3) NOT 200lb (425gsm) watercolor paper
- Size 3 mop brush
- Size 3 wash brush
- Large and medium squirrel-hair flat wash brushes
- Watersoluble 4B pencil

Color palette

- Vermilion
- Payne's Gray
- Yellow Ocher
- Cobalt Blue

In contrast to museum specimens, working from live animals requires a lot of patience and the ability to work quickly. I've chosen to paint flamingos at the zoo. They are great to work from as they are almost always in a large group, which makes them a very interesting subject because you can pick out different shapes and compositions. If the bird I have been painting moves, I will often find another one close by holding more or less the same pose.

1 Stretch the paper (see page 140) to help prevent it from buckling when washes are applied. Use the large mop brush, a lot of water, and a touch of Vermilion to sketch out the composition, using simplified shapes for the main bodies of the birds. I decided to include several flamingos in this composition in varying sizes to create the impression of a flock.

2 Strengthen the color in the second wash using the same brush but with less water and a touch more Vermilion. Go over the marks previously made, keeping the brushstrokes loose. Use the medium squirrel-hair brush when describing the S-shapes of the necks.

FLAMINGOS | 117

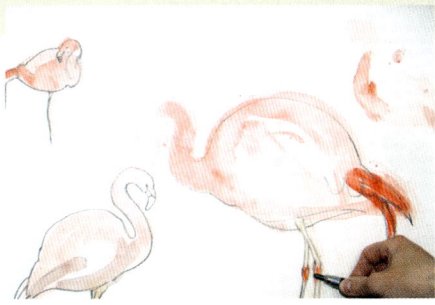 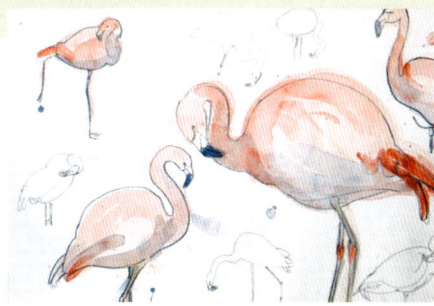

3 Work into the painting with a watersoluble 4B pencil—a nonwatersoluble pencil will make shiny marks that will sit on top of the painting and catch the light. Your lines should be confident and made purposefully, describing the crook of the beak, the curves of the body, and, of course, the matchstick-like legs. It's best to do this when the paper is still damp.

4 Draw the largest flamingo with more precision and detail, to create a focal point. Use the medium squirrel-hair brush and a little Payne's Gray mixed with Yellow Ocher to describe its long legs. Paint the bills in the same way with a more concentrated wash of Payne's Gray.

5 Mix a small amount of Cobalt Blue and Vermilion to make a diluted wash. Using the large squirrel-hair brush, apply this wash to the underside of the bodies and necks of the four main flamingos. This will help to cool down some of the hot colors and create shadows on the forms, making them appear more three-dimensional. I've also added in smaller studies that have little or no color, which create a sense of perspective and keep the painting lively.

41 | Trompe-l'oeil butterfly
Working from photos

Materials

- Watercolor block, 14 x 10 in. (355 x 254 mm)
- 2B pencil
- Size 6 round brush
- Black ink pen (optional)

Color palette

- Cadmium Yellow
- Cerulean Blue
- Cadmium Red
- Indigo
- Burnt Umber
- Payne's Gray
- Alizarin Crimson

The idea behind this exercise was to recreate a more humane example of those old pinned butterfly displays—a small trompe-l'œil. Use photographic reference for your subject. If you are taking the photos yourself, take shots from different angles to get as much visual information as possible. The color on photographs can be misleading—there may be a yellow cast, for example, or the detail might be lost. You are the artist—you can add detail or alter colors if you wish.

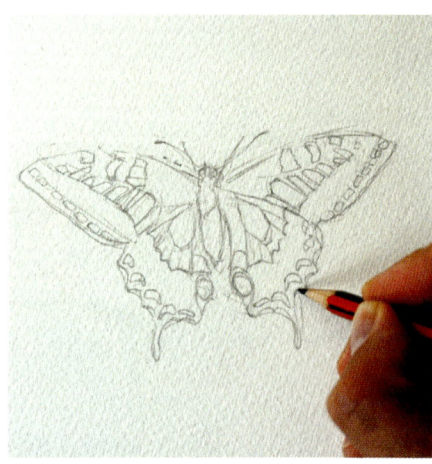

1 Make an initial pencil drawing, including the markings on the butterfly's wings.

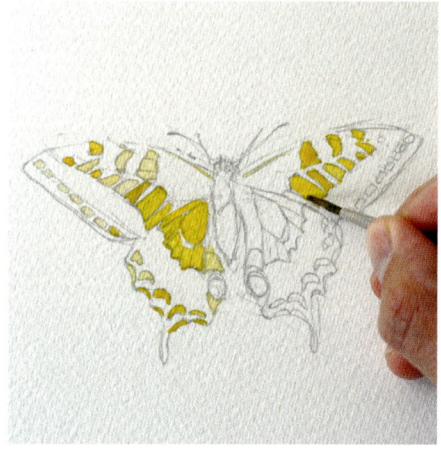

2 Start adding color to the wings. Begin with the lightest patches—the yellow markings, using a wash of Cadmium Yellow. Try varying the density of the yellow by varying the strength of the wash. In other lessons, you've allowed the colors to bleed into each other. Here, however, you want to paint accurately and neatly within the lines so that the butterfly looks as real as possible. Leave to dry.

TROMPE-L'OEIL BUTTERFLY 119

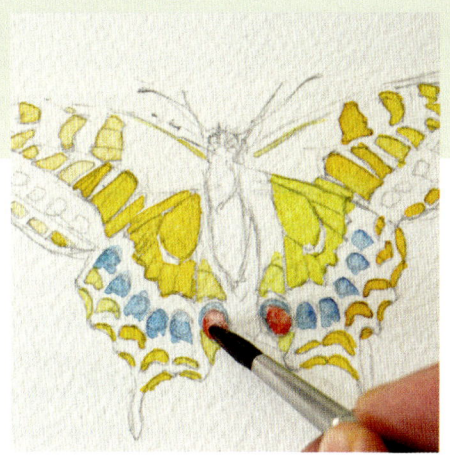

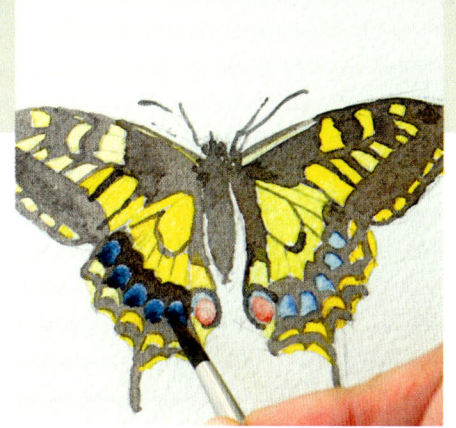

4 Paint the remaining patterns on the wings with a mixture of Burnt Umber and Payne's Gray. Take care, as before, to paint neatly and keep the color within the outlines you have drawn. Add an Indigo dot at the base of the Cerulean Blue dots.

Add depth to the darker part of the wings with more Burnt Umber and Payne's Gray.

3 Next add dots of Cerulean Blue and Cadmium Red. Apply a diluted version of the red, but drop in a more concentrated color near the bottom of each dot to create a slight gradation. Use the same technique with the Cerulean Blue dots. If you feel uncertain, make a small test on a blank piece of paper—though just going for it and seeing if it works can be fun!

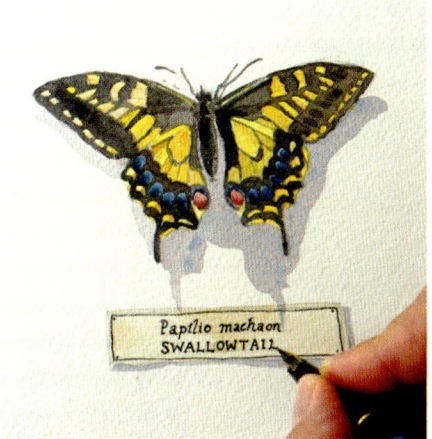

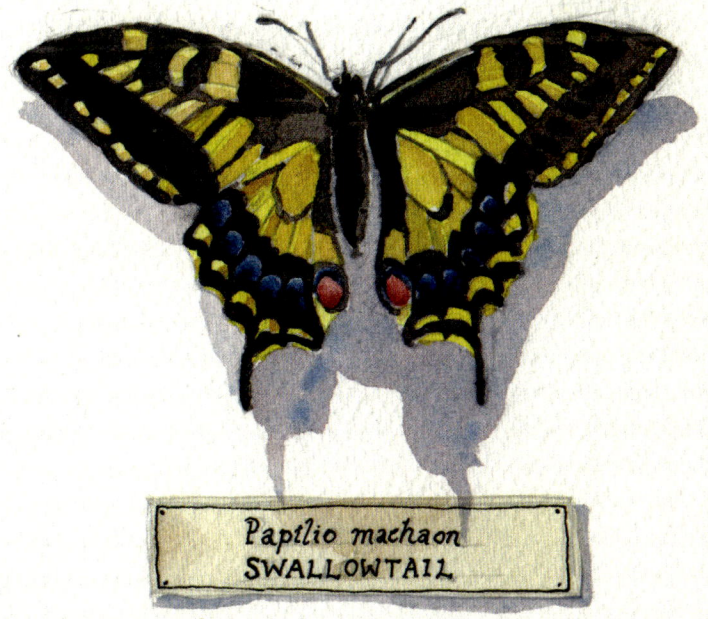

5 Carefully paint a shadow to the side of and underneath the butterfly, following its shape. Use a wash of Cerulean Blue and Alizarin Crimson.

Add a label if wished. This is just painted with a diluted yellow wash, and the wording is written with a black ink pen.

42 | Geese
Three-color washes

Materials

- Watercolor block, 14 x 10 in. (355 x 254 mm)
- H pencil
- Size 12 and 6 round brushes
- Paper towel

Color palette

- Cerulean Blue
- Cobalt Violet
- Cadmium Yellow
- Alizarin Crimson
- Indigo

This lesson shows you how to apply three-color, variegated washes. It will show you how the seamless, soft blending of colors, which happens when wet pigments bleed into each other, is a wonderful technique for skies.

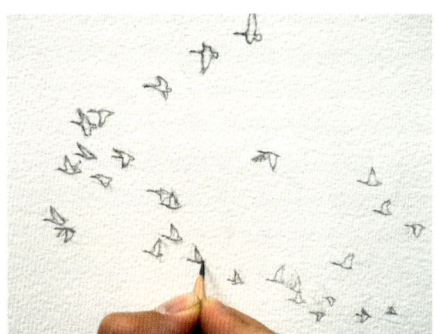

1 Draw the geese. I usually recommend using a 2B pencil, so that you're not tempted to get too precise, but this time you need to be accurate so use a harder grade—an H. You don't need to draw the clouds.

2 Use the large brush to apply a wash of plain water over the whole paper. You will be working wet in wet through to step 5, so you need to work quickly, while the washes are still wet.

GEESE 121

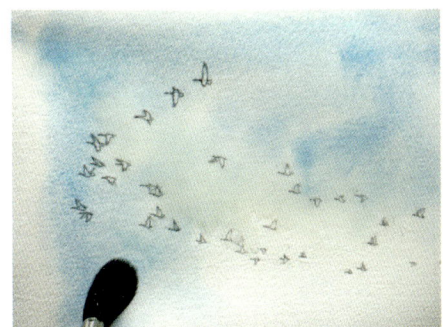 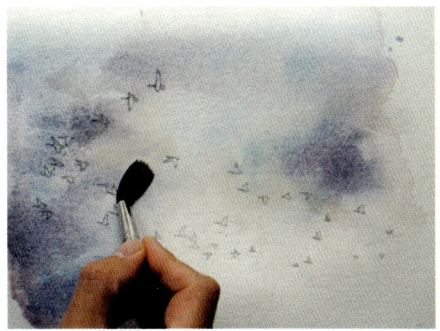 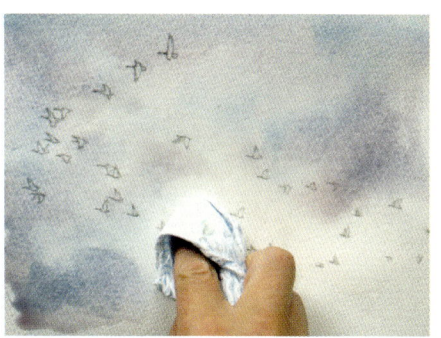

3 Apply a wash of Cerulean Blue for the clouds. Keep in mind the area you want to be the brightest, but if you find your wash going into your bright (sunlit) area, just use a paper towel to dab off the excess color. Leave the bottom right corner of the paper unpainted.

4 Add a wash of Cobalt Violet into the wet blue, again leaving the bottom right-hand corner unpainted. While this is still wet, add a wash of Cadmium Yellow. This will fade into the white of the paper.

5 Soften the edges of the clouds by dabbing them with a paper towel. You can also dab off any excess color at this stage, while the paint is still wet.

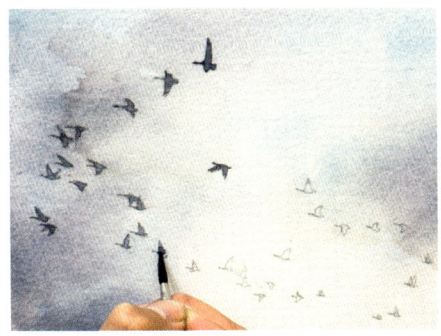 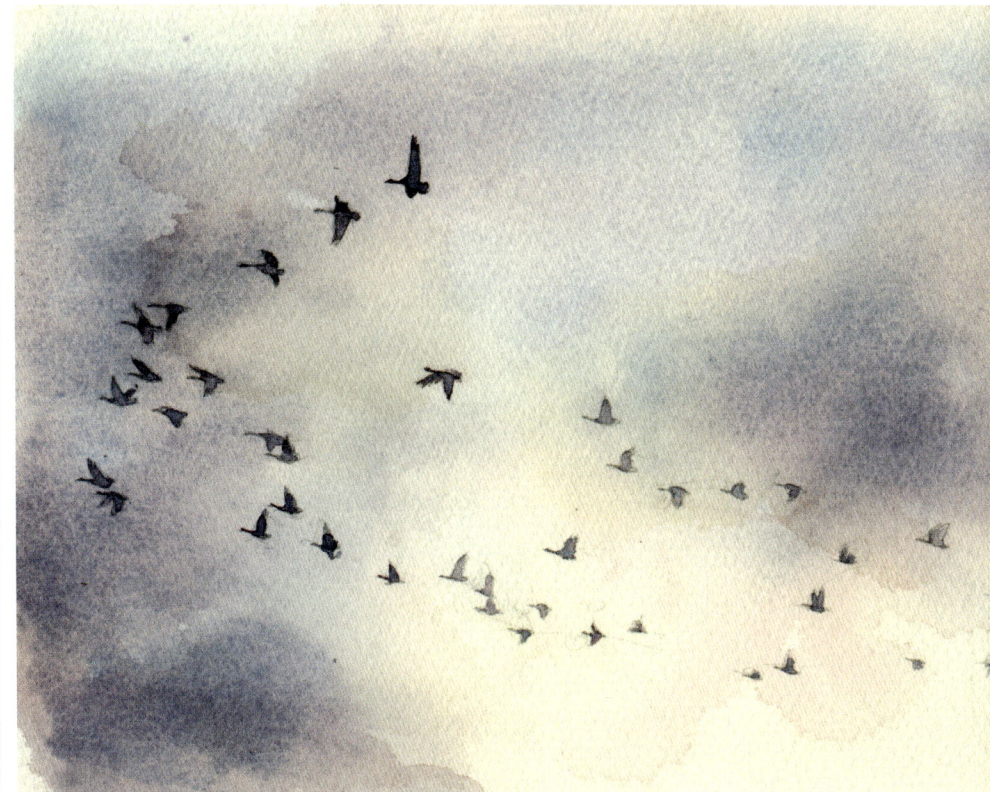

6 Once the paint is dry, use the smaller brush to paint the geese with a mix of Cerulean Blue and Alizarin Crimson, with a touch of Indigo. Use a more diluted version of this mix for the geese over the lightest part of the sky.

43 | Lobster
Painting a marine subject

Materials

- Watercolor block, 14 x 10 in. (355 x 254 mm)
- 2B pencil
- Size 12 and 6 round brushes

Color palette

- Indigo
- Alizarin Crimson
- Cadmium Orange
- Yellow Ocher
- Cerulean Blue
- Quinacridone Magenta

A lobster is a fascinating subject to paint because of the distinctive structure of its body. Made up of separate segments, it's almost architectural in shape, and it is these highly visible segments that make it an easy shape to understand—and to draw.

Watercolor is a great medium to use here. Its natural tendency to pool and form hard edges as it dries can be used to emphasize the segmented nature of the lobster's body.

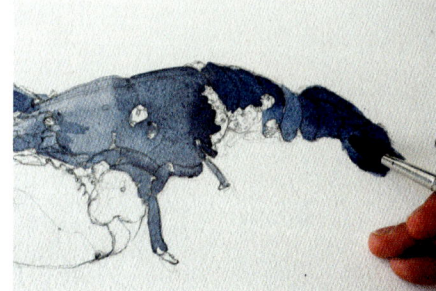

1 Make a fairly detailed drawing. Focus first on getting the overall structure of the lobster right, paying attention to the segments of its shell, the joints of its legs, and the angles at which it's holding its legs. When you are happy with the structure, you can add the fun details, such as the barnacles.

2 Apply an initial wash of Indigo to the main parts of the lobster's body and its legs. Use lots of water and the large brush, and let the wash form pools of color. Leave the head, clasper, and barnacles unpainted at this stage.

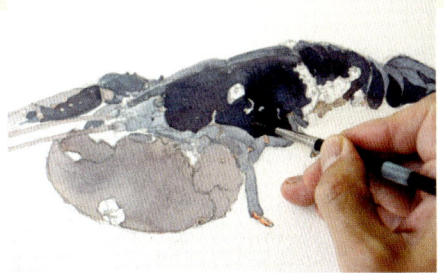 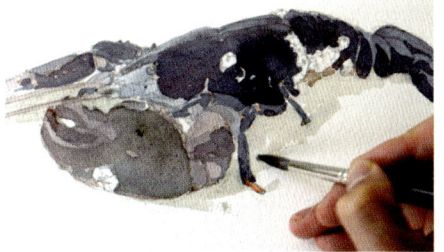 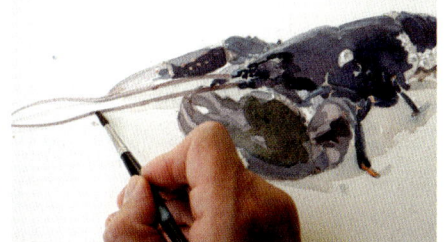

3 Add a touch of Alizarin Crimson to the previous wash to make a slightly warmer color. Use this mix for the head and the large claw. When the washes are dry, use the smaller brush to add a dab of diluted Cadmium Orange to the tips of the legs and the joints between the legs.

Start adding some depth with a richer Indigo wash to show the darker part of the lobster. It may take two or three washes to achieve this.

4 Use a darker version of the wash at the beginning of step 3 to darken the lobster's head.

Now make a very diluted wash of Yellow Ocher and Cerulean Blue. Use this for the shadow under the lobster, following the rough outline of its body to create the shadow shape. This pale shadow will help to "anchor" the lobster to the surface on which it is lying—without it, the lobster might appear to be floating in a white space.

5 Check your painting to see if there are any areas you want to darken further. Note that the barnacles are left unpainted and defined only by the pencil lines.

Finally, paint the lobster's antennae with Quinacridone Magenta.

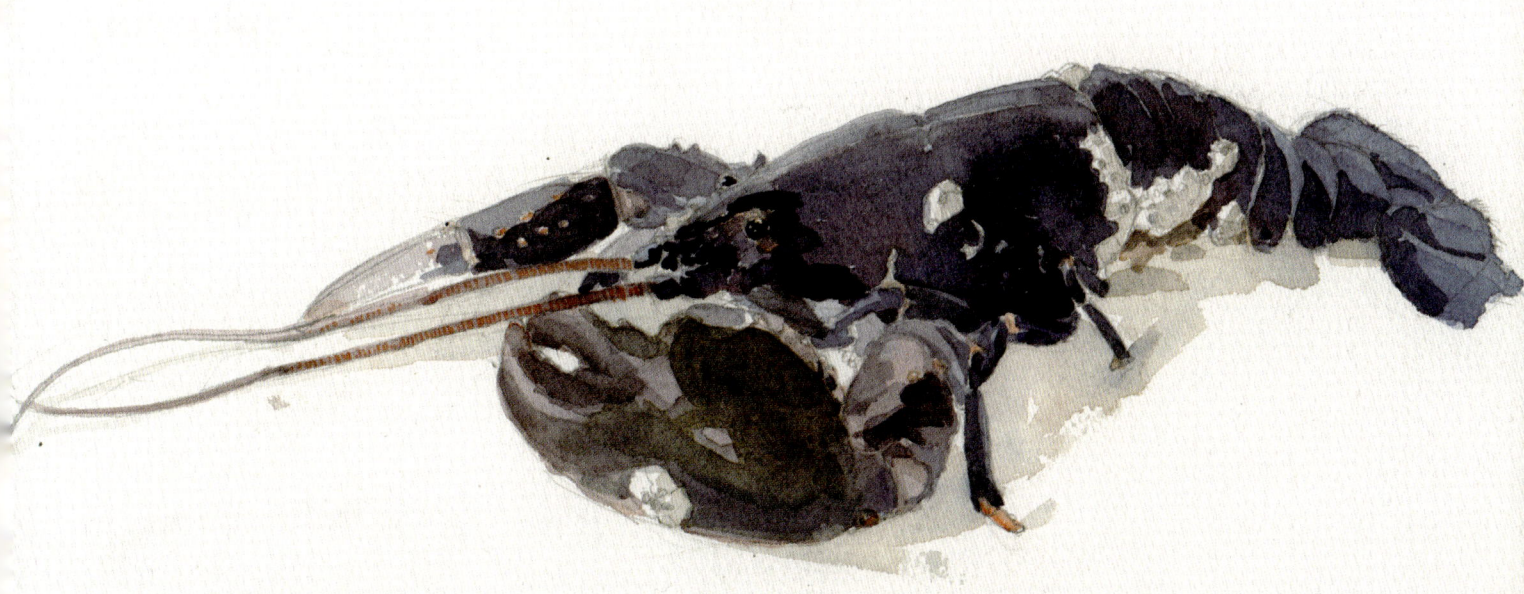

44 | Puffins
Landscapes with wildlife

Materials

- Watercolor block, 14 x 10 in. (355 x 254 mm)
- 2B pencil
- Size 12 and 6 round brushes
- Water sprayer (optional)

Color palette

- Manganese Blue Hue
- Cobalt Violet
- Payne's Gray
- Yellow Ocher
- Burnt Umber
- Lunar Black
- Cerulean Blue
- Sap Green
- Alizarin Crimson
- Undersea Green (or Perylene Green)
- Burnt Sienna
- Cadmium Red
- Cadmium Yellow

We've looked at a few variations of landscapes to paint, and now we consider ways of incorporating more wildlife into our paintings. Here we combine a landscape with buildings and birds, with the puffins arranged at the front in a composition that leads the eye to the lighthouse in the background.

For the bird in flight, you could use a water sprayer to create a blurry effect that suggests movement, such as at the puffin's wings and feet.

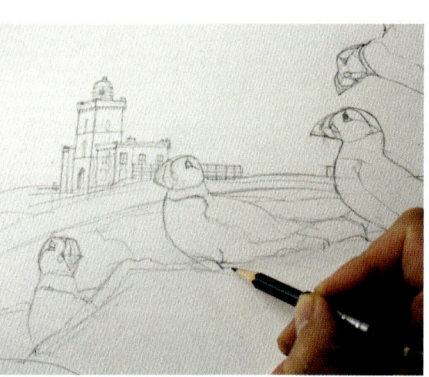

1 Use a 2B pencil to draw the main outlines of the puffins and the lighthouse in the background. You need only to suggest the shapes of the clifftop with a few light lines.

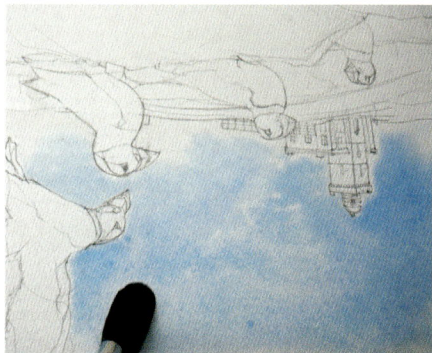

2 For a really vivid blue, use the larger brush to apply an initial wash of Manganese Blue Hue to the sky. If you turn the painting upside down, you will find it easier to control the wash and to avoid painting the puffins.

Continue the blue across the shadowed walls of the lighthouse.

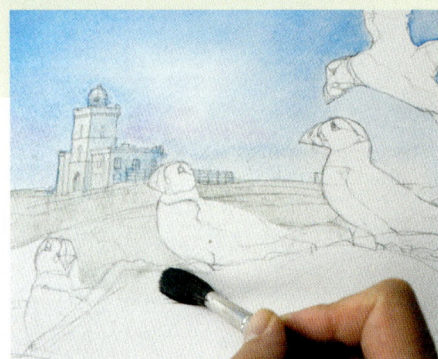 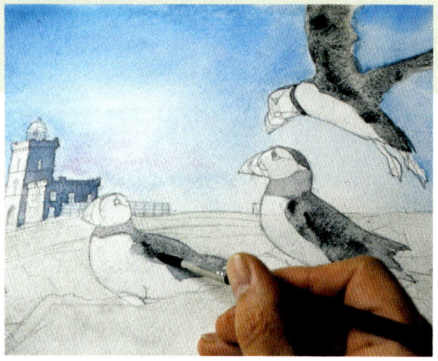 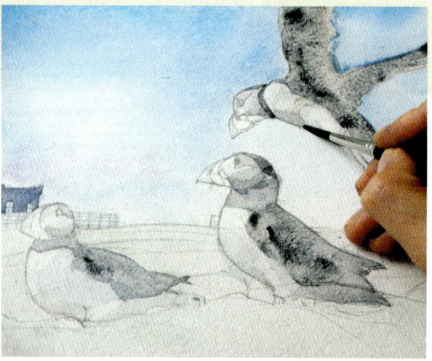

3 Working quickly while the sky is still wet, drop in a little very diluted Cobalt Violet near the horizon and allow it to bleed into the blue.

When the blue is dry, start adding color to the ground. Use a grayish wash made with Payne's Gray and a touch of Yellow Ocher and Burnt Umber.

Take this same color across the whole of the lighthouse. Leave to dry.

4 Paint the shadowed walls of the lighthouse with a mix of Cerulean Blue and Alizarin Crimson, using the smaller brush.

Use the smaller brush to paint the puffins. Use a wash of Lunar Black for their darker feathers. This is a granulating pigment, so it creates a great texture that is perfect for suggesting the velvety quality of the puffins' coats. Let dry. Increase the color density of the feathers with richer washes of Lunar Black.

5 Use a very diluted Payne's Gray wash, with a touch of Cerulean Blue, for the slightly darker areas of the white parts of the feathers.

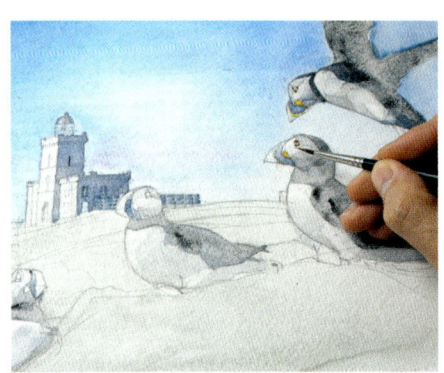

6 Paint the puffins' beaks, feet, and other colored highlights with Cadmium Red, Cadmium Yellow, and Cerulean Blue.

7 Now paint the clifftop. For the middle ground, apply light, loose washes of Yellow Ocher and Sap Green, with a little Undersea Green or Perylene Green.

For the foreground, use a granulating wash of Cerulean Blue and Alizarin Crimson with a little added Burnt Sienna.

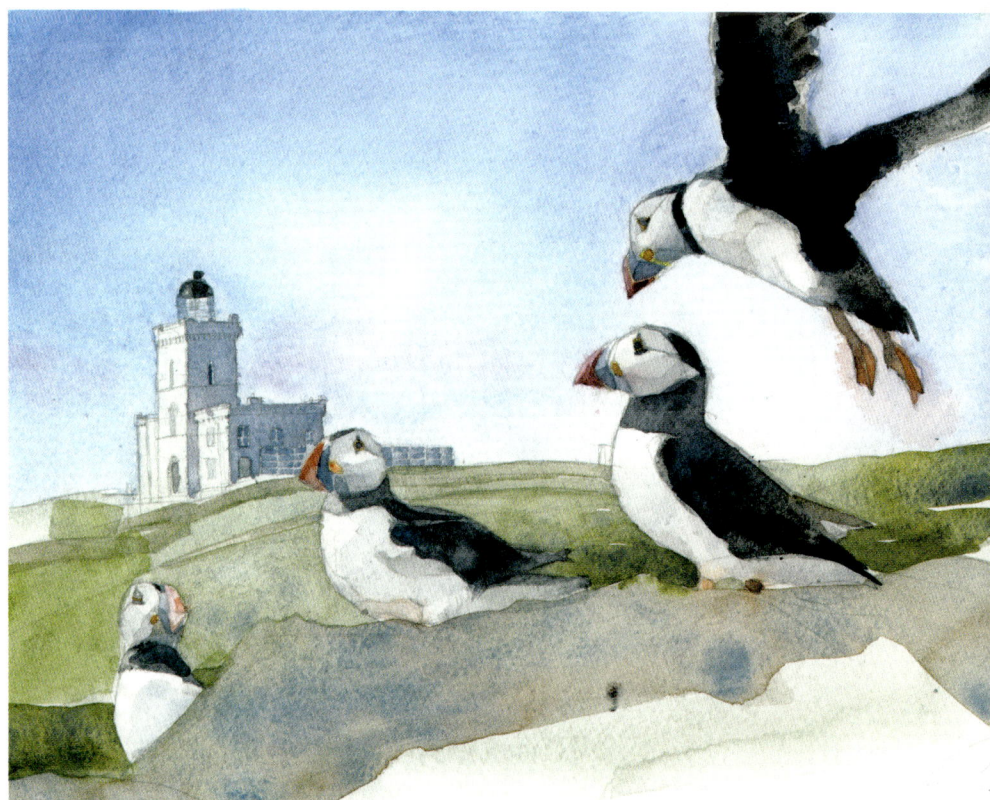

Chapter 6
People

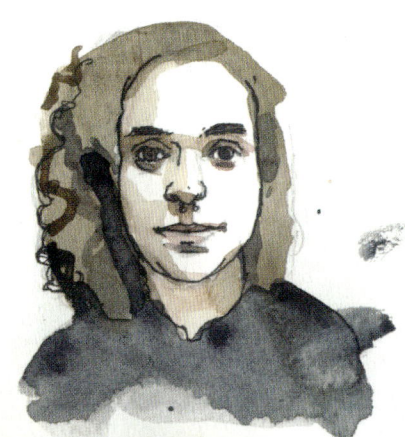
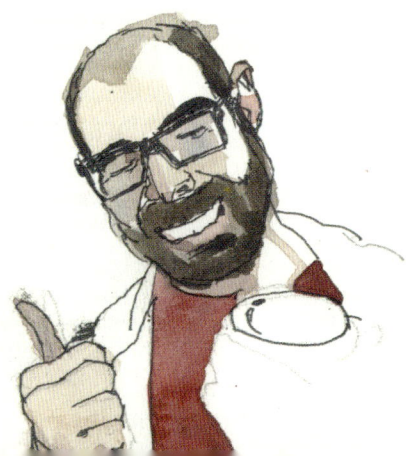

45 | In the park
Adding figures to landscapes

Materials

- Watercolor block, 14 x 10 in. (355 x 254 mm)
- 2B pencil
- Size 12 and 6 round brushes

Color palette

- Cadmium Yellow
- Sap Green
- Cobalt Turquoise Light
- Cerulean Blue
- Alizarin Crimson
- Perylene Green
- Indigo

Public parks are good places to find subjects for figure painting, since people there can be quite static. Even friends throwing balls or frisbees will repeat motions that will make drawing them easier for you.

In this composition, I've cropped the top of the trees, which makes the drawing easier and creates a convenient "roof" or frame for the painting. Framing the scene in this way draws the viewer in and focuses attention on the figures lying under the trees.

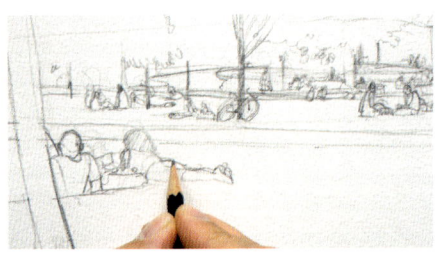 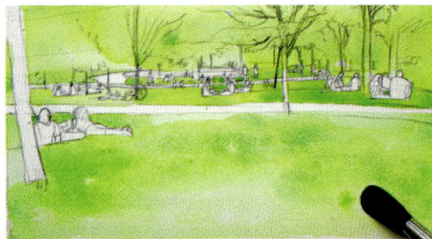

1 Draw the scene, keeping your lines quite loose. Drawing people sitting down is a bit easier than standing figures—you just need to draw the torso, and the arms are really easy to place. Don't try to draw people's features at this scale. You can suggest the trees with a few lines to indicate the trunks and branches.

2 Mix up a rich yellow-green wash using Cadmium Yellow and a touch of Sap Green—you can make it more zingy by adding a little Cobalt Turquoise Light. Brush this color across the background and the grassy area in the foreground. Don't try to get an even finish—use lots of water and the larger brush to achieve a variety of marks.

When this wash is dry, paint the paths with a diluted mix of Cerulean Blue and a tiny amount of Alizarin Crimson.

3 Now paint the tree trunks with diluted Perylene Green. When the trunks are dry, paint the people. Use different colors from your palette and whichever brush is most suited to your subject. You don't have to be too precise and it's OK if the colors overlap. Where you want to show sunny highlights on the figures, leave the paper unpainted.

4 The paths are a light wash of Cerulean Blue and Alizarin Crimson. Use a darker version of this wash for the tree shadows that go over the path. Use the larger brush to paint the foliage with a mix of Sap Green and Perylene Green. Use a variety of brushmarks to indicate the foliage, but don't apply the color to the brightest, sunlit parts, to allow the initial bright yellow-green to show through.

5 While this green is still wet, drop in washes of Indigo to create interest and to vary the color and texture.

6 For the shadows, mix up a Sap Green wash and let your brush travel freely over the grass. To give the illusion of depth, make the shadows darker in the foreground. Leave some spaces between your brushmarks for the sunlit areas of the grass. For the shadows on the paths, use a mixture of Cerulean Blue and Alizarin Crimson.

46 | Waiting in line
Simplifying people

Materials

- Watercolor block, 14 x 10 in. (355 x 254 mm)
- 2B pencil
- Size 6 round brush

Color palette

- Yellow Ocher
- Alizarin Crimson
- Burnt Umber
- French Ultramarine Blue
- Indigo
- Payne's Gray
- Lunar Black
- Cadmium Red

Here is an exercise in depicting people that is good practice for your watercolor work. Drawing figures in a sketchbook is about conveying gestures and posture rather than trying to capture facial features. You can also enjoy showing the differences in clothing, while including details such as bags, hats, and pets will add character and uniqueness to your painting.

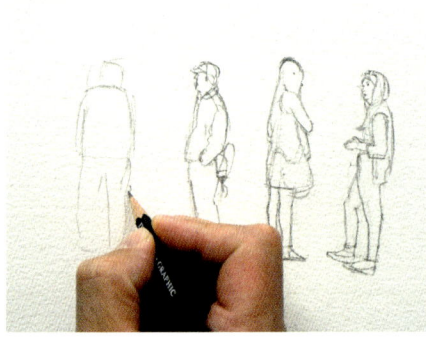

1 Use a 2B pencil to make a rough drawing of the figures. Concentrate on getting the gestures right and building up the placement of the arms and legs as you go.

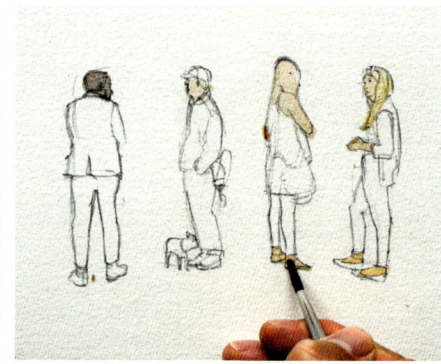

2 For the Caucasian skin, mix up a wash of Yellow Ocher with a small amount of Alizarin Crimson. Take this same color over the hair as well. For the darker skin, add Burnt Umber to the wash. If you want the color to be a bit cooler, add a touch of French Ultramarine Blue; for a warmer tone, add Alizarin Crimson.

WAITING IN LINE | 131

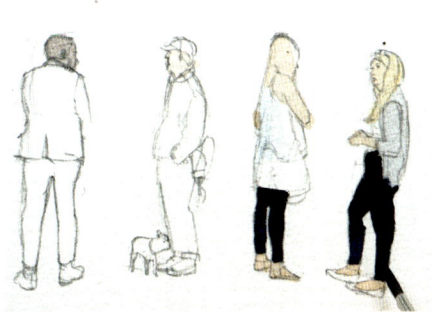 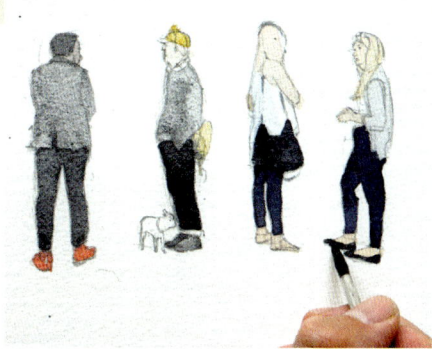 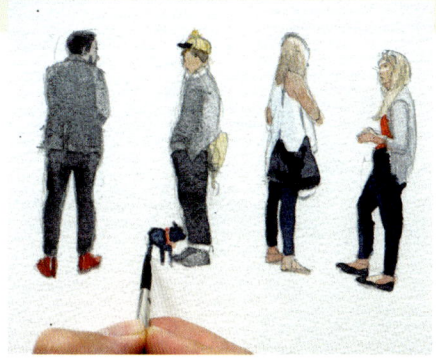

3 Use an Indigo wash for the jeans. Try not to just "fill in," but consider how to vary your application of the paint. I used a lot of water and pigment to add extra interest.

Take a very diluted Ultramarine wash over the shaded area on the shirt of the third figure. Use a diluted Payne's Gray wash for the cardigan worn by the fourth figure.

4 Now build up the color on the remaining clothing and shoes, using varying washes of Lunar Black. This pigment gives an amazing charcoal-like effect. I've let the washes run into each other in some parts, but use your own judgment.

5 Paint the dog with the same Lunar Black wash.
Add a touch of Cadmium Red to the shoes of the first figure and to the dog's collar.
Finally, add depth. Notice where the arms and faces are in shadow, and paint a darker version of the existing color—mostly this just means adding more paint to your mixtures.

47 | Coffee shop
Painting quickly *in situ*

Materials

- Sketchbook
- 2B pencil
- Platinum carbon pen, fountain pen with waterproof ink, or black fine liner
- Brush pen
- Size 8 round brush

Color palette

- Yellow Ocher
- Cerulean Blue
- Payne's Gray
- Alizarin Crimson
- Sap Green

Drawing and painting in cafés is great fun and a good way to record life in your own town or city in a way that is unique to you. Working in this kind of setting is different from working at home, however, because you will probably be under time constraints to record information. Luckily, you'll be able to capture the poses of the people working there, since they will return to the same one again and again—for example, at the coffee machine.

Using ink for your sketch cuts down on the areas, and therefore the amount of time, you need to paint. Remember to use waterproof ink, since you don't want the ink to run when you apply the watercolor washes. You'll want to retain the strength of the black lines that are so much part of the character of this scene.

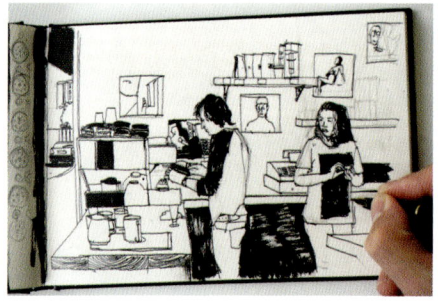

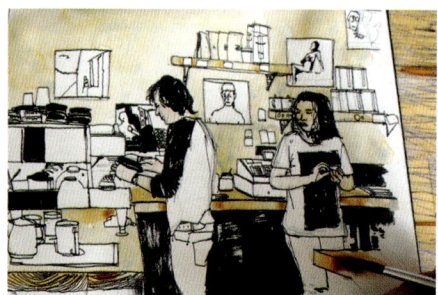

1 Roughly sketch out the position of the people and objects in the scene. You may feel happier doing a pencil sketch first, then going over it in pen, or you can go straight to penwork—both approaches work well, so choose the one you feel most comfortable with. For the darker areas and to create a nice texture, I've used a brush pen as well as my ink pen.

2 Mix up a wash of Yellow Ocher with a touch of Cerulean Blue for a slightly cool color. Use this for the background and for the faces.

Vary the density of this wash by adding more Yellow Ocher and use this for relevant parts of the scene—for example, the edge of the wooden countertop.

COFFEE SHOP 133

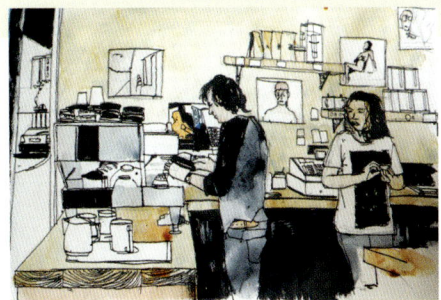

3 Now apply a wash of Payne's Gray to the clothing and to some of the metal surfaces of the kitchen equipment. Again, vary the density of the wash so that some parts are a darker gray. Add touches of an Alizarin Crimson wash to the photographs on the wall.

4 Because the darkest areas have been painted black with the brush pen, there isn't a huge amount of painting to be done. The picture reads quite easily already—and that's what makes this a good method for painting in a situation when you don't have much time.

5 Add some final touches of extra color—diluted Alizarin Crimson, Sap Green, Cerulean Blue—to details of the painting. You'll notice that some areas remain unpainted. The picture still holds together, though, because of the strength of the original black lines and marks.

134 PEOPLE

48 | Shades of gray portrait
Grisaille

Materials

- Watercolor block, 14 x 10 in. (355 x 254 mm)
- 2B pencil
- Size 8 and 6 round brushes

Color palette

- French Ultramarine Blue
- Burnt Sienna
- Yellow Ocher
- Alizarin Crimson
- Burnt Umber
- Sap Green

This portrait is based on a traditional technique called grisaille. The term comes from the French word, *gris*, or gray, and the technique involves creating an underdrawing or painting entirely in shades of gray, or a similar neutral color. Color is then built up in thin, transparent layers, known as glazes. The finished result is subtle and beautiful, and can look rather like those old tinted black-and-white photographs, from the days before color photography.

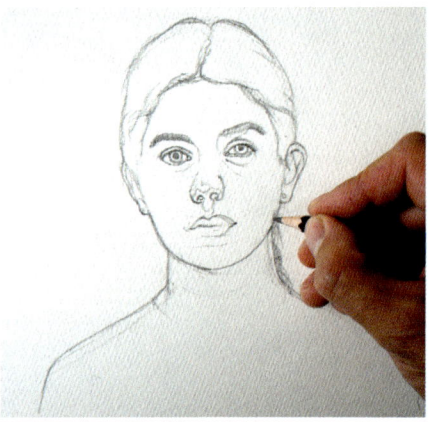

1 Make an initial drawing of your sitter, keeping your lines quite dynamic. Do a fairly accurate drawing and make sure you include the main features and shapes—for example, the hair. You may want to include finer detail for features such as the eyes and ears—you will retain this detail in the finished piece.

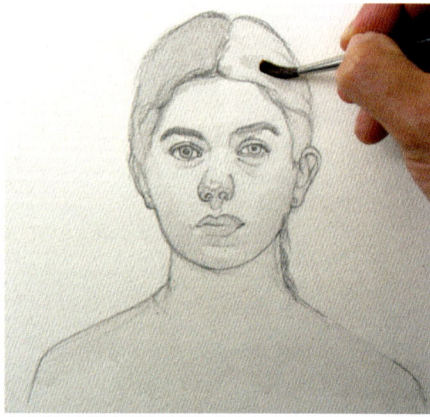

2 Now begin to build up subtle layers of color with the larger brush. Start with a light but warm gray wash mixed from French Ultramarine Blue and Burnt Sienna. Use this wash as an underpainting, applying it to the darker areas such as the hair and the shadows on the left of the face, around the eyes, and under the nose.

SHADES OF GRAY PORTRAIT 135

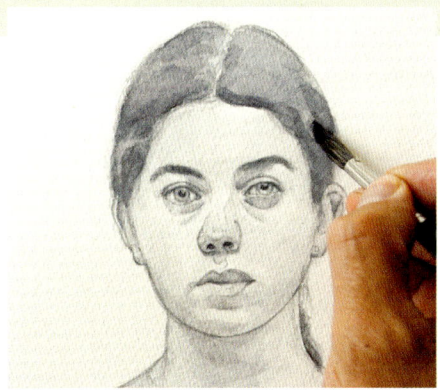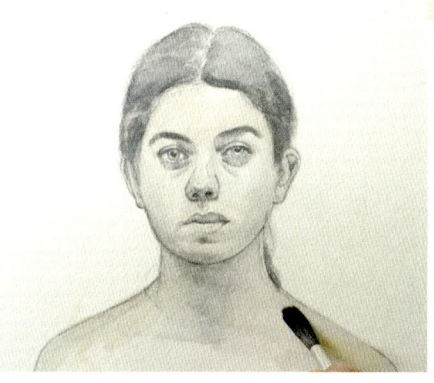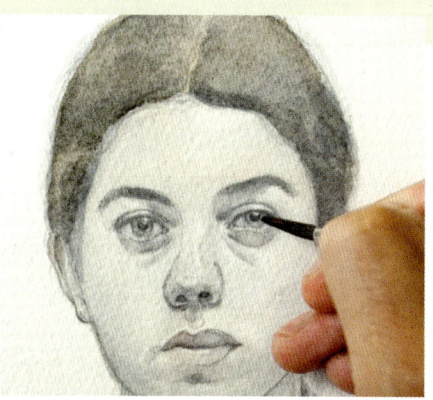

3 Continue to build up the forms with glazes of the same wash—overlays of subtle color—leaving washes to dry between applications. At this stage you are just deepening the tones rather than adding new colors. Take your time and you'll start to see the face becoming more three-dimensional.

4 Start to add more warmth to your portrait with redder washes—a Yellow Ocher wash with a little Alizarin Crimson. Apply this in very diluted form to parts of the face, such as the lips and cheeks.

If you're uncertain, try it out on a spare piece of paper first, since it can be unnerving painting over all the work you've already done.

5 Add Burnt Umber to the hair and a light wash of Sap Green to the eyes with the smaller brush.

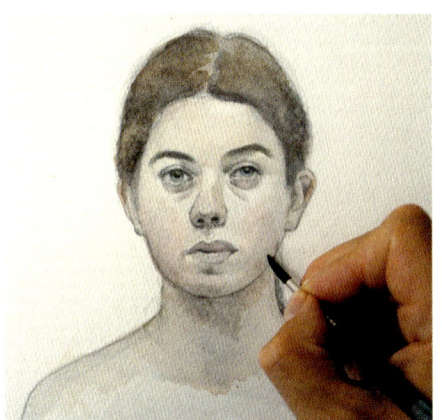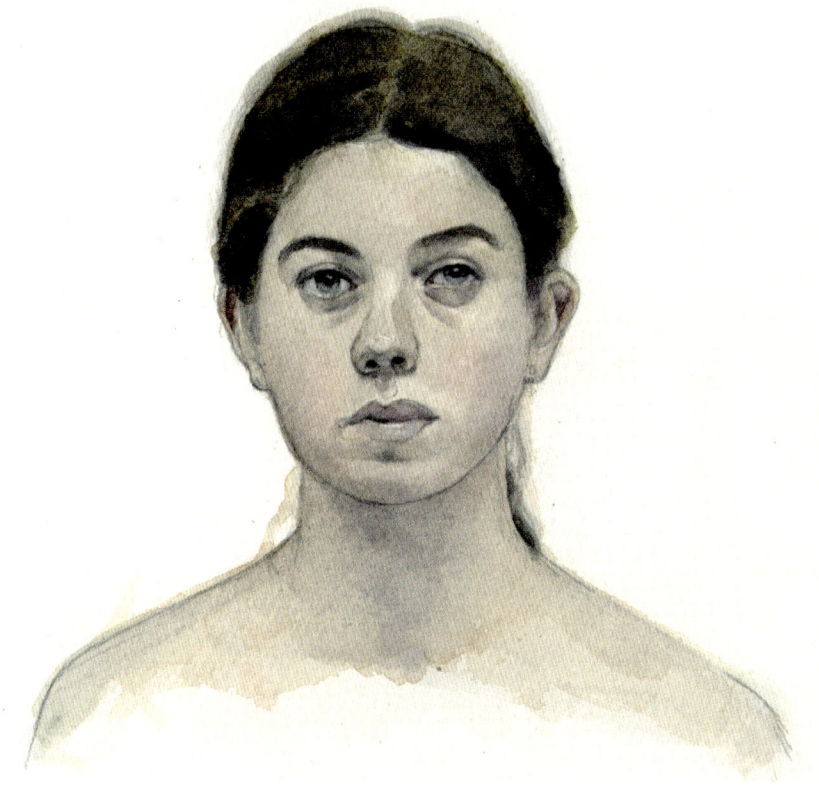

6 It takes a bit of time to slowly build up your painting, but it's worth it. In the finished piece, you can see how adding washes of warmer color brings life to the portrait.

49 | Dance practice
Capturing movement

Materials

- Watercolor block, 14 x 10 in. (355 x 254 mm)
- 2B pencil
- Size 12 round brush

Color palette

- Payne's Gray
- Alizarin Crimson

This exercise involves drawing people in motion rather than in stationary postures. I've chosen ballet dancers here, but it could just as easily be skaters at a park, players at a sports game, or people at a train station. Each of these little drawings and paintings takes only a few seconds to do, so, instead of steps culminating in a finished painting, as elsewhere in the book, this demonstration features multiple examples of quick paintings to give you an idea of what can be achieved when you're capturing people on the move.

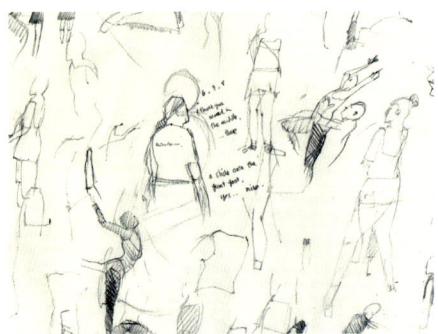

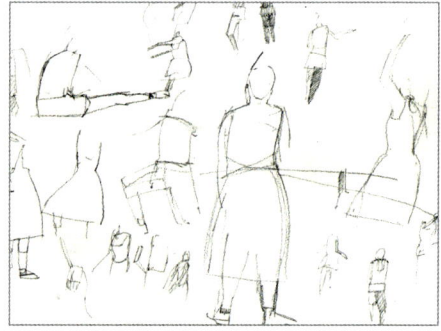

Memorize the movements
A 2B pencil is fairly soft and will make marks easily, giving you the flexibility to create expressive gestures. Drawing people in motion is largely about memory—try holding a pose in your mind and get it down on paper as quickly as possible. Lots of your drawings won't quite work out, but you'll soon start to get the hang of it. Remember that details are not important at this stage.

Look for repeated movements
There can be a lot to take in when drawing dancers, but after a while you'll start to see movements being repeated which will make them easier to draw.

Take advantage of resting figures, too, since you'll have more time to draw them.

DANCE PRACTICE· 137

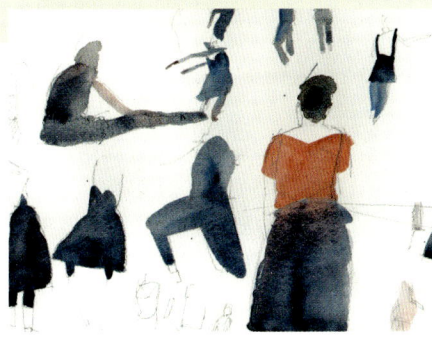

Restrict your colors
By the time you start applying paint, the dancers will have moved from where they were. So just keep it simple and use only a couple of colors—in this case, Payne's Gray and Alizarin Crimson.

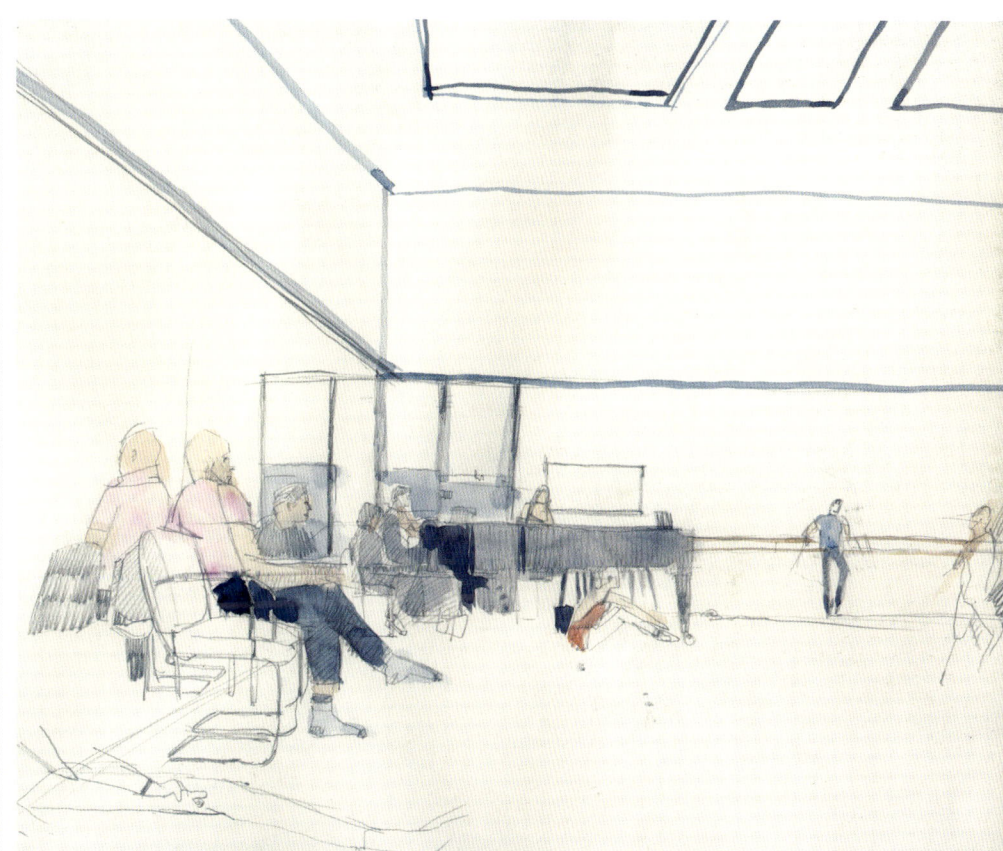

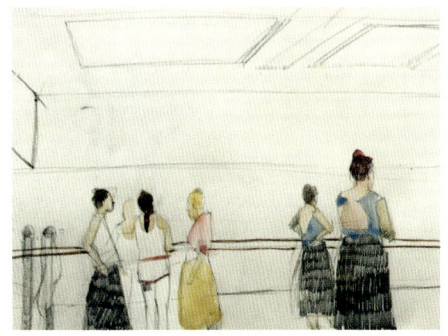

Analyze postures
Another approach is to draw more static figures, like these dancers who are waiting to start dancing. There's no need to include facial features at this stage—just try to get the rough posture of the figures correct.

Using a few lines to suggest details of the dance studio—the barre and the skylights—helps to place the figures in context and "grounds" them in their setting.

Add a few touches of color to your standing figures to help bring them alive.

Place the figures in their setting
Here there is a mixture of moving and static figures. The moving dancers need only to be roughly suggested to offer a nice contrast to the seated and standing figures. As before, a few lines and touches of color suggest the details of the dance studio and place the figures in their setting.

50 | Ballet dancers
Mixing media

Materials

- Watercolor block, 14 x 10 in. (355 x 254 mm)
- Size 6 and 12 round brushes
- Charcoal sticks of different thicknesses
- Charcoal pencil
- White gouache
- Paper towel
- Aerosol fixative

Color palette

- Yellow Ocher
- White gouache
- Alizarin Crimson
- Payne's Gray

This exercise was inspired by the pastel studies of dancers made by Edgar Degas for his famous statue, *Little Dancer of Fourteen Years*.

Here charcoal and watercolor have been used. You might think this pairing wouldn't work, because the powdery charcoal doesn't combine well with liquid. However, you can turn this incompatibility to your advantage to create an interesting effect, juxtaposing the dry, rough qualities of charcoal with the wet watercolor.

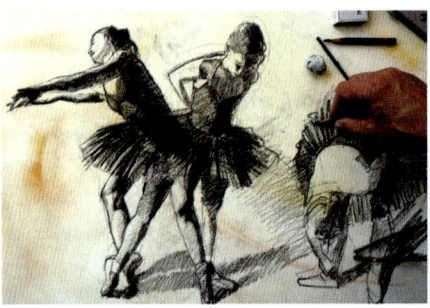

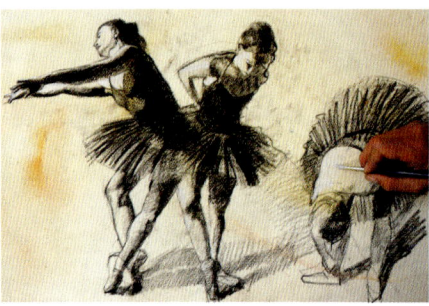

1 To give the paper that aged yellow tone, mix a large quantity of a Yellow Ocher wash and brush this across the whole surface of the paper. The paper will buckle heavily but don't worry—just wait until the wash is fully dry and it will go back to being flat.

Now start your drawing in charcoal. Use a mixture of sticks and pencil to achieve a variety of line. Here the first two figures are deliberately drawn overlapping each other, while the last one is left relatively unfinished.

2 Degas used white pastel to define the highlights on the dancers' figures. To replicate this, apply white gouache to the brightest parts.

BALLET DANCERS | 139

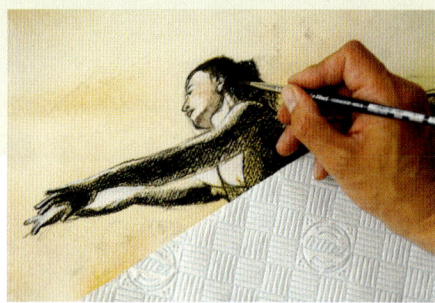
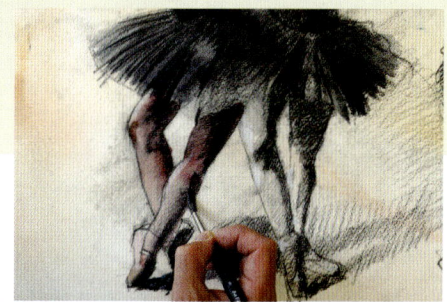

3 Next, apply color to the skin, using a Yellow Ocher and Alizarin Crimson mix and the smaller brush. It is a good idea to carefully lay some paper towel over the part you're not working on to avoid smudging the charcoal.

Apply Payne's Gray to the darker areas, such as the hair.

4 Continue building up the black areas with Payne's Gray. Don't try to hide the charcoal strokes, but allow them to show through. Take special care not to obscure the lines on the dancers' tutus, since these give a real sense of the fabric.

Paint the dancers' legs with a wash of Alizarin Crimson. Use a richer, darker version of the wash for the more shadowy parts.

5 Paint the shadows on the floor with a diluted wash of Payne's Gray. Make the tone darker where they join the feet. These shadows will help to "anchor" the figures to the floor.

Finally, spray your painting with fixative to fix the charcoal.

Stretching paper

You can buy pads of prestretched watercolor paper or stretch it yourself at home.

Stretching your paper before painting will give you a smooth, flat surface to work on. The surface will stay flat as you work, and the finished painting will dry flat. To stretch paper yourself, I recommend buying sheets of plyboard from your local hardware store. They can often cut them down to the size you require. I use at least ½ in. (12 mm) thick plyboard and cut them to 24 × 14½ in. (60 × 37 cm).

It's more economical to buy a larger sheet of watercolor paper (22 × 30 in./56 × 76 cm), fold it in half, score it, carefully tear it in half, and repeat to get four equal sheets. It gives really nice edges to your paper.

Once your paper is the right size, cut four strips of gum tape, one for each edge—each one should be about 2 in. (50 mm) longer than the length of each paper edge. Have a jar of water ready to moisten the tape and some paper towels handy. It's a good idea to have the gum strips precut before you get started.

Immerse the sheet of paper in a tray of water. I use my bath but any big container that can hold the sheets will do. Leave it in the water for about 10 minutes—if the paper is larger, keep it in longer, up to 15 minutes maximum. Any longer and there's a chance you'll remove the "size" (the treatment that prevents water from completely penetrating the paper).

Pick the paper up by two corners and let the excess water drain off. Lay the sheet, right side up, on a clean drawing board. Use paper towels to remove excess water. Next, moisten the gum tape with a small sponge and lay it about 1 in. (25 mm) over the paper, sticking the rest to the board. Smooth it down firmly with a cloth and leave it to dry flat: this can take a couple of hours. To remove the paper use a blunt knife and work your way under the tape and paper, lifting your artwork from the board. Some tape will remain stuck to the board but can easily be removed by wetting the tape and scraping it away with an old paint stripper.

You will need
Working surface such as a sheet of plyboard
Small sponge
Paper towels
Gum tape
Large container of water

Glossary

Complementary colors
A pair of colors consisting of a primary color and a secondary color that is made up of the other two primaries. The complementary of red, for example, is green (made from blue and yellow). Positioning two complementary colors side by side produces maximum contrast, with an almost electrical effect.

Cool colors
Colors that are toward the blue end of the spectrum and evoke subjects that we regard as "cool"—for example, water or sky. Thus, blues, greens, violets, and grays can all be called cool colors. Adding red to these colors makes them warmer, producing warm greens, grays, and purples.

Depth
The perceived distance between the foreground, middle ground, and background in a painting. There are various ways to create an illusion of depth—for example, by using warmer colors and crisper shapes in the foreground and paler, softer ones in the background.

Dry-brush
A technique of applying dryish paint which only partially covers the paper, catching on the "tooth" as the brush is dragged across to produce a soft, feathery effect.

Eye level
The line on which your eye rests when looking straight ahead at the subject before you, without looking either up or down—effectively the viewer's "horizon" line. Altering the eye level in a composition can dramatically alter its impact.

Hot-press paper
A type of machine-made watercolor paper manufactured to have a smooth surface. It is also known as HP paper. It is suitable for fine work, such as line and wash.

Landscape format
A composition with a horizontal emphasis, in which the width of the picture is greater than the height, reminiscent of the panorama of a landscape. (See also, Portrait format.)

Masking
Protecting selected parts of a painting from a particular application of color. Masking fluid or pieces of paper may be used, depending on the size of the area to be masked.

Monochrome
A term used to describe a painting produced with different tones of a single color.

Palette
A tray containing small, cup-shaped hollows in which watercolor washes can be mixed. The term is also used to describe the range of colors an artist has used in a particular painting.

Perspective
The optical illusion whereby objects appear smaller the farther away they are, and lines appear to converge as they recede into the distance. The place where these lines meet is known as the "vanishing point."

Pigment
The fundamental coloring agent of a paint. Pigments may be natural in origin (for example, "earth" pigments such as the siennas) or synthetic. To make them into paint, pigments are bound together in one or more mediums.

Portrait format
A composition with a vertical emphasis, in which the height of the picture is greater than the width—a shape most suited to portraiture. (See also, Landscape format.)

Secondary colors
Colors produced by mixing two primaries: purple made from red and blue; green made from blue and yellow; and orange made from red and yellow.

Texture
In a painting, the illusion of a rough, uneven, or patterned surface—for example, that is found on brickwork, old wood, shingle, or coarsely woven cloth.

Tone
The degree of lightness or darkness of a color.

Tooth
The mass of minute, irregular projections all over the surface of watercolor paper. Rough paper has the most pronounced tooth.

Warm colors
Colors that are toward the red end of the spectrum and evoke subjects that we regard as "warm"—for example, fire or earth. Thus, reds, oranges, and browns can all be called warm colors. Adding blue to these colors makes them cooler, producing cooler reds and browns.

Wash
An application of watercolor paint diluted with water. The more water used, the paler the wash will be. Washes may be flat—made up of a single color applied evenly all over; graded or gradated—made up of a single color that gradually changes from a light to a dark tone, or vice versa; or variegated—made up of more than one color.

Wet in wet
A term used to describe the technique of applying wet paint to an existing layer of color that is still wet.

Wet on dry
A term used to describe the technique of applying wet paint to an existing layer of color that is dry.

Index

A
abstract patterns 84–85
alizarin crimson 14
animal portraits
 editing out 110–111
 expressive brushwork 112–113
 grouping subjects 108–109
 landscapes with wildlife 124–125
 marine subjects 122–123
 museum specimens 114–115
 painting live animals 116–117
 three-color washes 120–121
 working from photos 118–119
arranging simple still life 38–39
atmosphere 22–23
 washes for atmosphere 60–61

B
backgrounds 34–35, 56–57
blues 14
 mixing blues 16
browns 15
brushes 12, 13, 28
buildings 88–89
 complex scenes 100–101
 exploiting granulation 90–91
 multiple buildings 96–97
 perspective 98–99
 sense of scale 104–105
 symmetry and proportion 94–95
burnt sienna 15
burnt umber 15

C
cadmium lemon 14
cadmium orange 15
cadmium red 14
cadmium yellow 14
cerulean blue 14, 29
cityscapes
 building up a complex scene 100–101
 exploiting granulation 90–91
 finding your interpretation 102–103
 introducing a sense of scale 104–105
 painting multiple buildings 96–97
 perspective for beginners 98–99
 simplifying what you see 88–89
 sparkling sunlight 92–93
 symmetry and proportion 94–95
cobalt turquoise light 15
cobalt violet 15
colors 14–15
 additional colors 15
 bright colors in landscapes 68–69
 cold colors 29
 color mixing 16–17
 color, light, and atmosphere 22–23
 dark colors 15
 dropping color 29
 get confident with color 42–43
 minimal palette 36–37
 premixing 28
 testing 28
 warm colors 29
 working with one color 78–79
complex scenes 100–101
composition 46–47
 grouping subjects 108–10
 ideas for composition 70–71
contrast 56–57

D
distance 64–65
drawing 40–41
 see the form layer 41
 see the shadow layer 41

E
edges 54–55
editing out 110–111
equipment 12–13
erasers 12, 13
expressive brushwork 112–113

F
flowers 44–45, 56–57, 68–69
 wild flowers 46–47
form layer 41
French ultramarine blue 14
fruit 50–51

G
gouache, white 12, 13
gradated washes 21, 62–63
granulation 28
 exploiting granulation 90–91
greens 14, 15, 29
 mixing greens 17
greys 29
grisaille 134–135
gum tape 12, 13

H
hair-dryers 13, 29
hard pencils 28

I
indigo 15
ink 48–49, 52
interpretation 102–103

K
kit 12–13

L
landscapes
 abstract patterns 84–85
 adding figures to landscapes 128–129
 bold shapes 72–73
 bright colors in landscapes 68–69
 creating sense of distance 64–65
 ideas for composition 70–71
 interesting shapes 74–75
 landscapes with wildlife 124–125
 masking areas of white paper 66–67
 pure texture and subtle washes 76–77
 reserving colors 80–81
 simple wash with gradation 62–63
 telling stories 82–83
 washes for atmosphere 60–61
 working with one color 78–79

INDEX

light 22–23, 92–93
lunar black 15, 29, 78–79

M
marine subjects 122–123
masking fluid 12, 13
 masking areas of white paper 66–67
 reserving colors 80–81
minimal palette 36–37
mixed media 138–139
movement 136–137
museum specimens 114–115

O
outdoor practicalities 25

P
palettes 12, 13
paper 18
 cold-press paper (rough or not) 18–19, 29
 color 19
 hot-press paper (smooth) 18–19, 29
 stretching paper 140
 watercolor blocks 19
 weight 19
paper towels 13
patterns 84–85
Payne's gray 15
pen and ink 48–49, 52
pencil sharpeners 12, 13
pencils 12, 13, 28
people
 adding figures to landscapes 128–129
 capturing movement 136–137
 grisaille 134–135
 mixing media 138–139
 painting quickly in situ 132–133
 simplifying people 130–131
perspective 98–99
perylene green 15
photographic reference 118
proportion 94–95

R
reds 14
 mixing reds 17

S
sap green 14
scale 104–105
shadow layer 41
shapes in landscape 72–75
sight sizing 50–51
sketch free 28
sketchbooks 24–25
 bindings 25
 formats 24
 mini sketch pads 25
 sketchbook gallery 26–27
soft pencils 28
spattering 29
sponges 13
still life
 arranging simple still life 38–39
 backgrounds 34–35
 basic drawing for watercolor 40–41
 classic subjects, new approaches 44–45
 compose as you go 46–47
 creating dynamic contrast 56–57
 get confident with color 42–43
 hard edges 54–55
 lively washes 32–33
 quick watercolor sketch 52–53
 sight sizing 50–51
 watercolor with pen and ink 48–49
 working with a minimal palette 36–37
stories 82–83
stretching paper 140
sunlight 92–93
symmetry 94–95

T
texture 76–77
travel kit 13

U
underpainting 68–69
unity 26

W
washes 20–21
 flat wash 21
 gradated wash 21
 lively washes 32–33
 multiple colors wash 21
 simple wash with gradation 62–63
 subtle washes 76–77
 three-color washes 120–121
 washes for atmosphere 60–61
water 28
water jars 12–13, 29
water sprayers 13
watercolor paints 12–15
 refilling pans 29
watercolor sketch 52–53

Y
yellow ocher 14
yellows 14
 mixing yellows 16

Credits

All step-by-step and other images are the copyright of Quarto Publishing plc. While every effort has been made to credit contributors, Quarto would like to apologize should there have been any omissions or errors—and would be pleased to make the appropriate correction for future editions of the book.

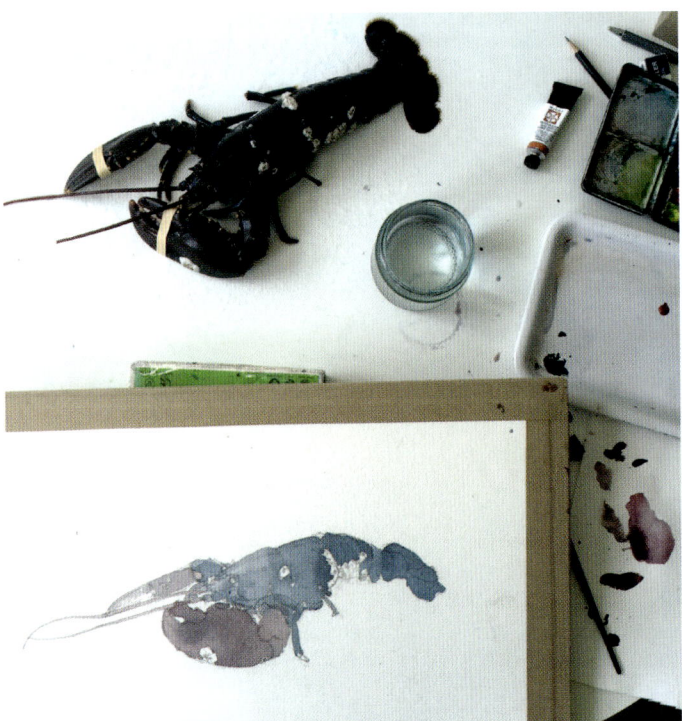